SUZANNE MIDDLEMASS

It's All About

Shoes

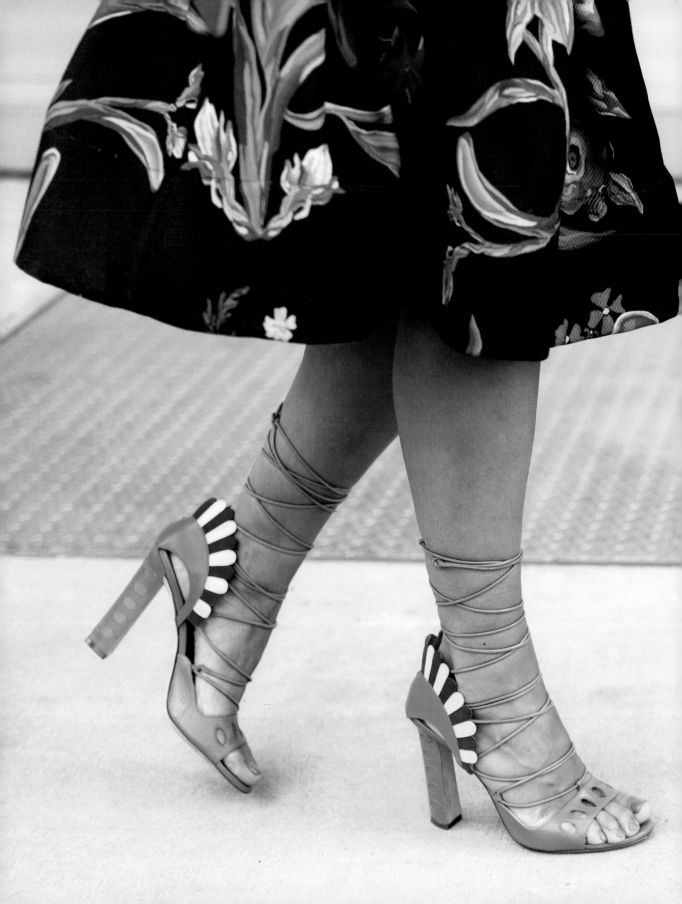

SUZANNE MIDDLEMASS

It's All About

Shoes

teNeues

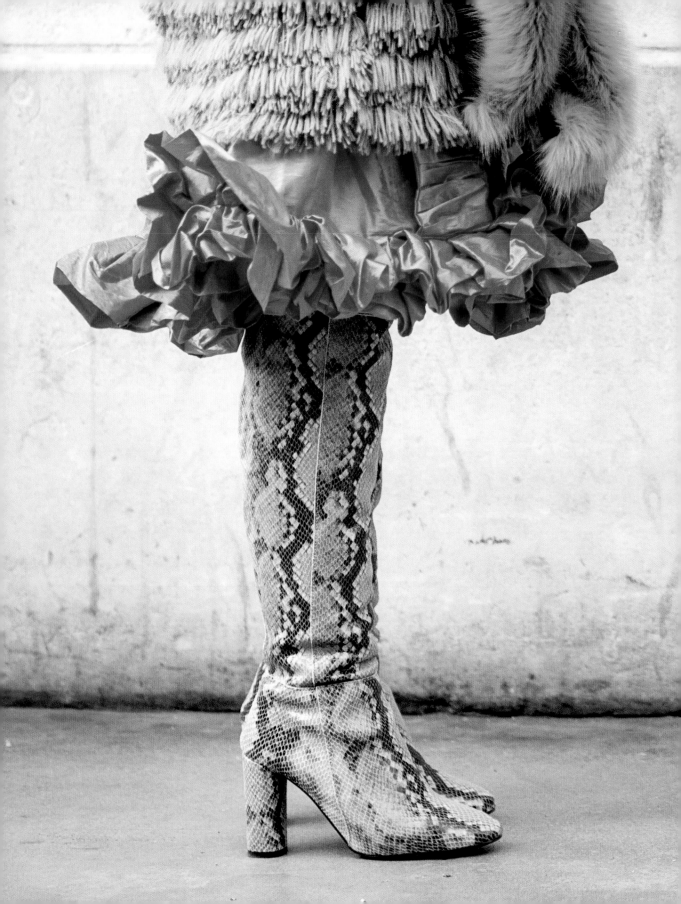

Introduction

Shoes, to me, are what jewelry is to Holly Golightly! Whether it's wearing them, photographing them, or shopping for them, delighting in my love of shoes is one of my favourite pastimes... With a beautiful new pair on my feet, I can escape the reality of everyday and morph into Cinderella!

So, when it comes to my work as a street style photographer, I am immediately drawn to wondrously adorned feet because, for me, style begins at the bottom! I have fashionable friends who choose their shoes first before they pick out their outfit for the day—they believe shoes are the ultimate accessory!

When deciding who and what to shoot, I am not necessarily interested in the latest designs, essentially I am looking for something that stands out from the crowd, something outside the realm of the ordinary, a diamond in the rough! From original detailing to eccentric characteristics, I lust after unique designs, and if it catches my eye, I stalk and hunt until I get the shot!

My ethos for this book is to present my favourite shoes, which I have photographed all over the world during the past few years, in an aim to show the diverse range of styles that exist on the streets—from the fun and whimsical to the seductive and bizarre, and lastly to keep the shoe lover's flame alight!

Pour moi les chaussures c'est comme les bijoux pour Holly Golightly ! Que ce soit pour les porter, les photographier ou les acheter, un de mes passe-temps favoris c'est de me délecter dans mon amour des chaussures ... En étrennant une belle paire aux pieds, je peux m'évader de la réalité quotidienne et me transformer en Cendrillon !

Et donc, quand il s'agit de mon travail de photographe de mode de rue, je suis irrésistiblement attirée par des pieds merveilleusement ornés parce que pour moi, le style commence du bas ! J'ai des amies passionnées par la mode qui choisissent en premier leurs chaussures avant de se décider pour la tenue du jour car d'après elles les souliers sont l'accessoire ultime !

Au moment de décider qui et quoi prendre en photo, je ne suis pas forcément intéressée par les tous derniers modèles, en fait je recherche quelque chose qui se distingue de la foule, qui sorte de l'ordinaire, un vrai diamant brut ! Des détails originaux aux caractéristiques excentriques, je convoite les modèles uniques et si mon œil est attiré, je traque et je chasse jusqu'à ce que j'obtienne une photo !

Ma philosophie au long de ce livre est de présenter mes chaussures préférées que j'ai photographiées dans le monde entier au cours de ces dernières années dans le but de montrer la vaste diversité des styles qui existent dans les rues, en passant par tout ce qui est amusant et fantaisiste ou séduisant et bizarre, tout pour que la flamme des amoureux de la chaussure ne s'éteigne jamais !

"TO WEAR DREAMS
ON ONE'S FEET IS TO
BEGIN TO GIVE A REALITY
TO ONE'S DREAMS."

- Roger Vivier

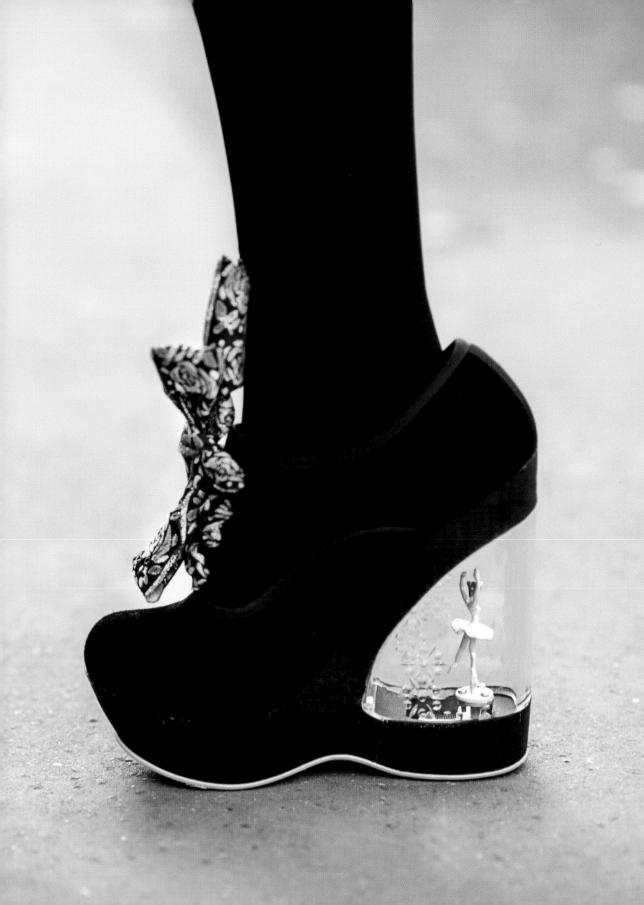

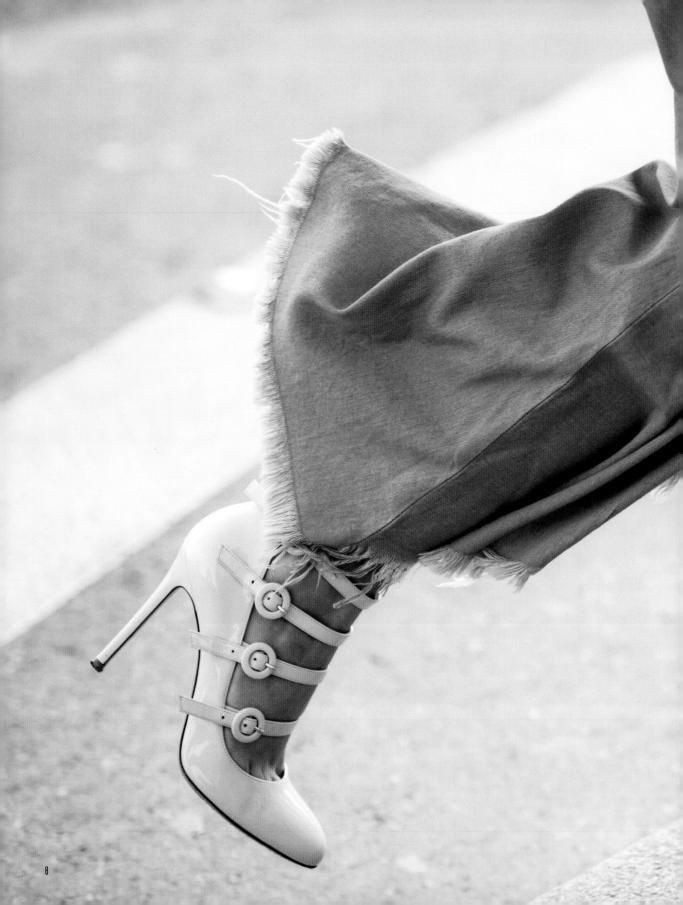

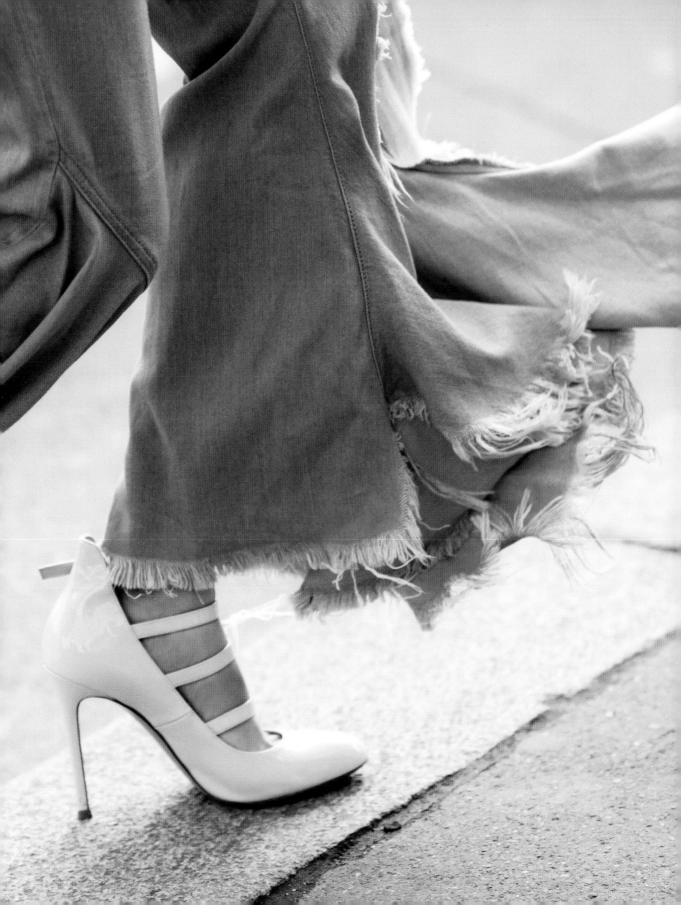

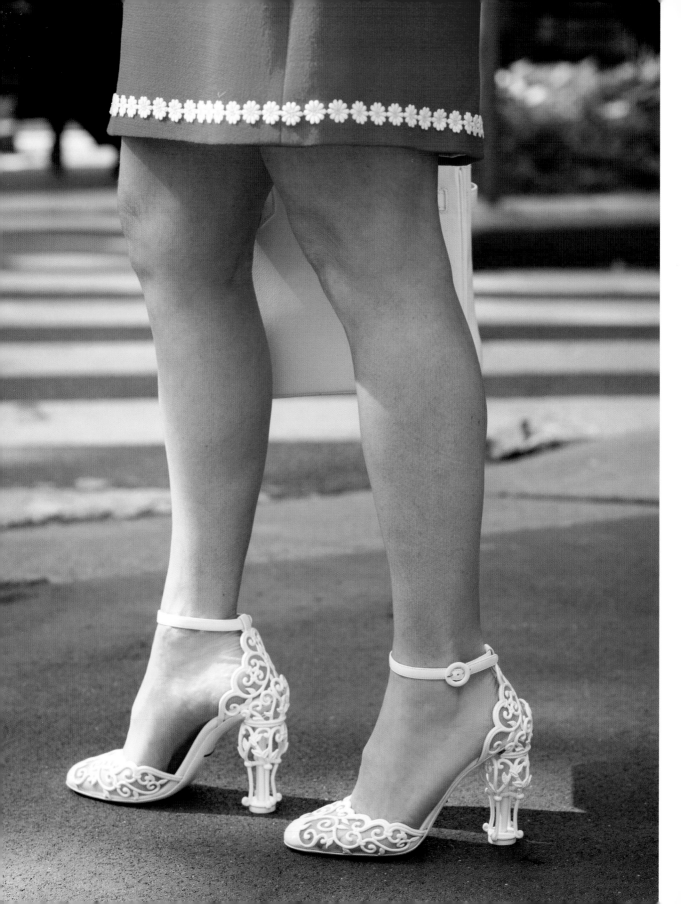

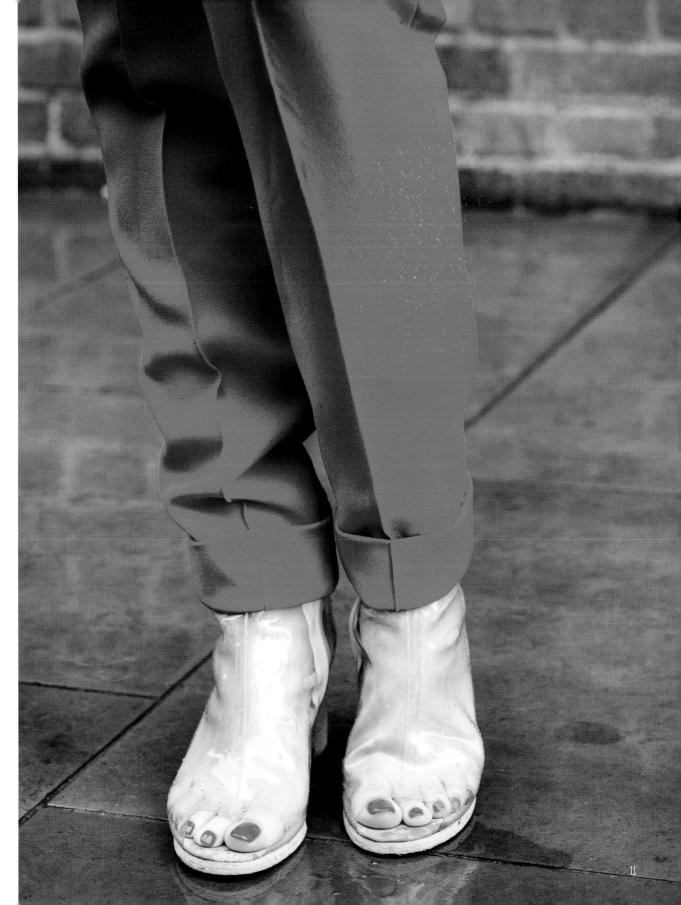

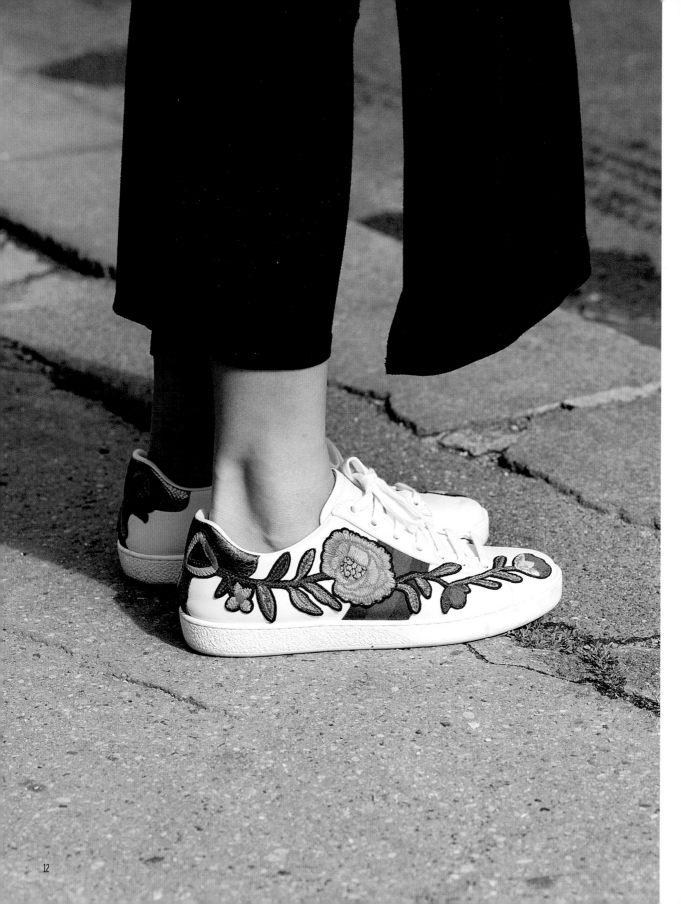

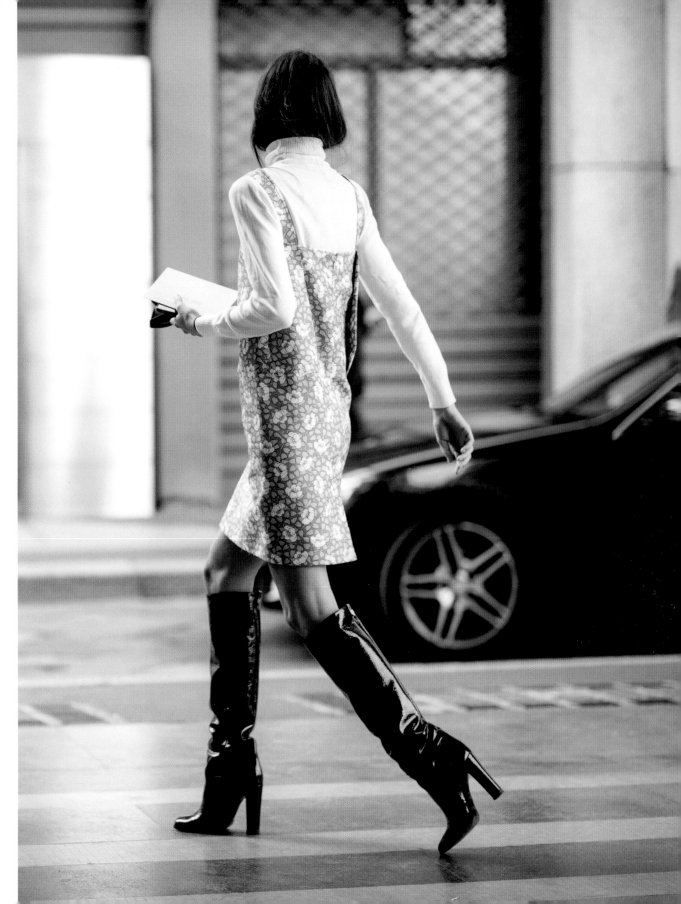

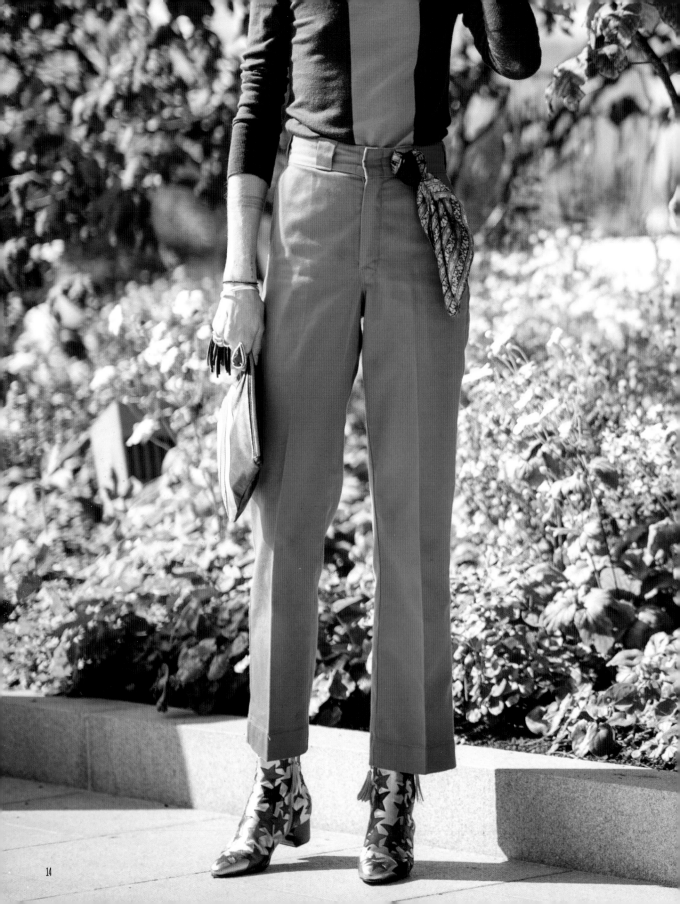

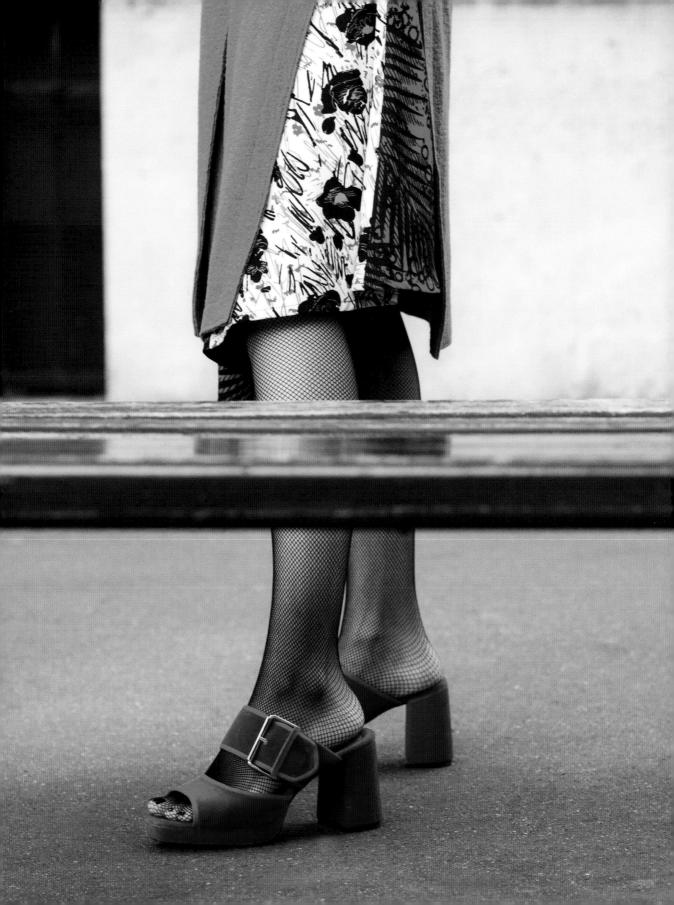

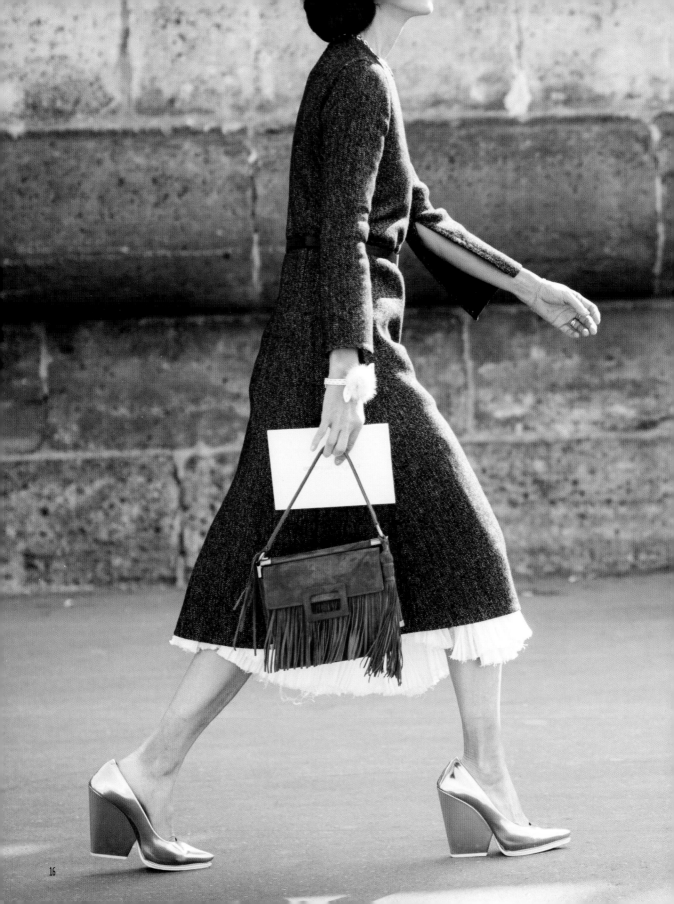

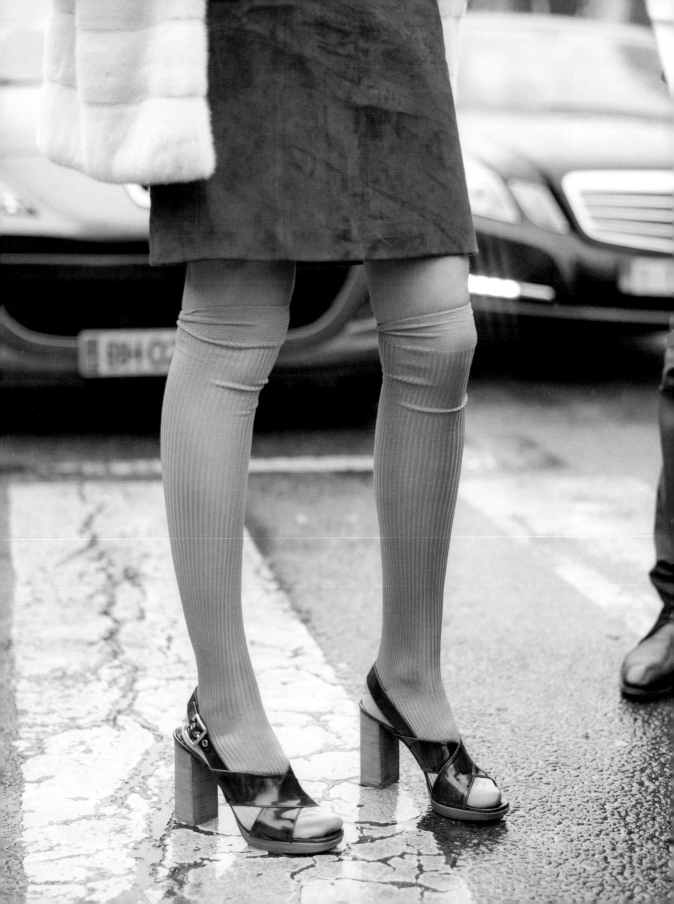

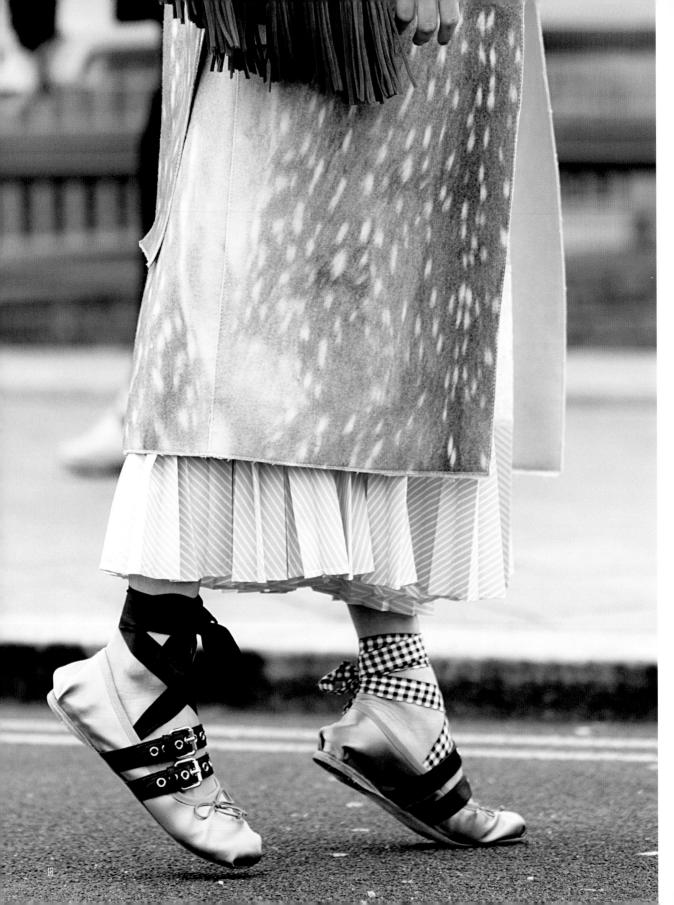

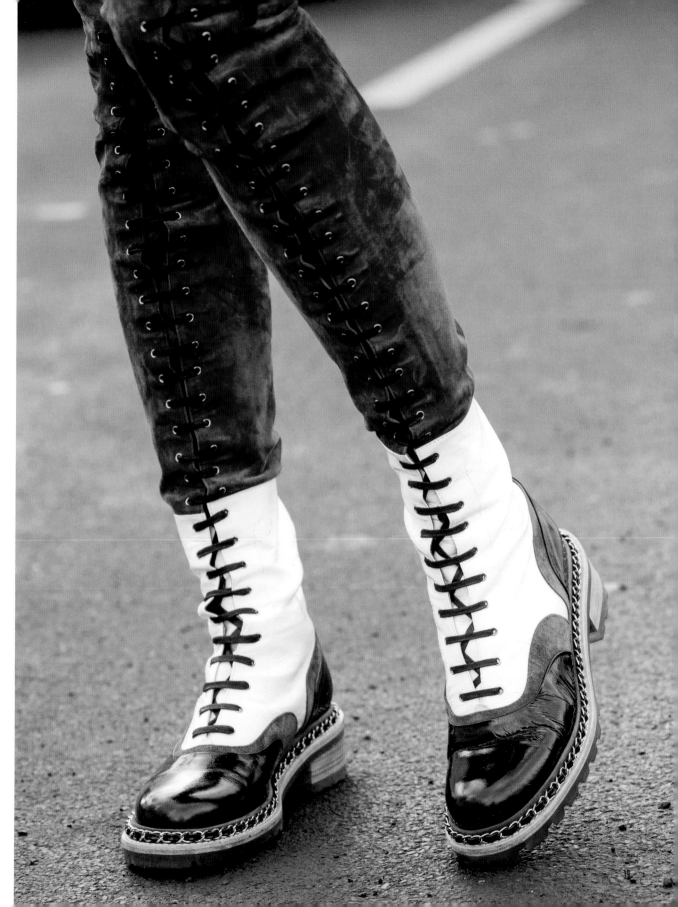

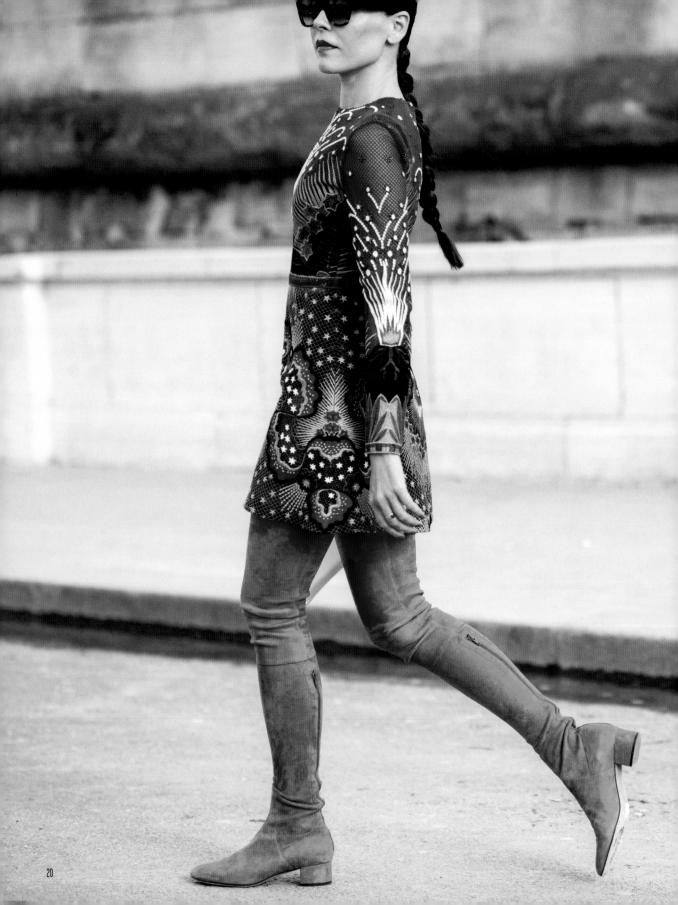

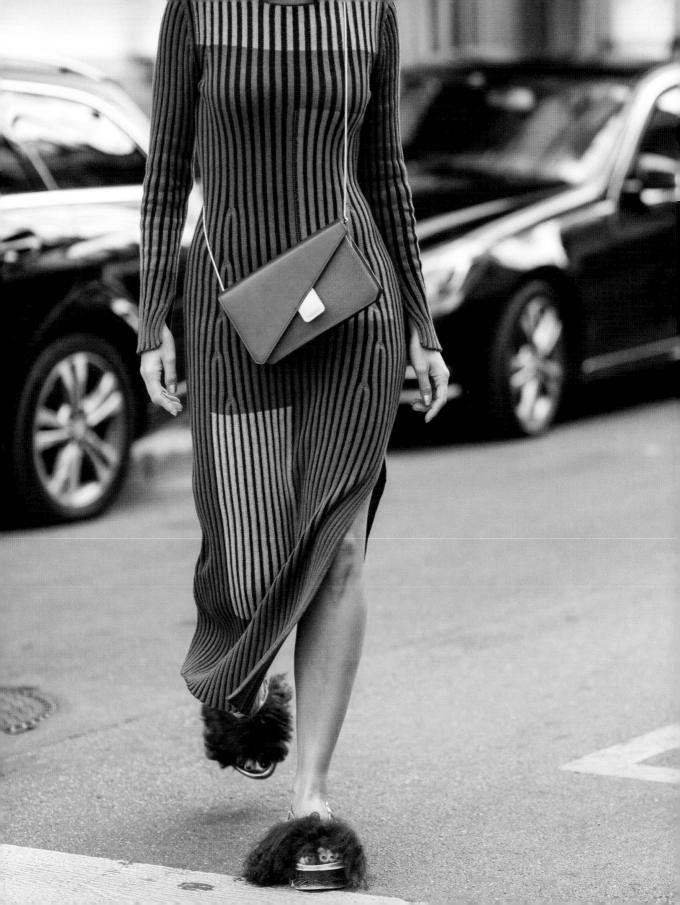

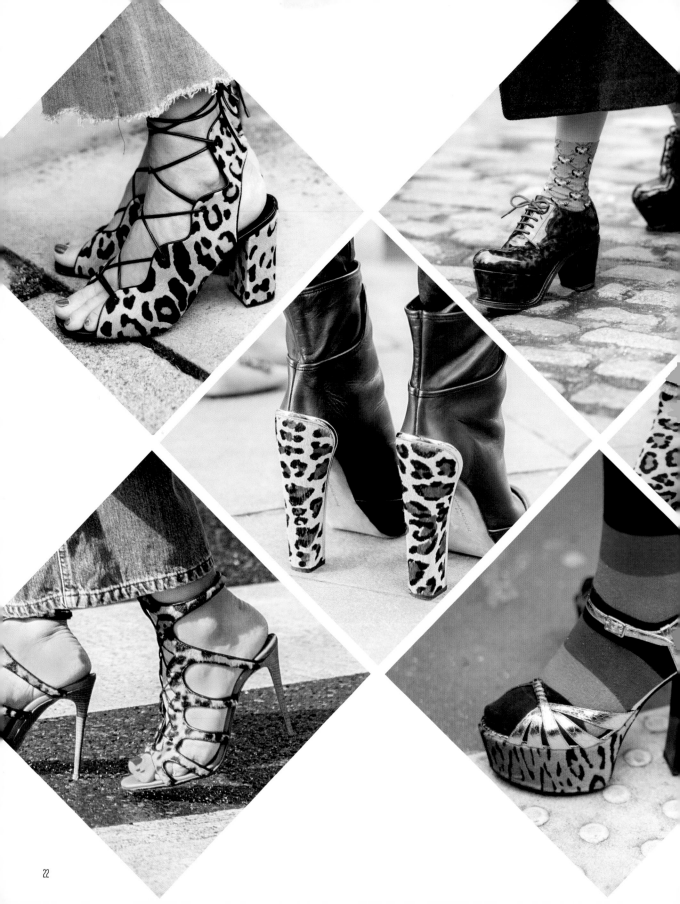

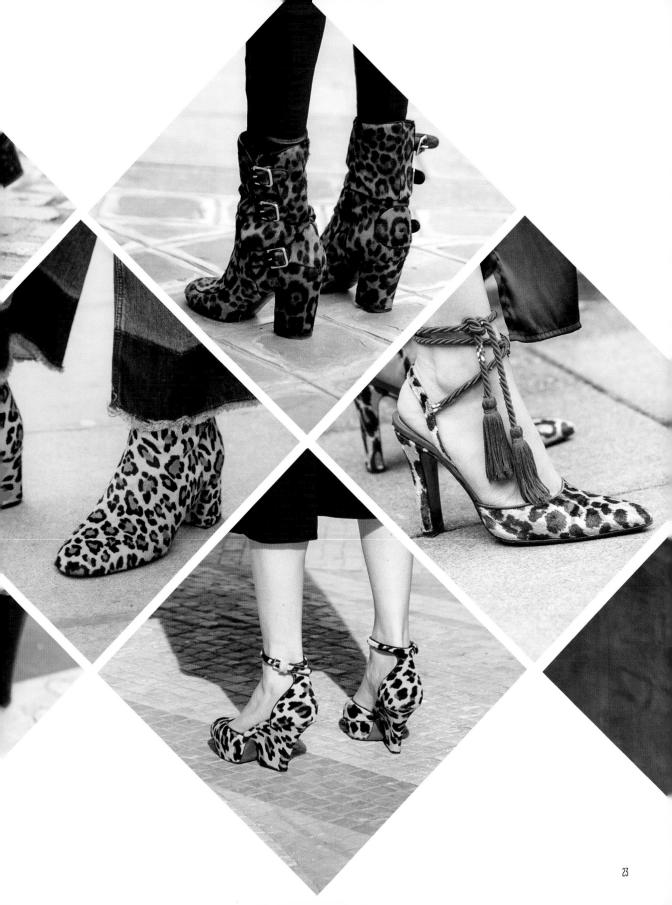

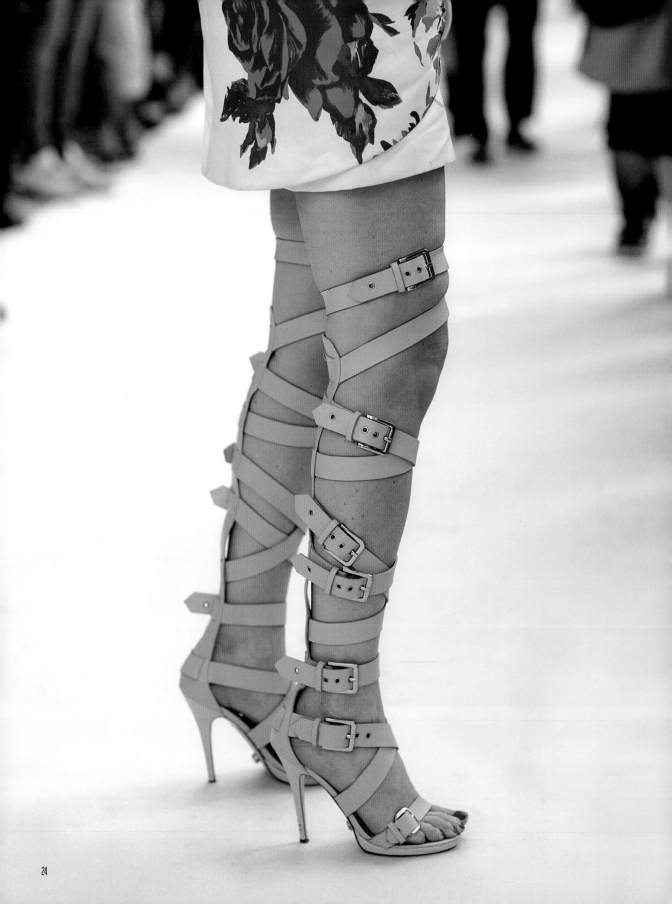

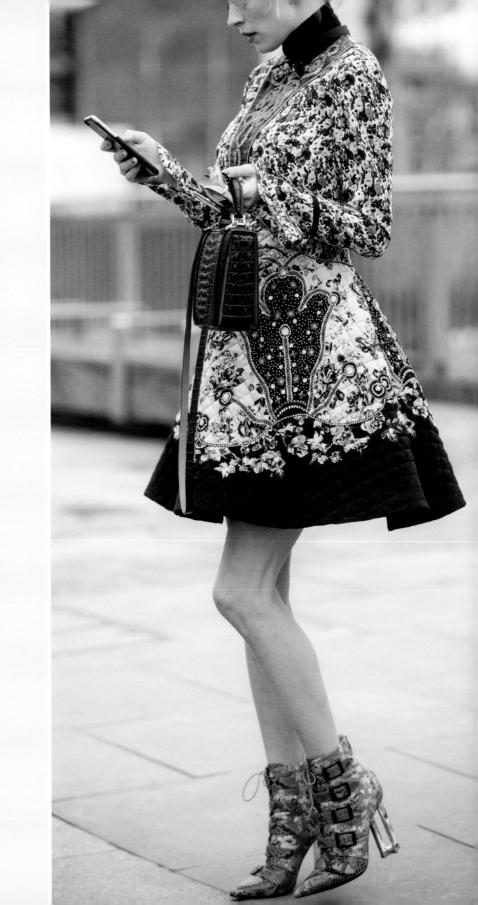

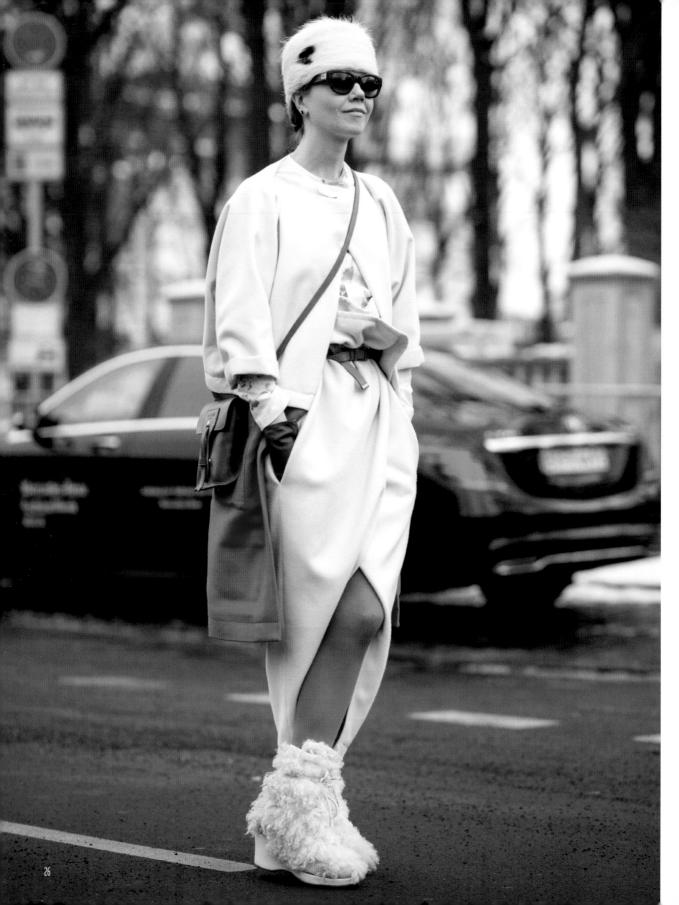

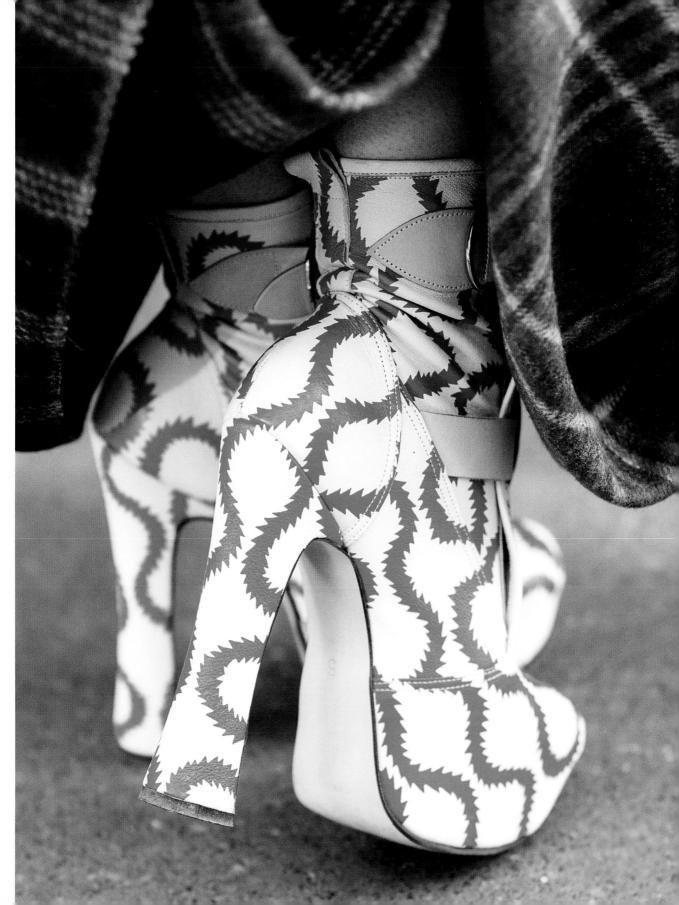

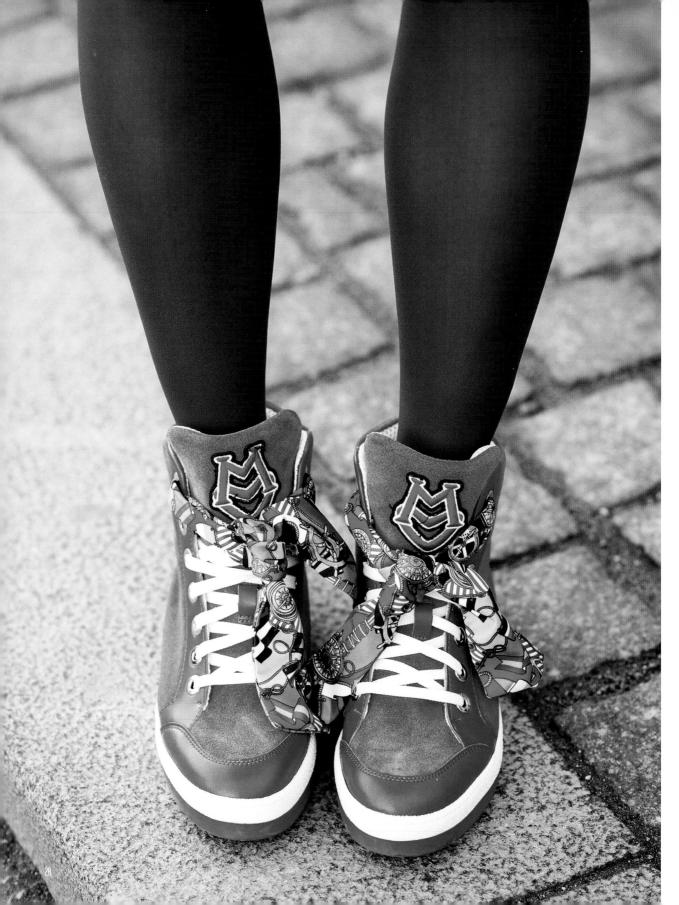

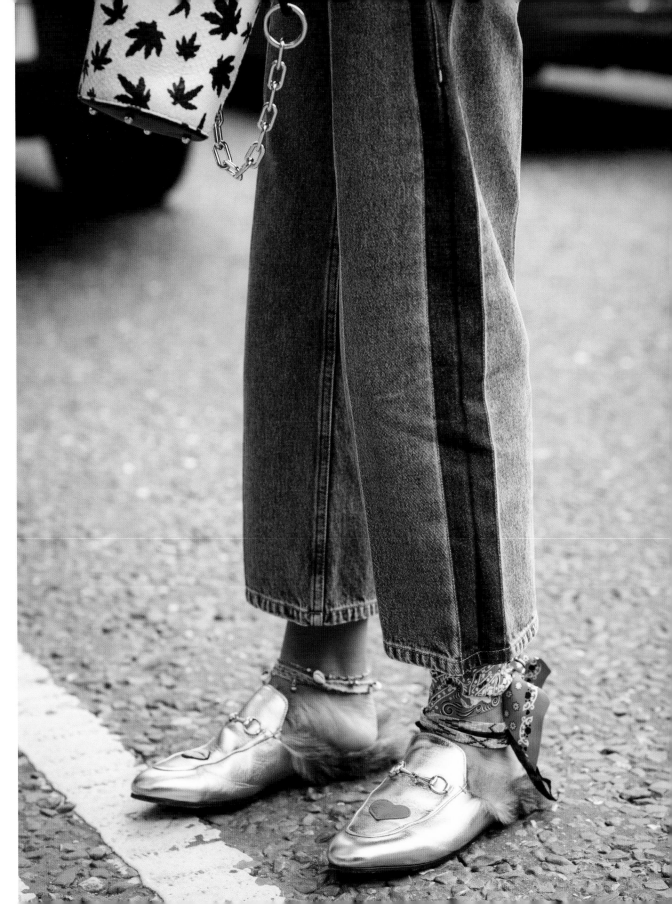

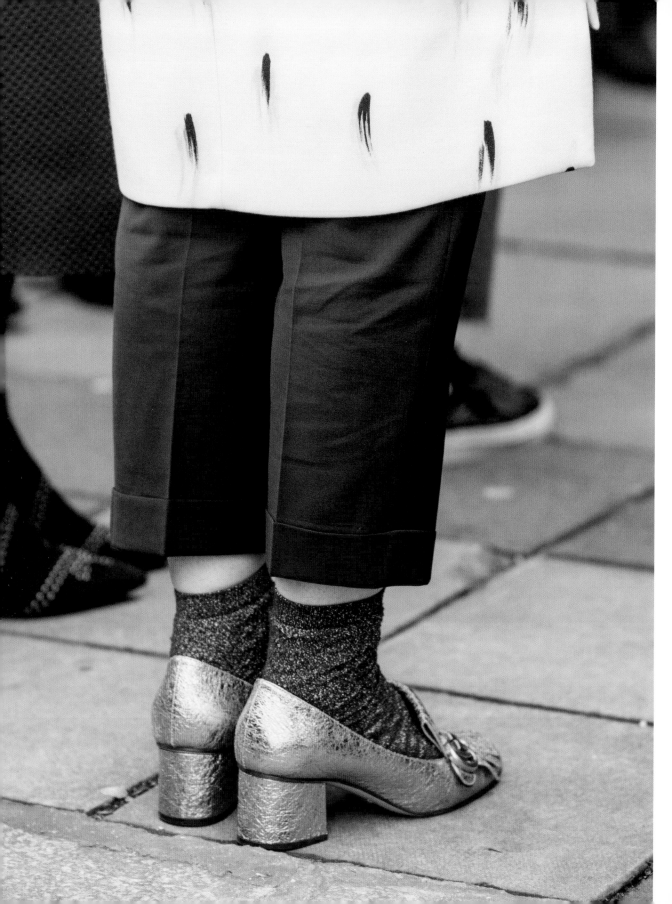

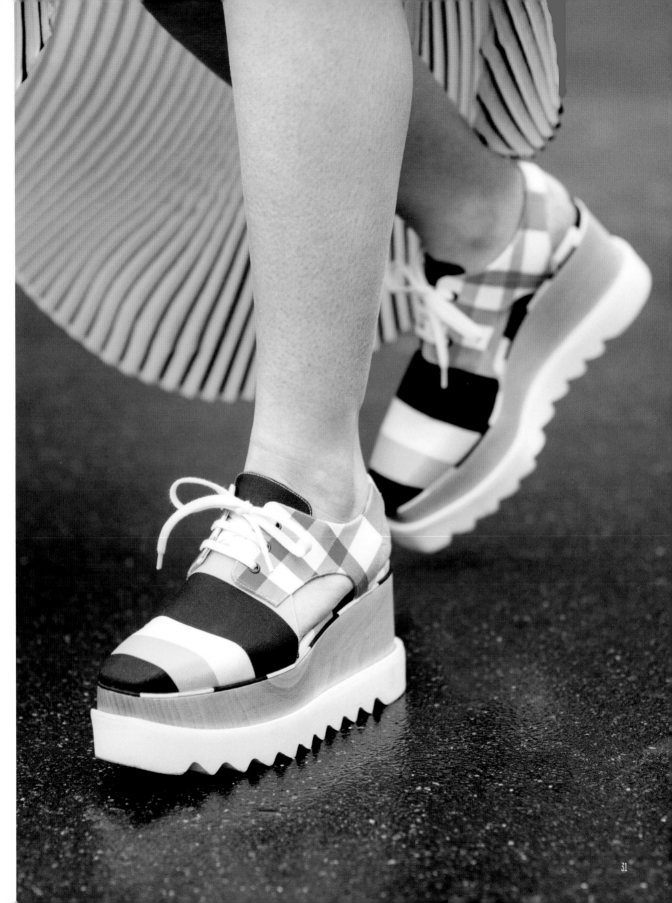

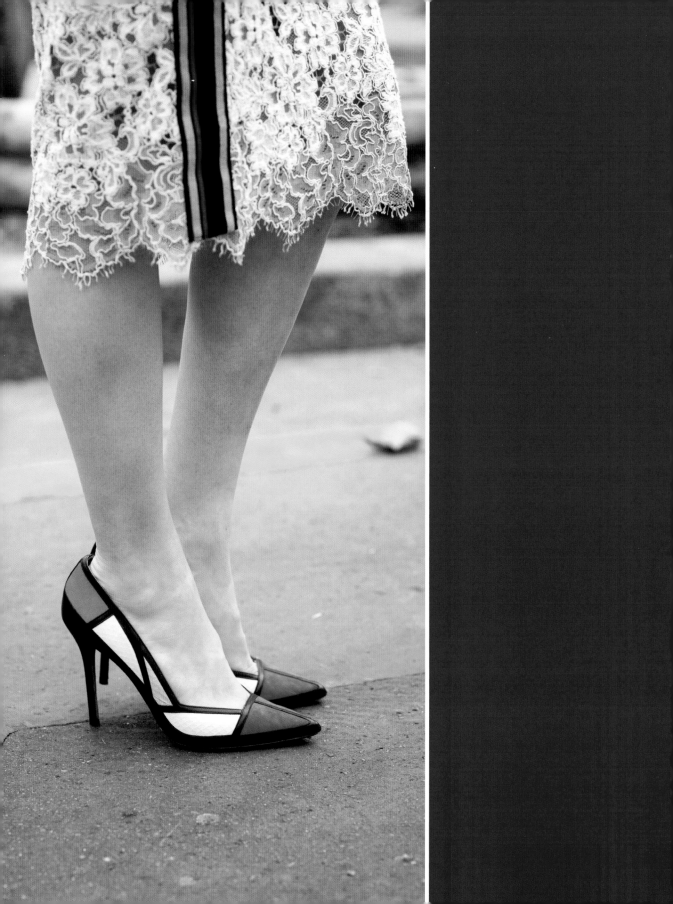

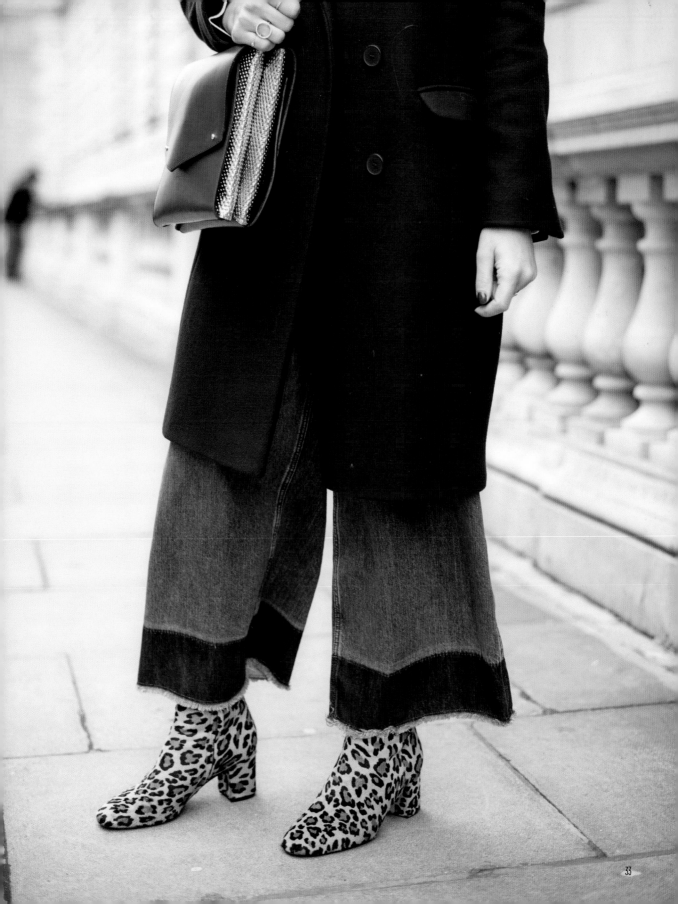

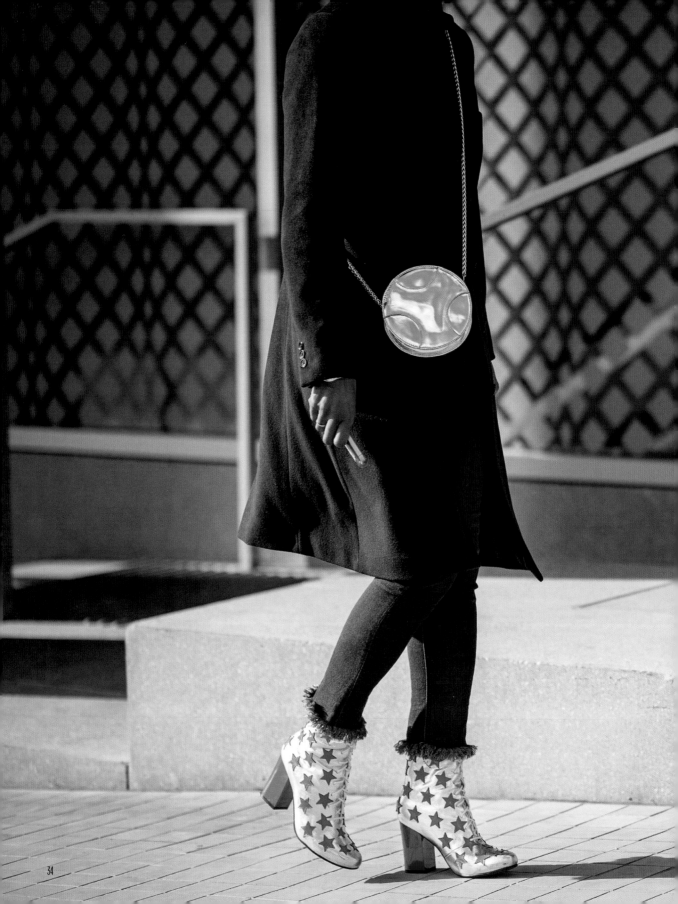

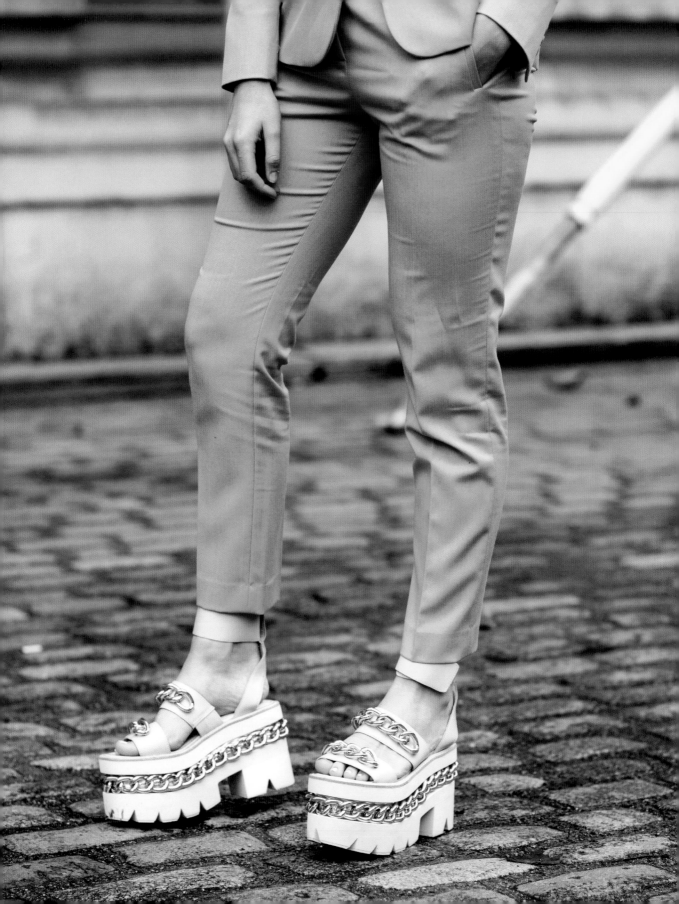

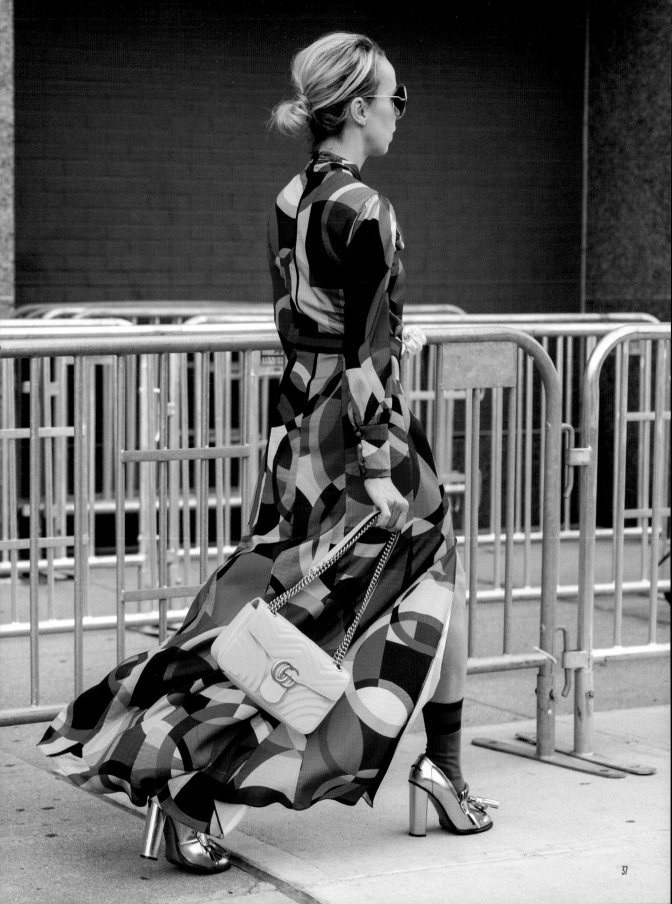

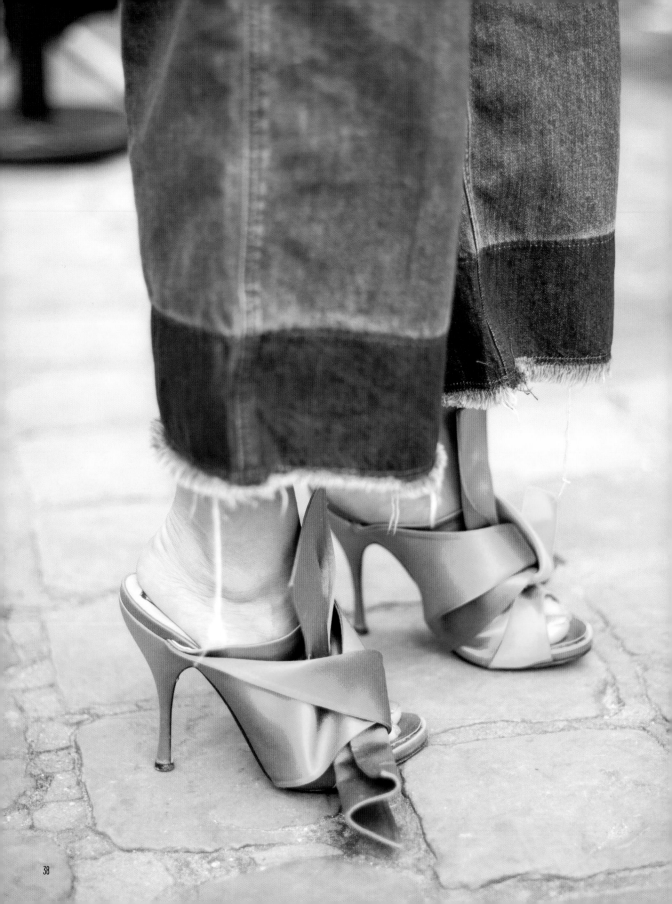

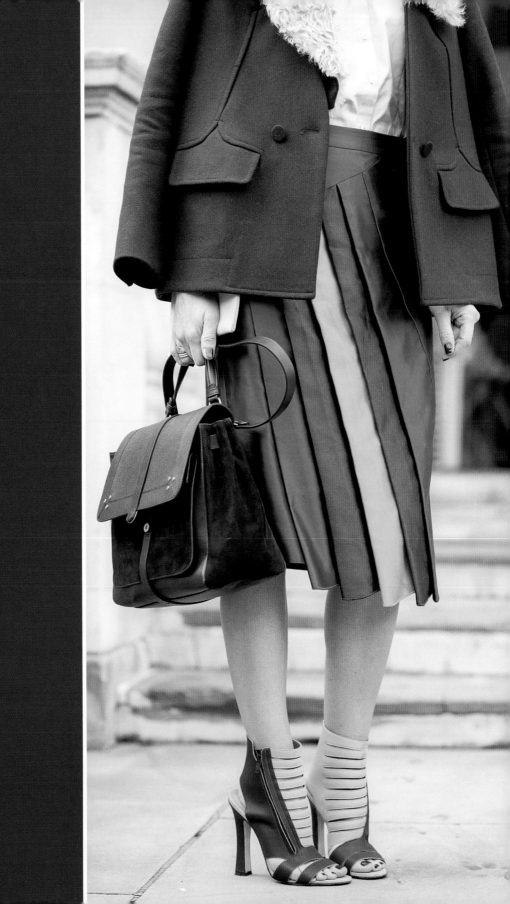

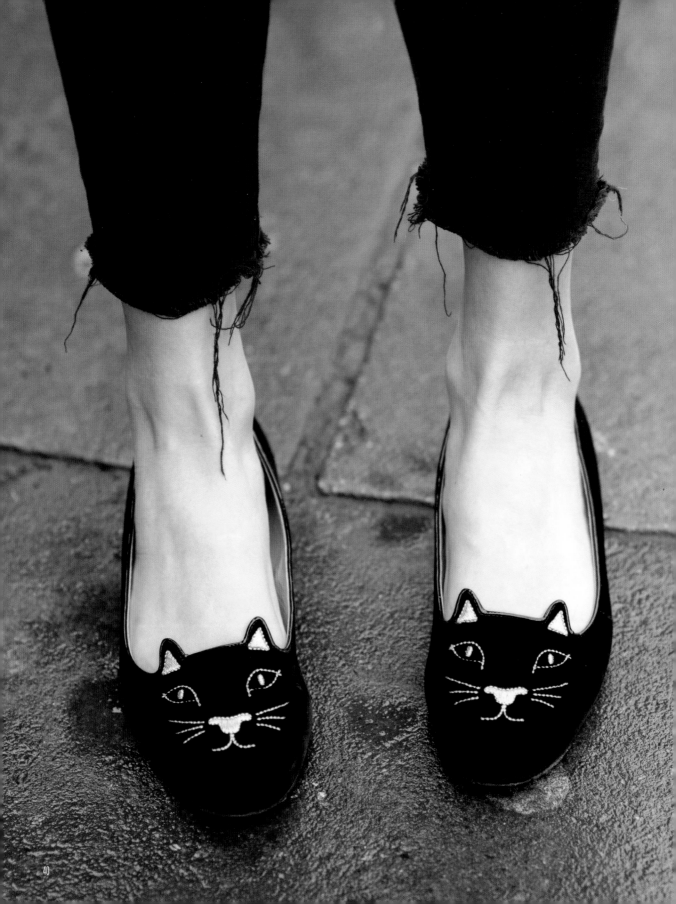

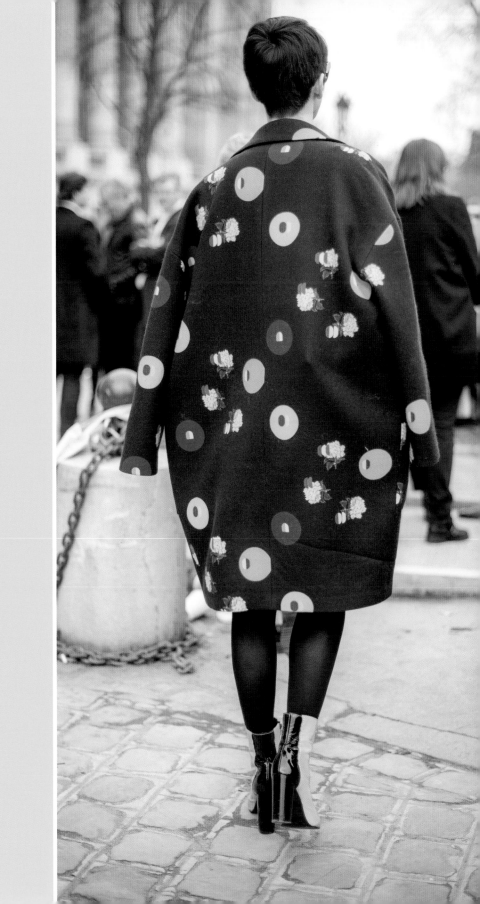

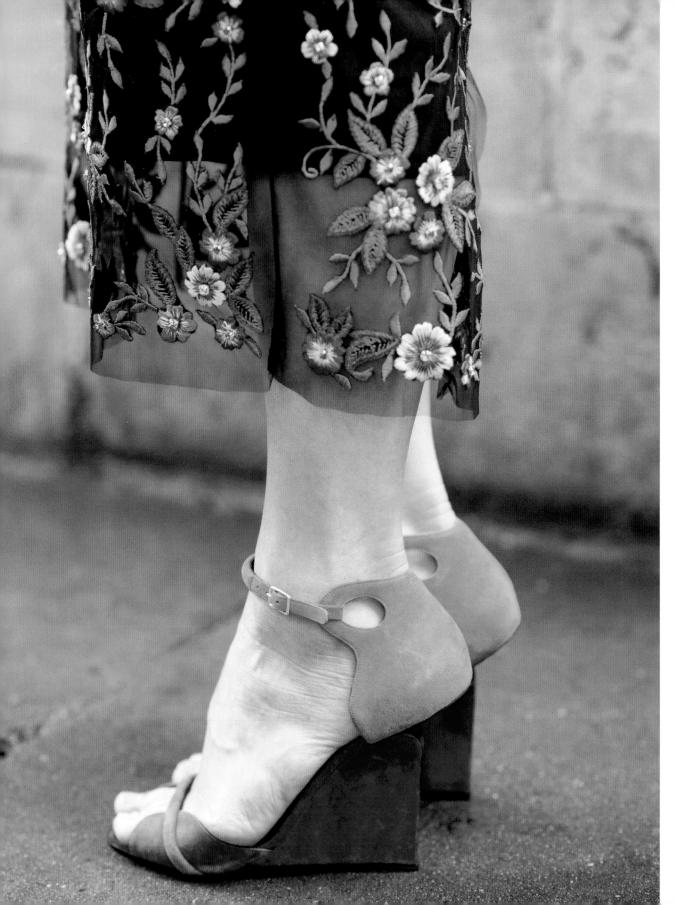

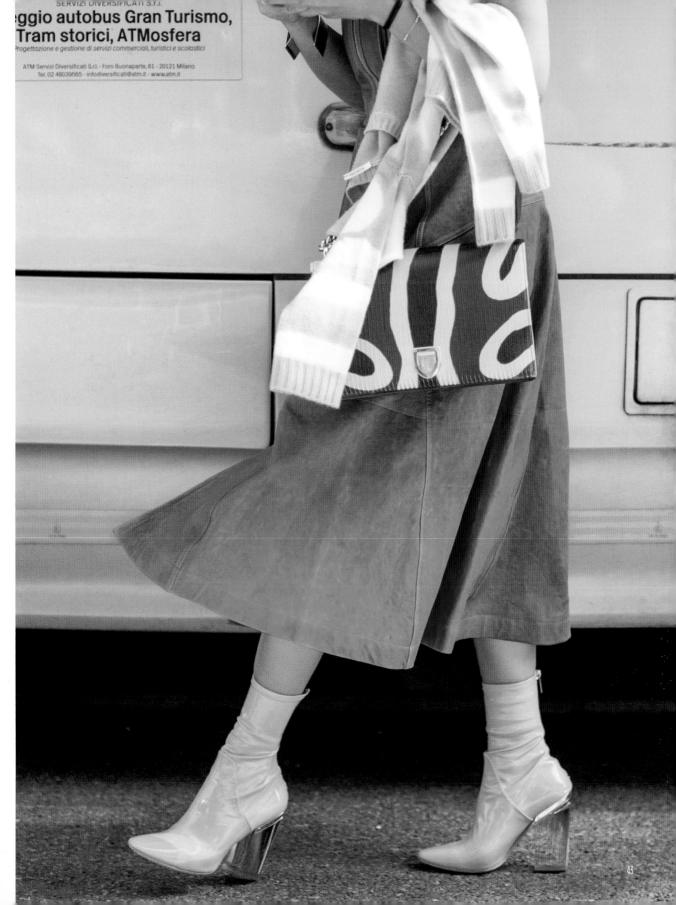

43

"IF YOUR HAIR IS DONE PROPERLY AND YOU'RE WEARING GOOD SHOES, YOU CAN GET AWAY WITH ANYTHING."

- Iris Apfel

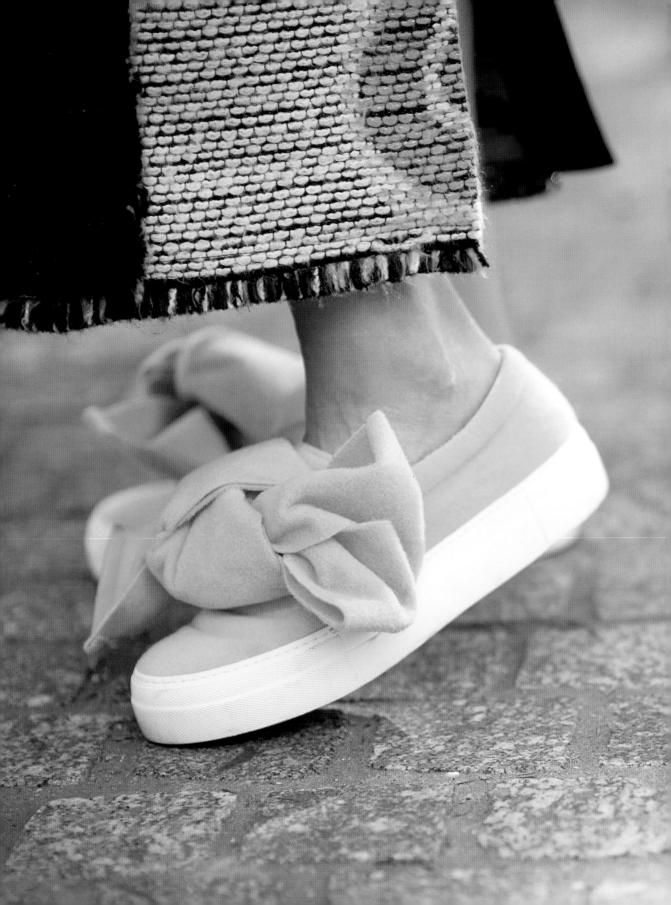

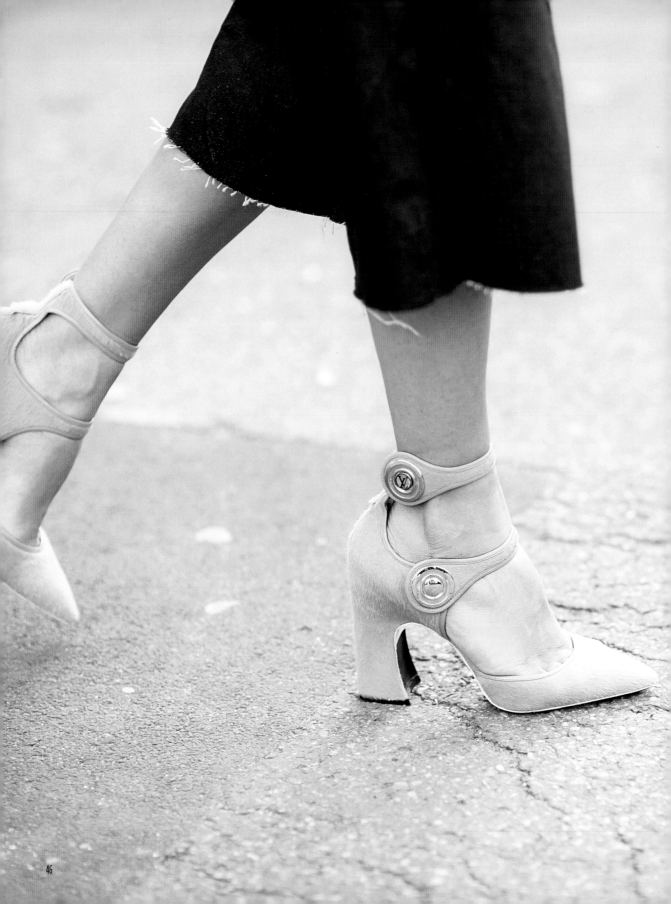

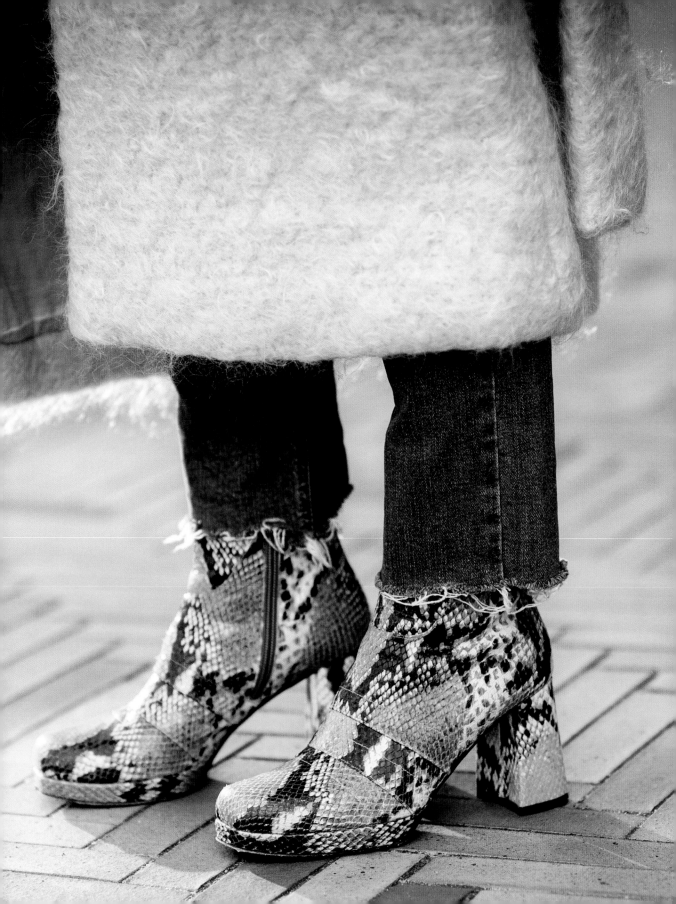

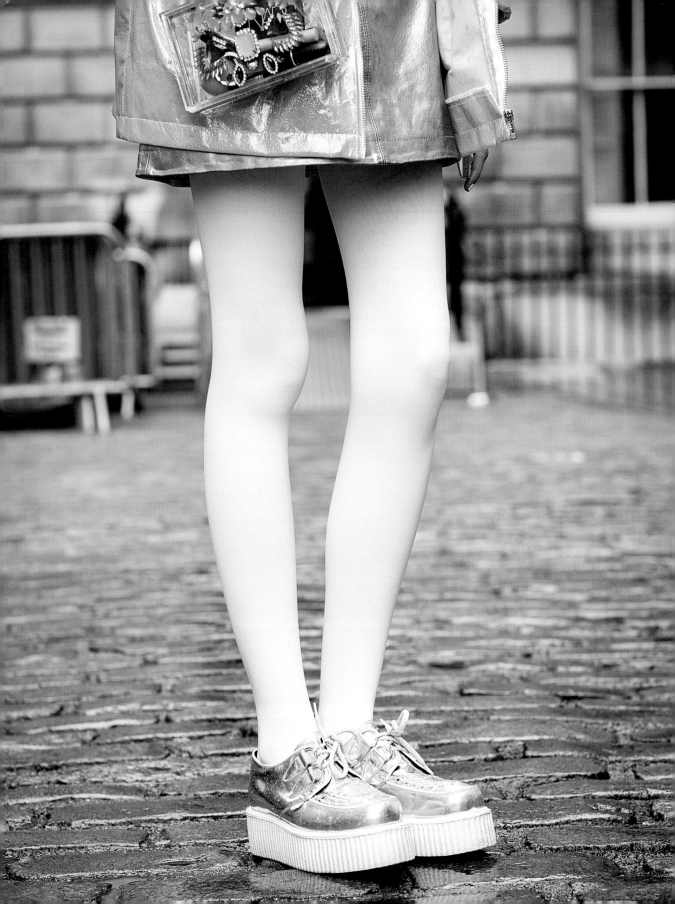

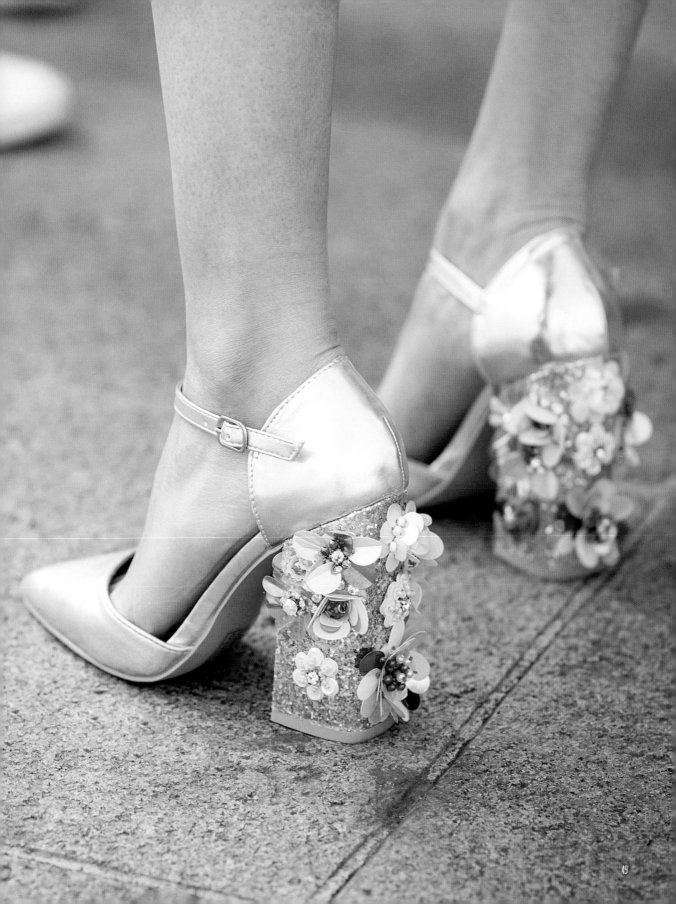

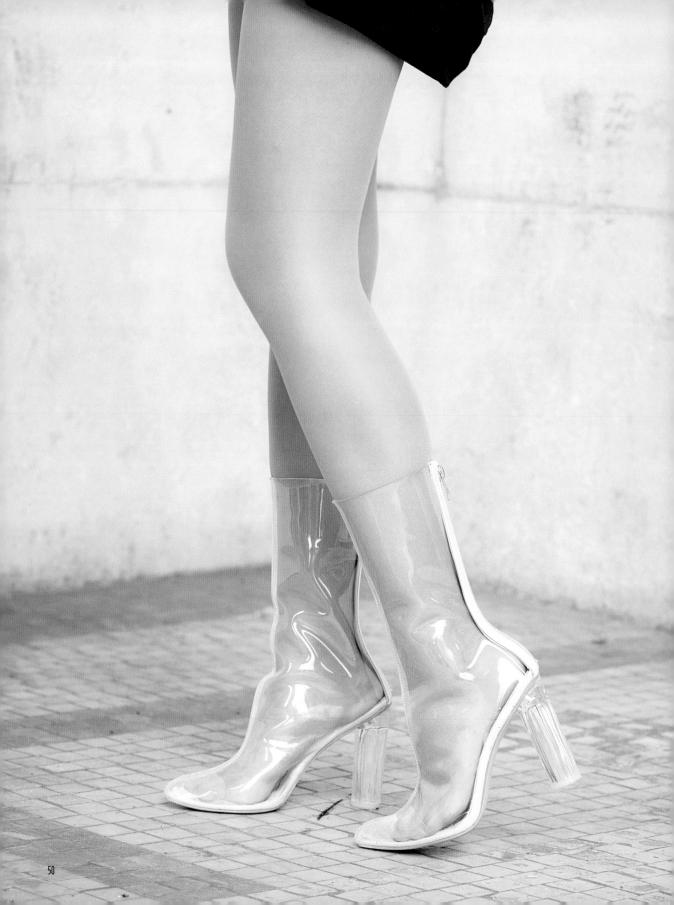

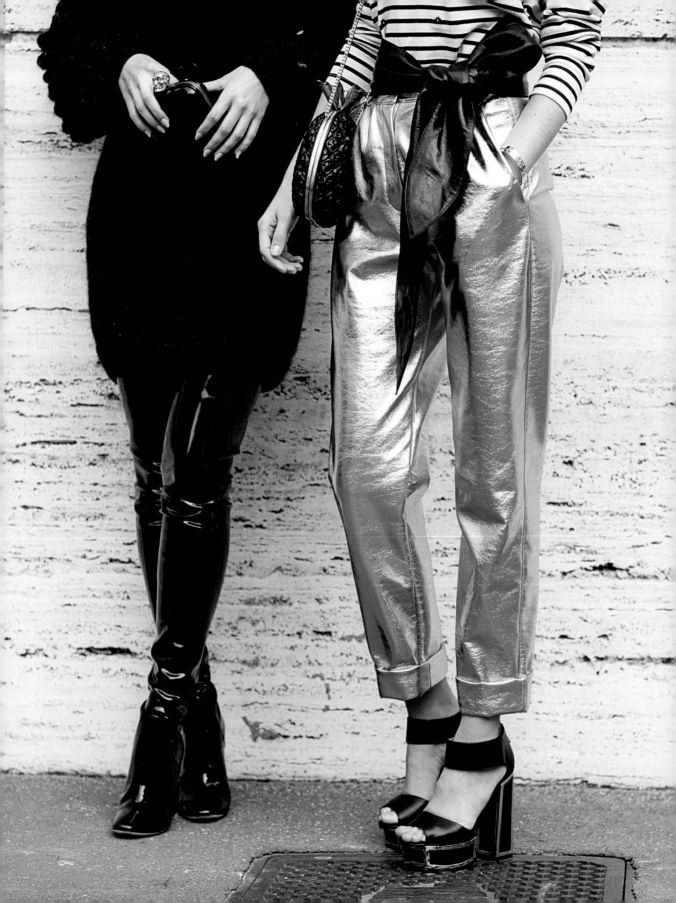

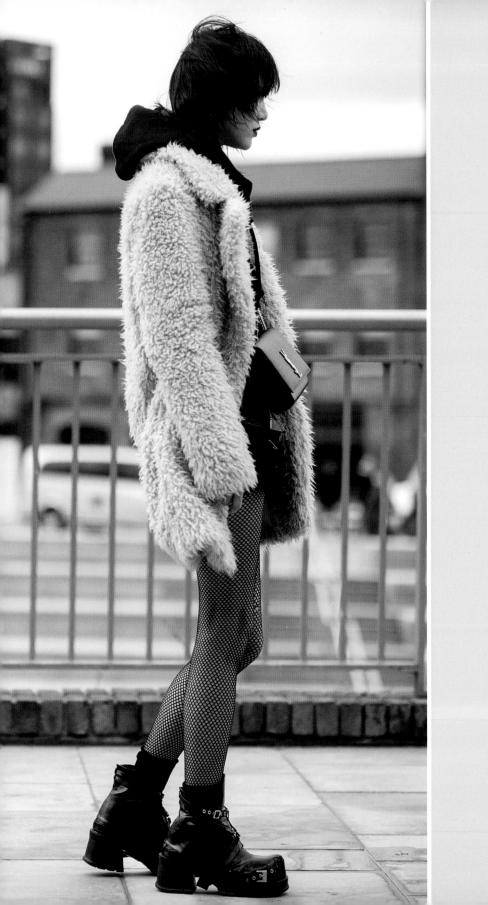

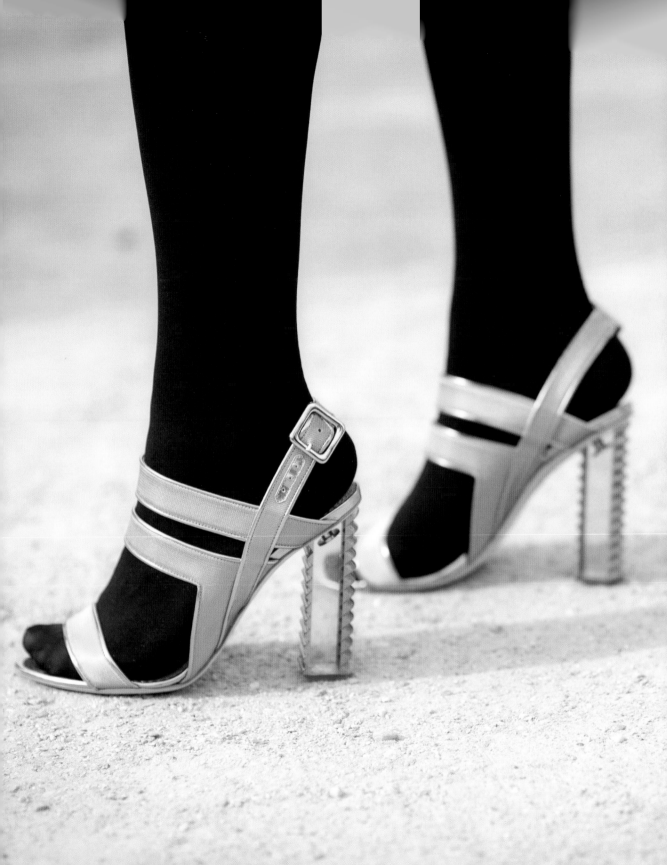

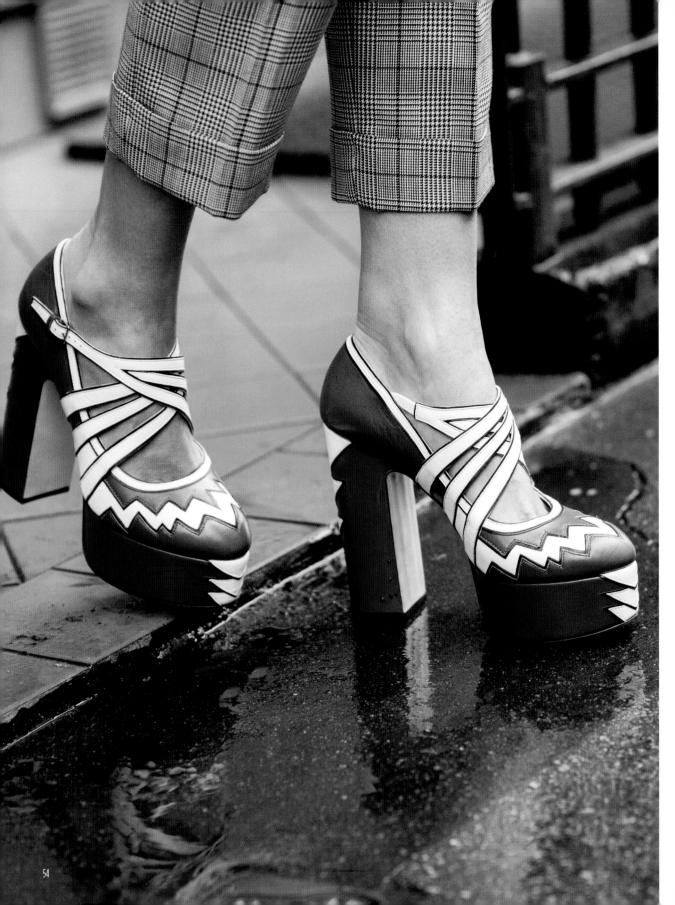

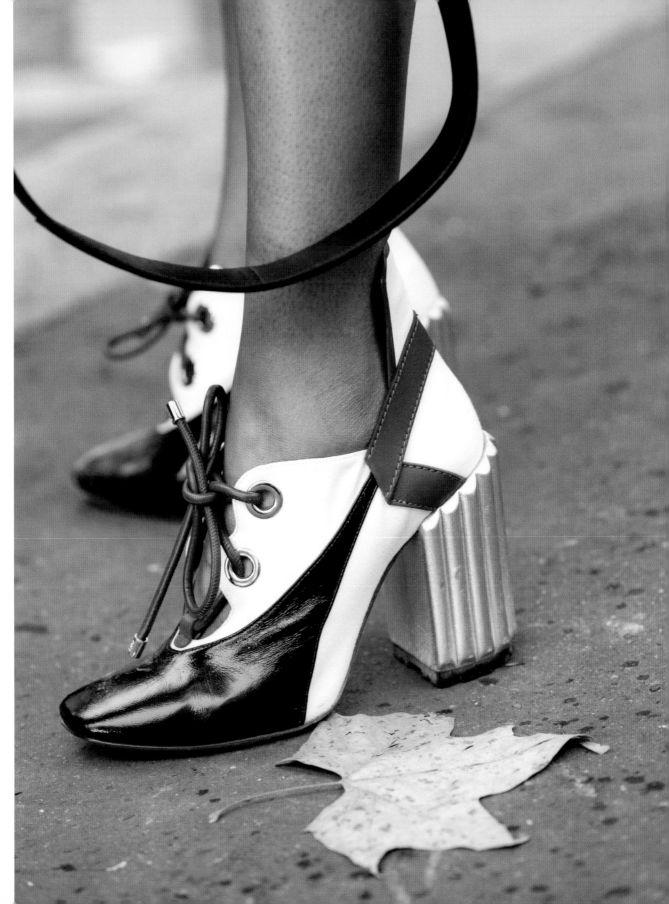

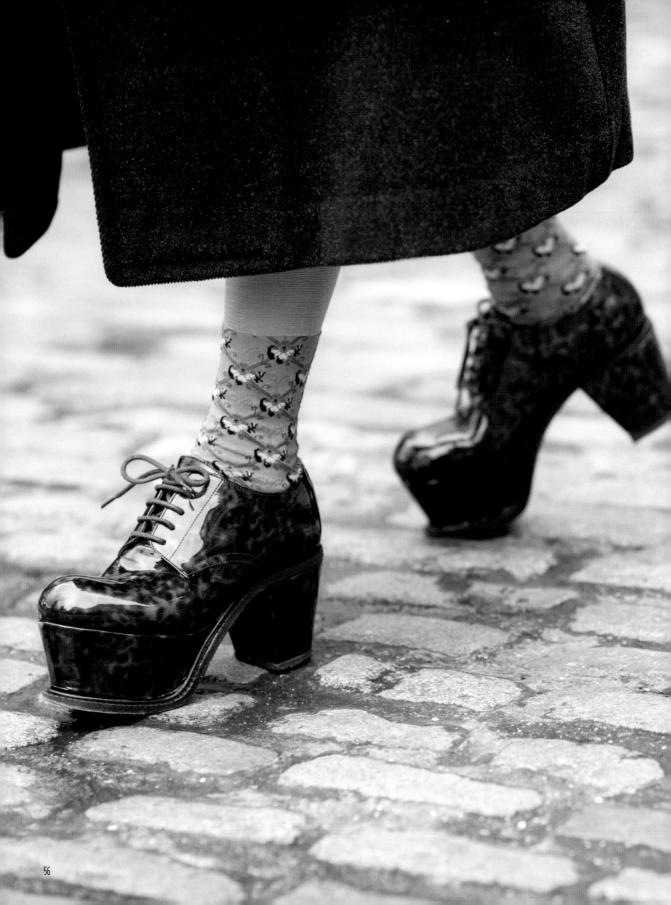

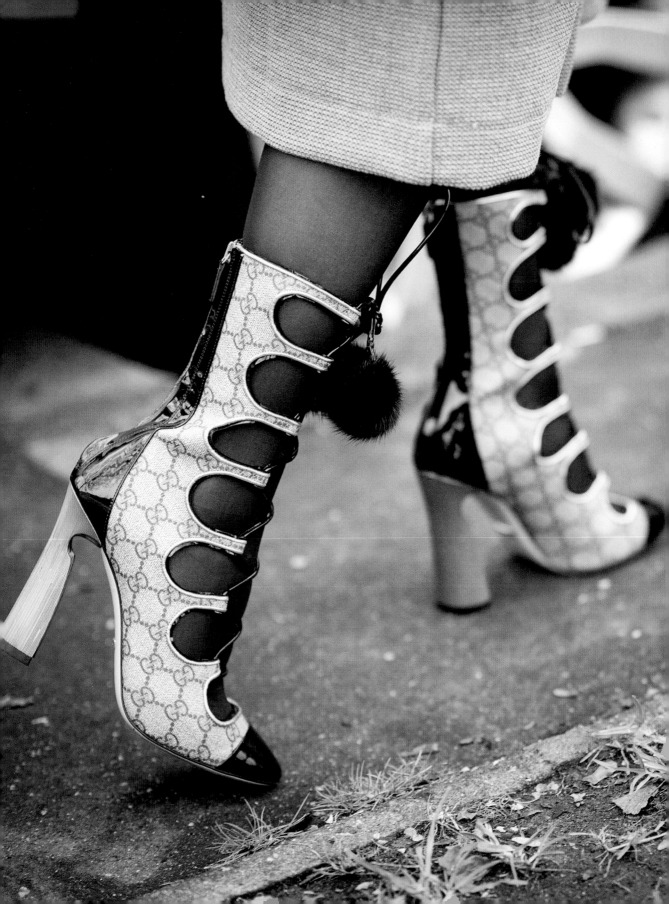

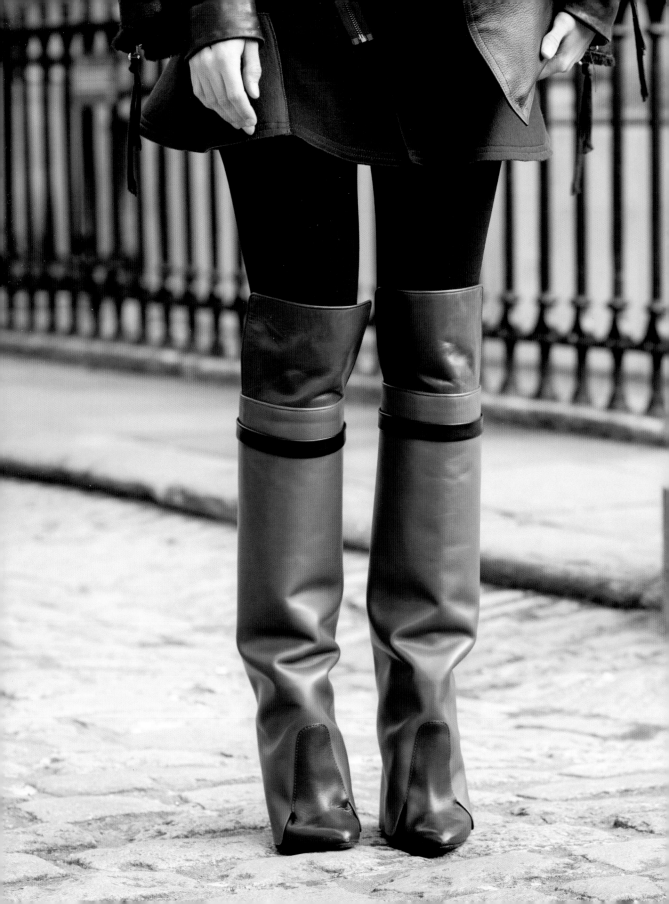

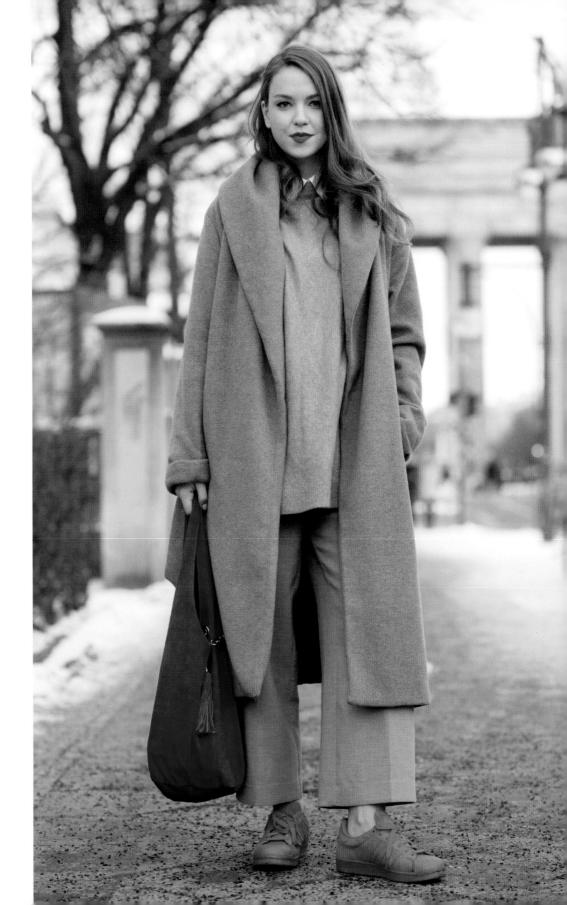

"GIVE A GIRL THE RIGHT SHOES,
AND SHE CAN CONQUER THE WORLD."

- Marilyn Monroe

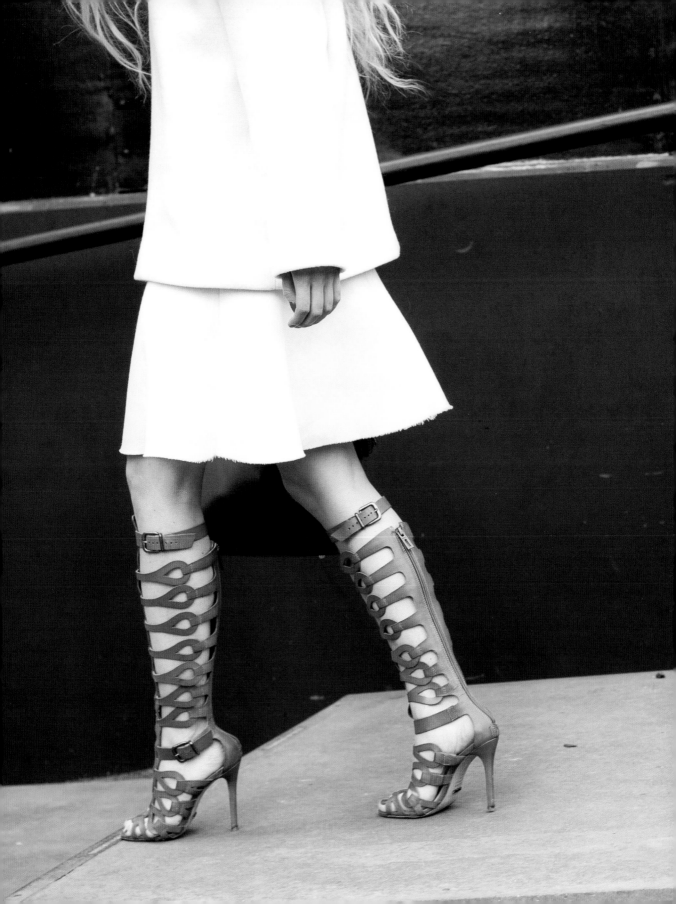

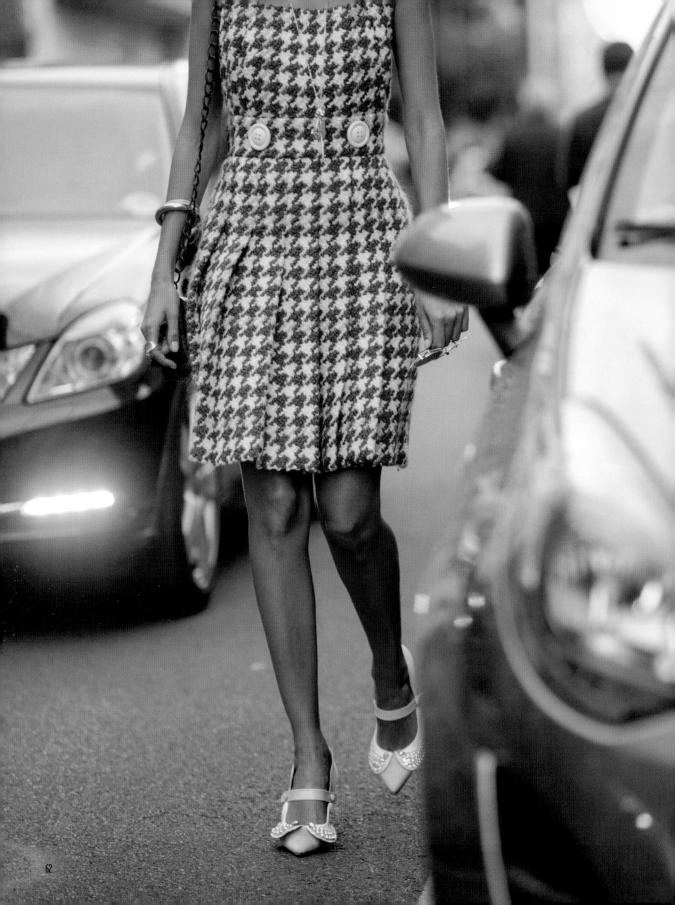

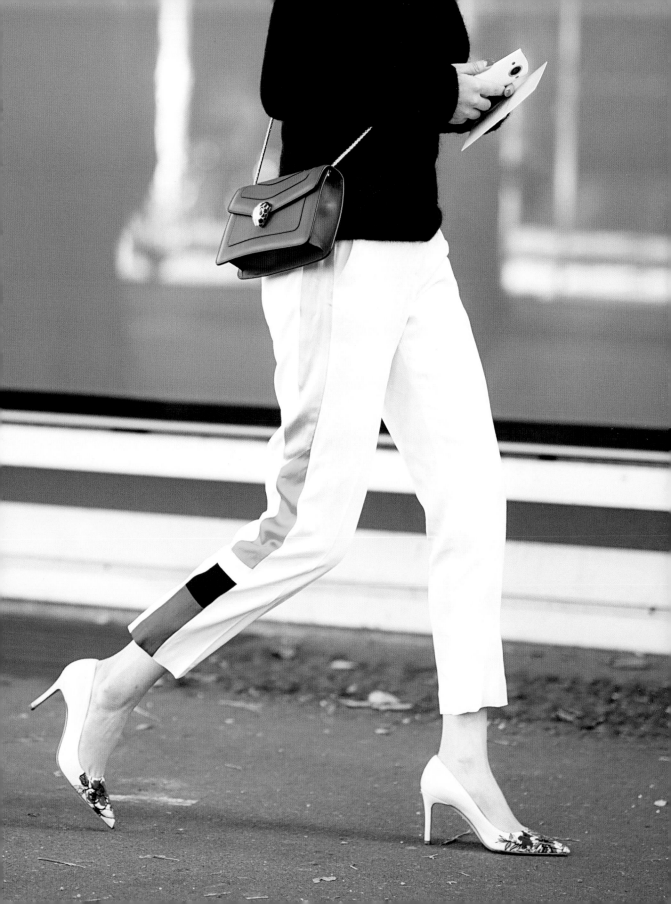

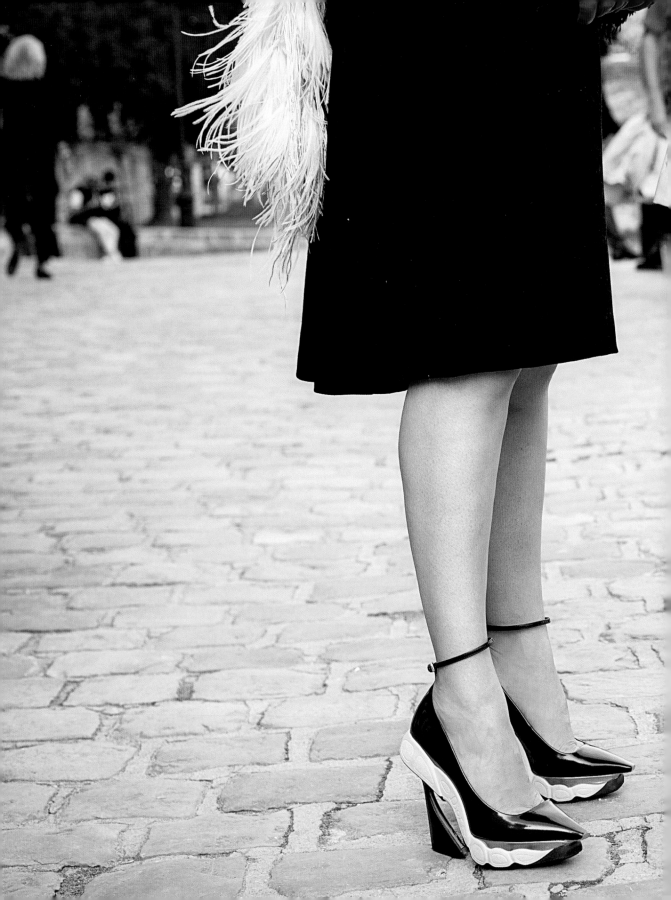

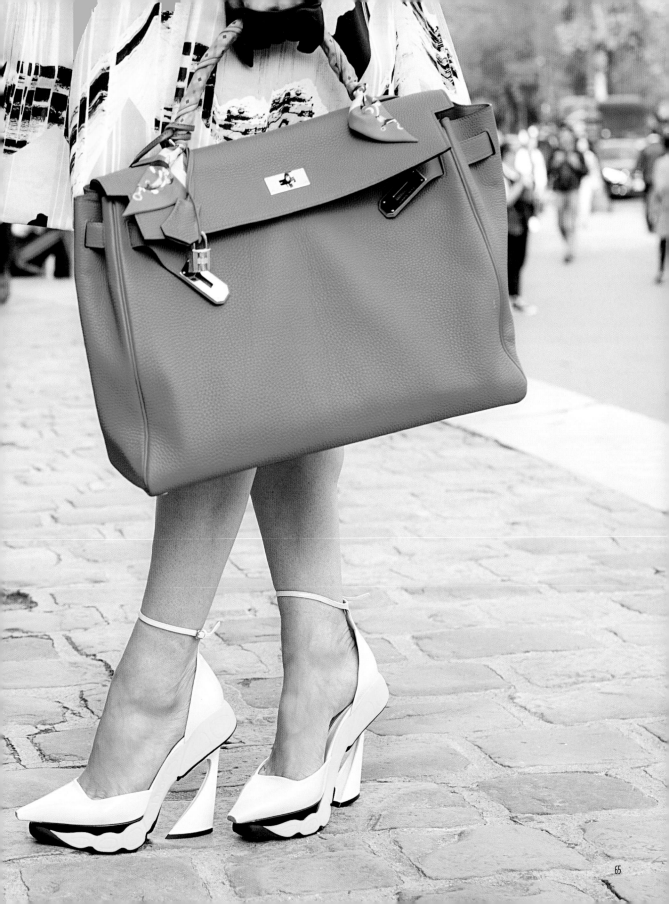

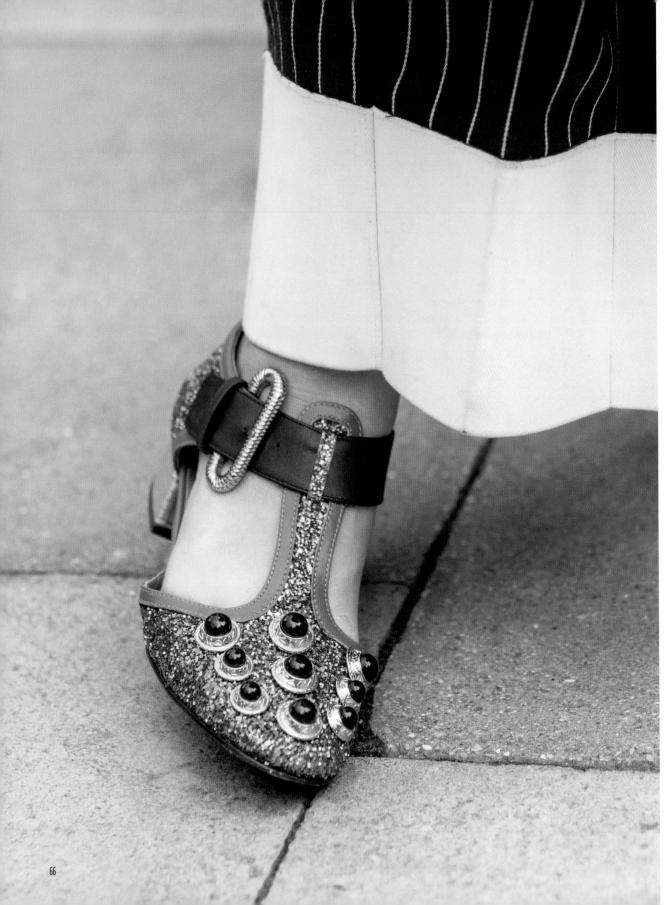

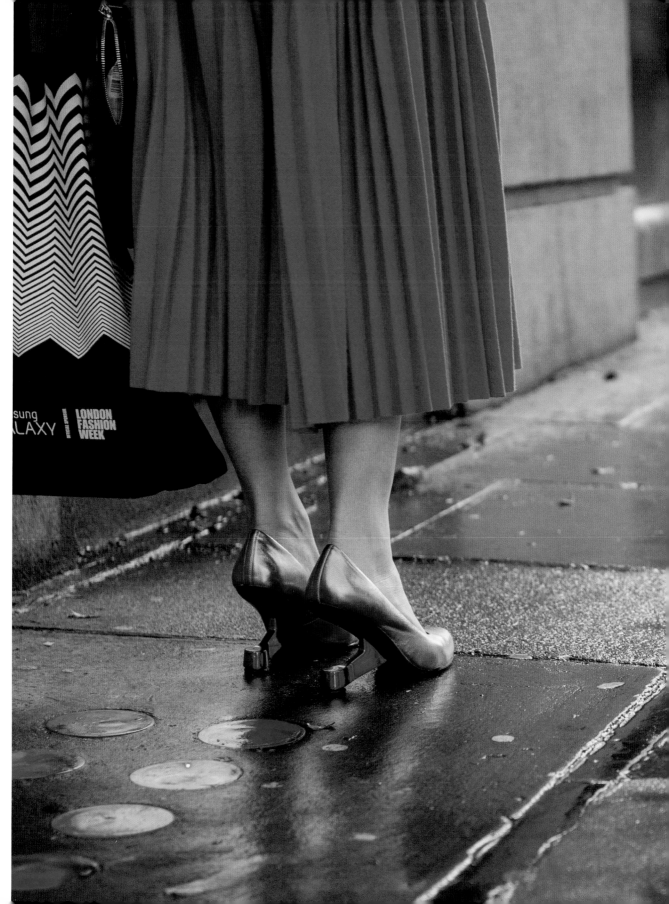

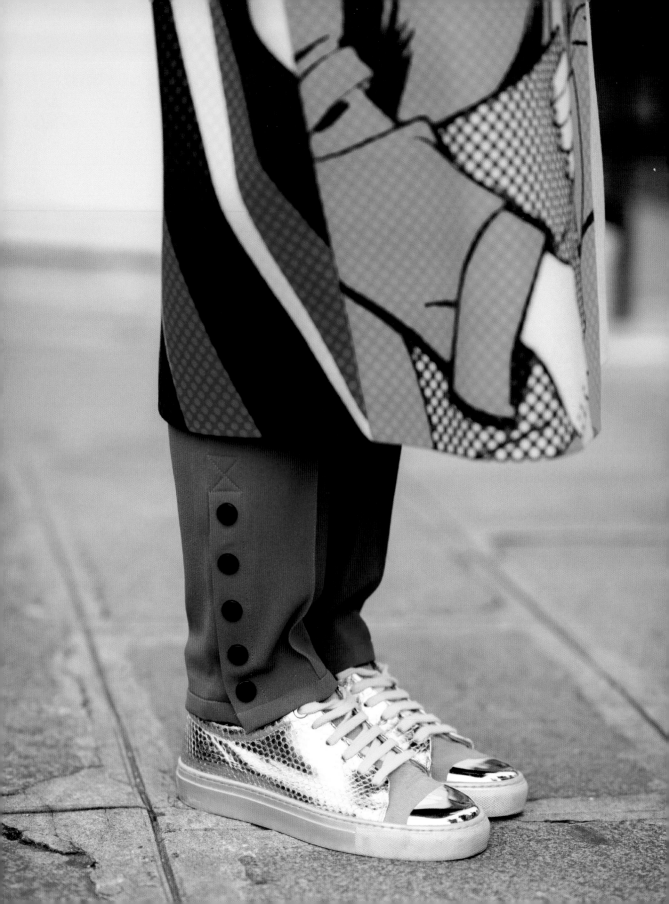

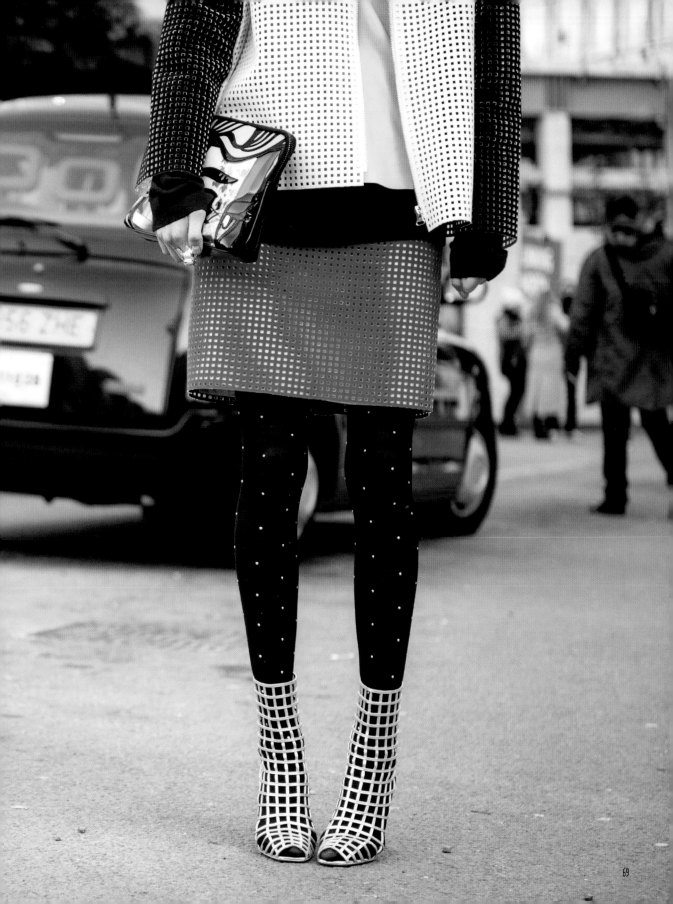

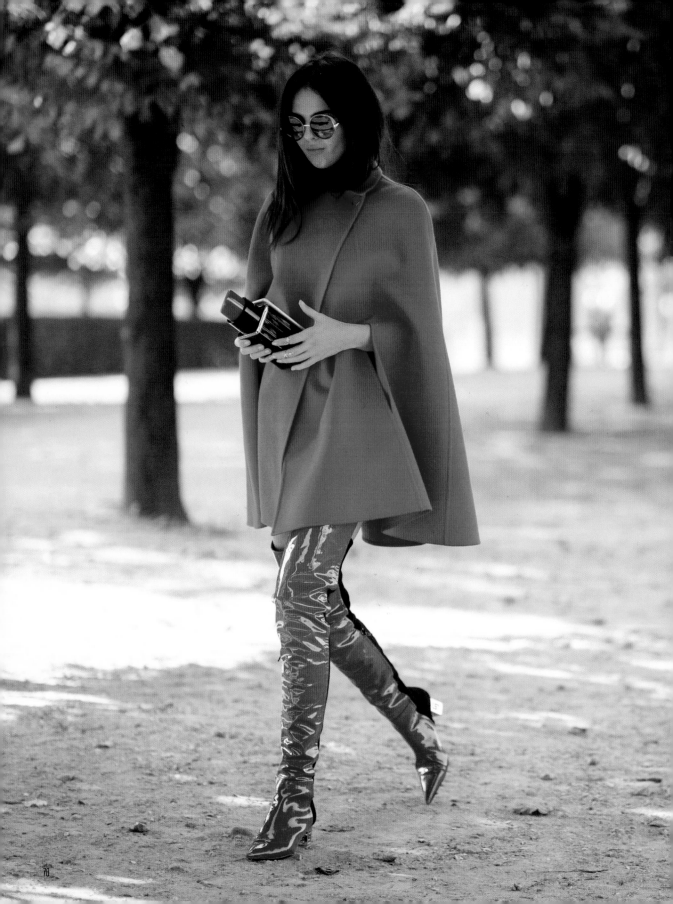

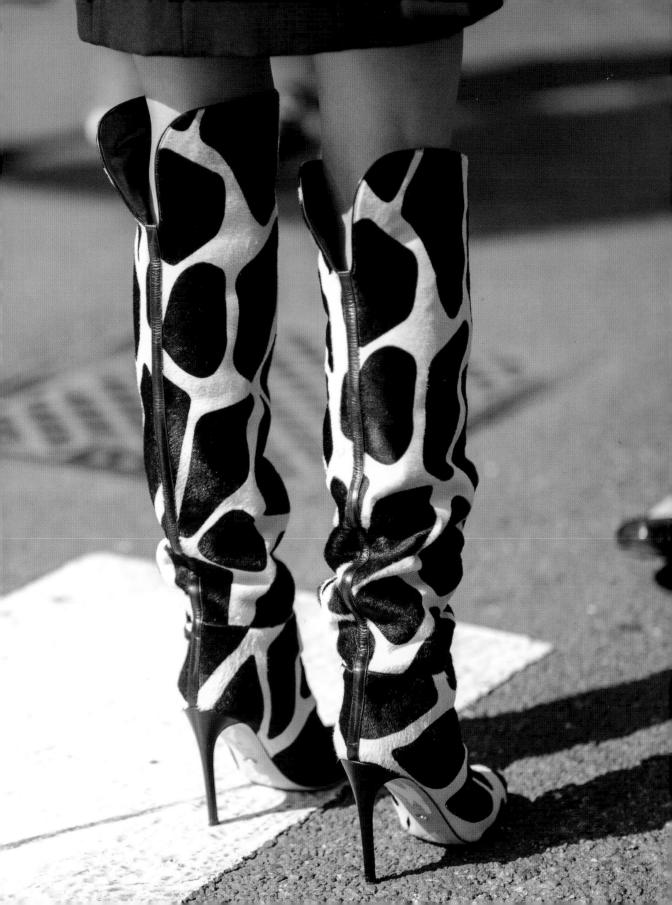

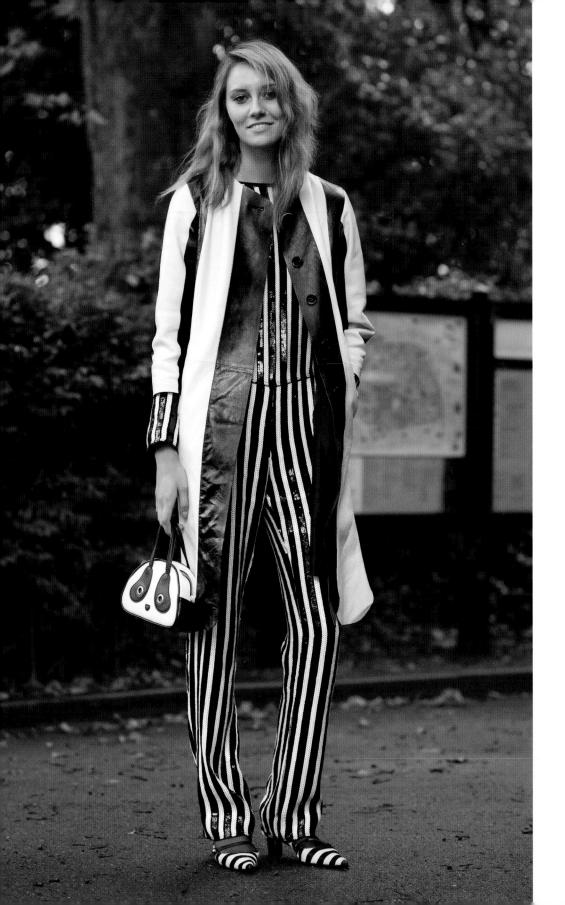

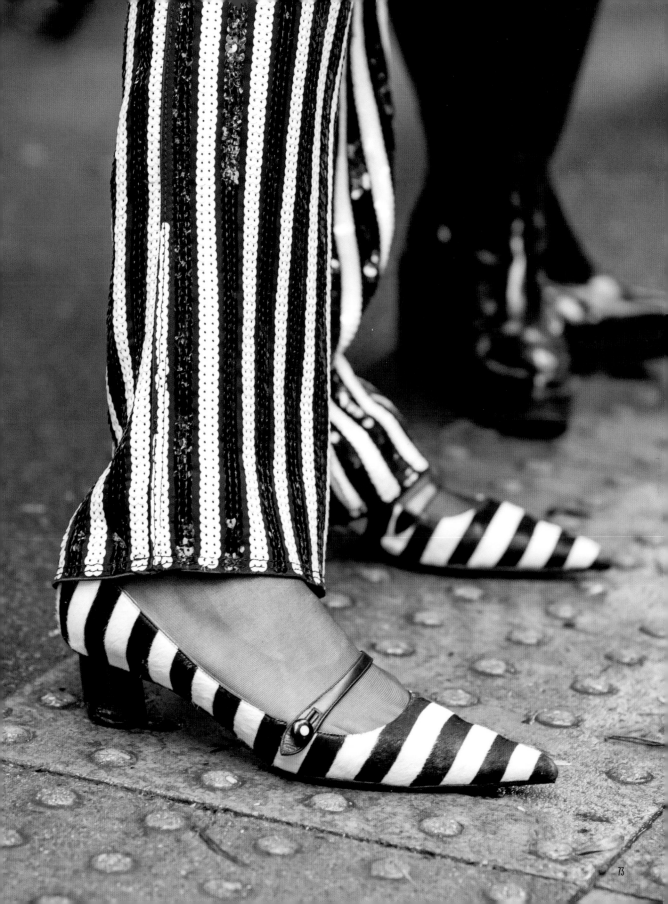

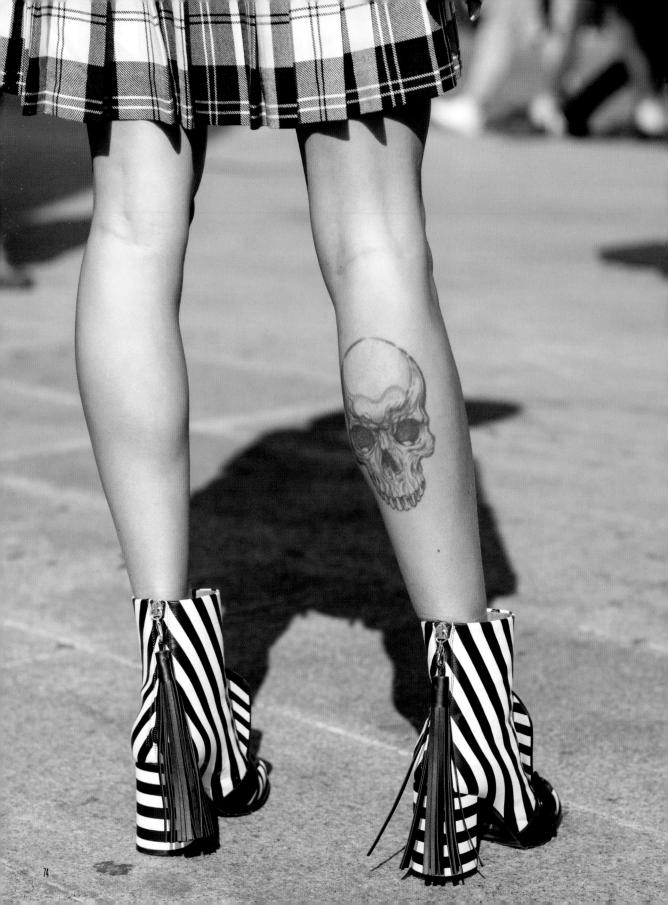

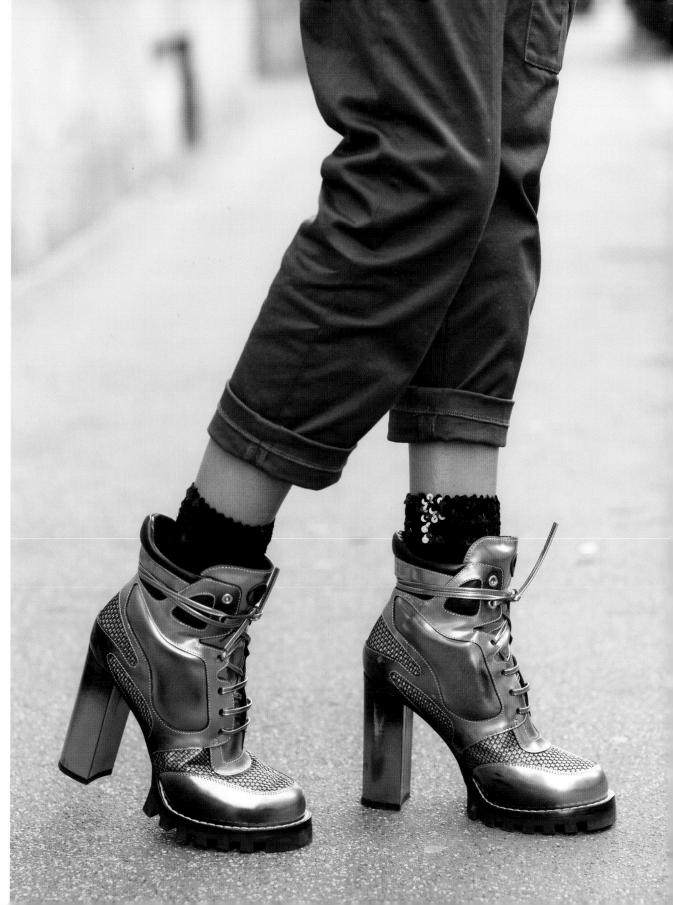

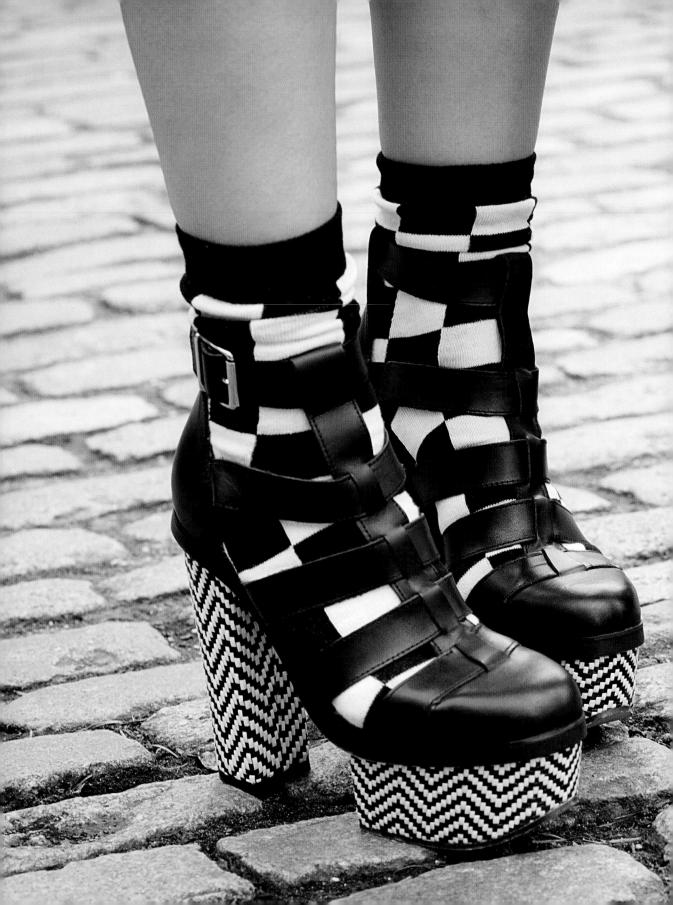

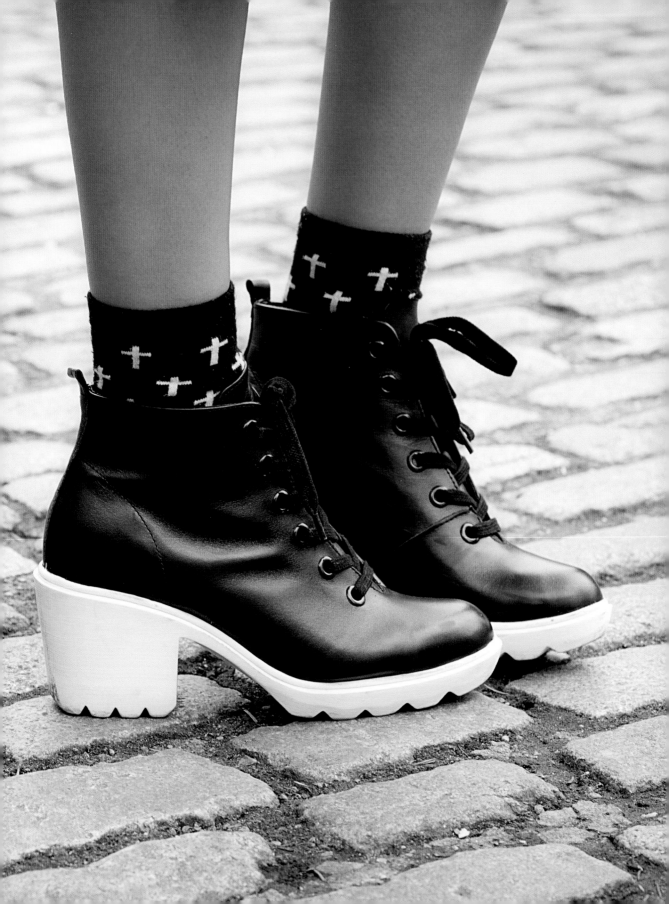

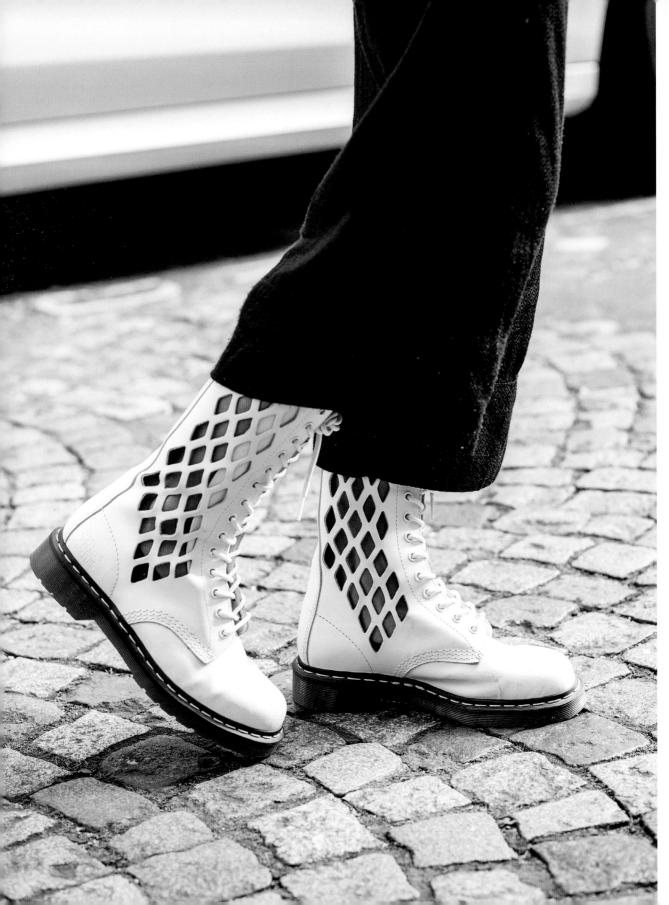

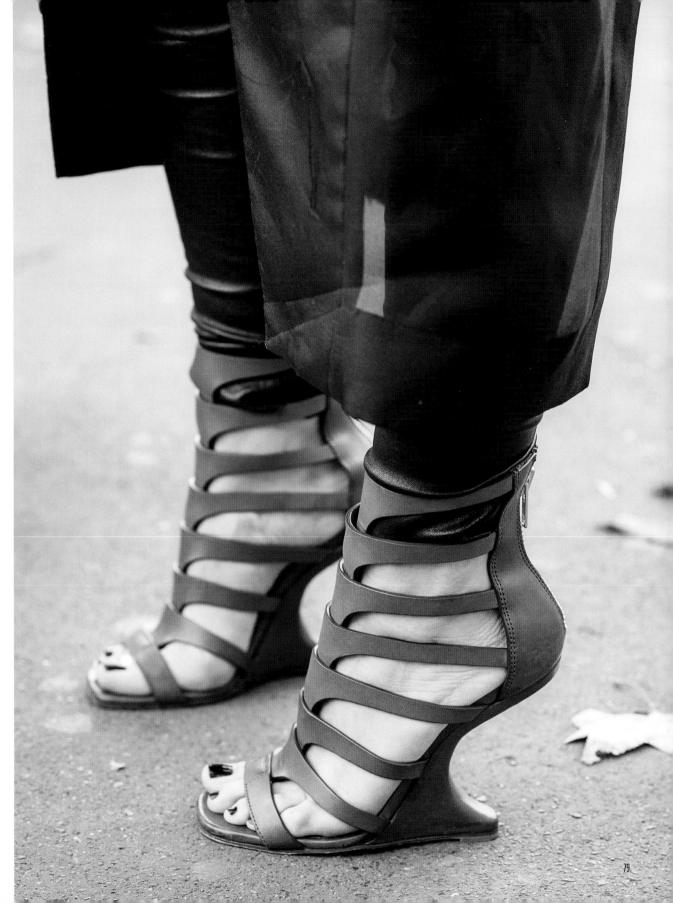

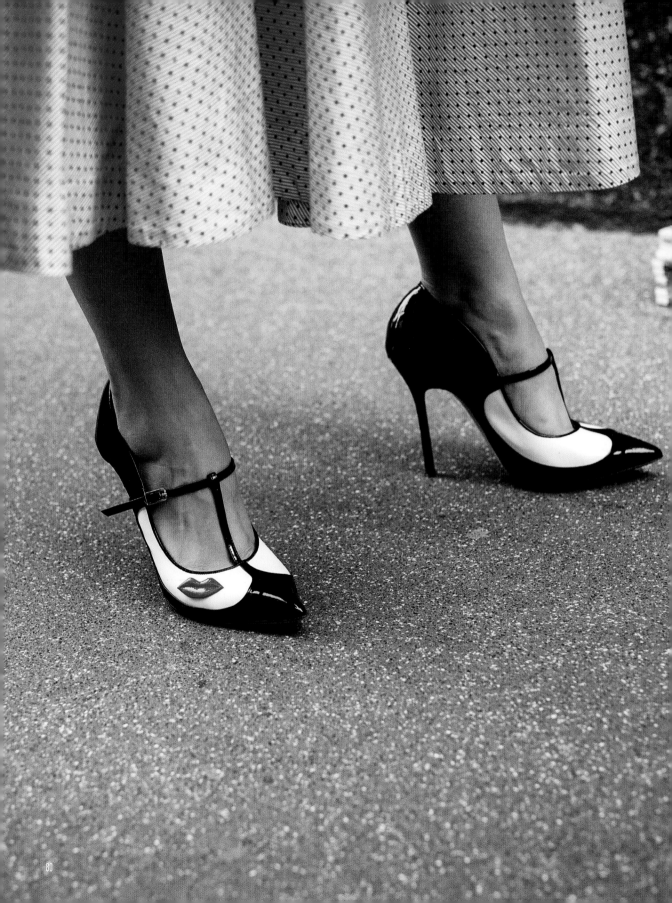

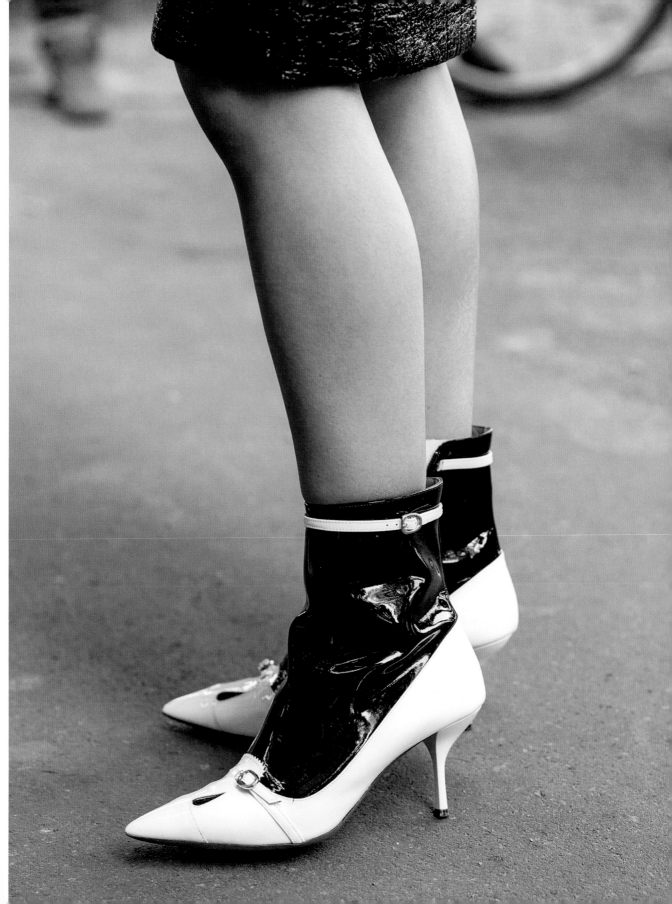

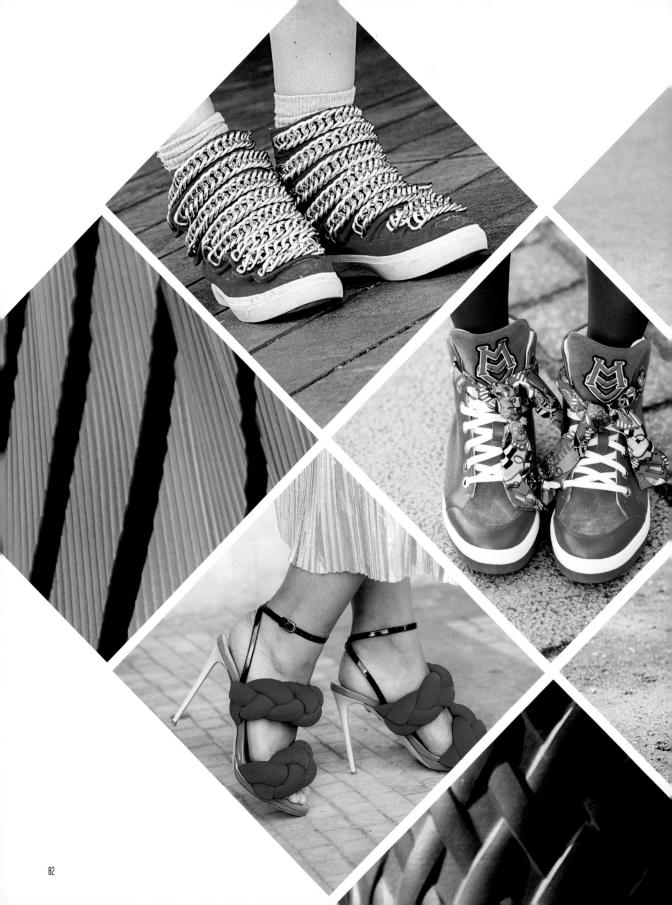

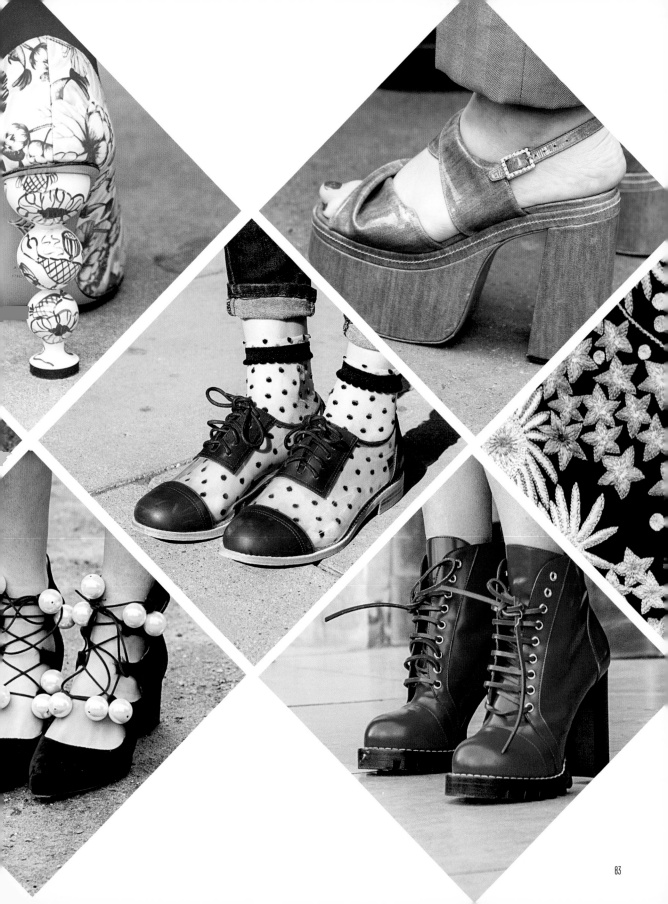

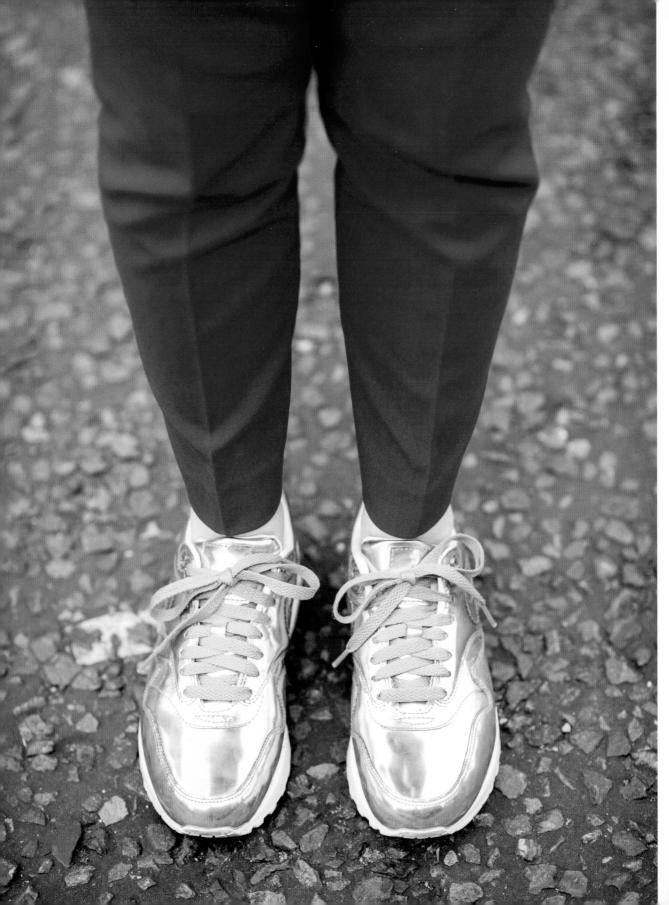

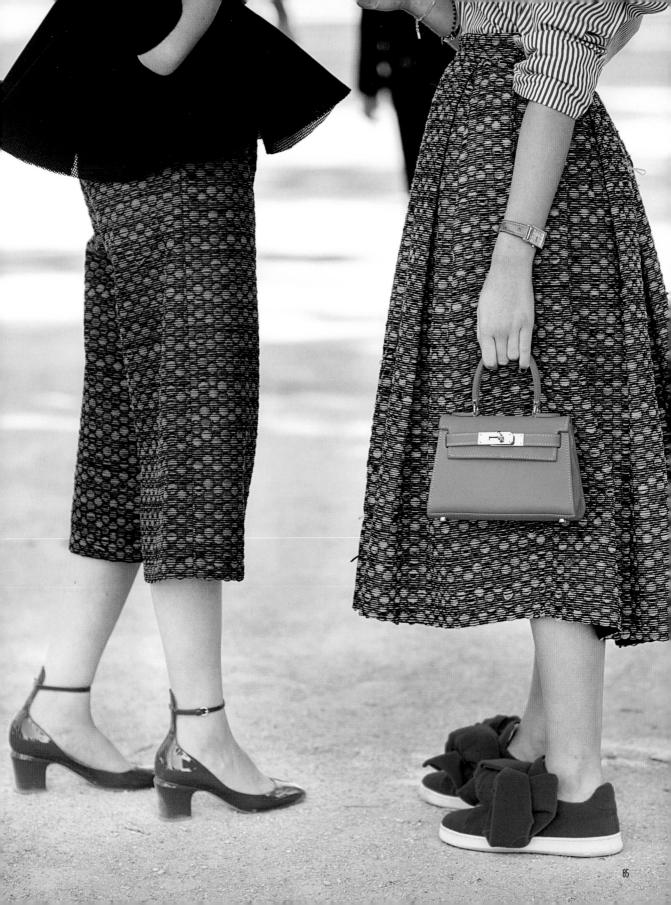

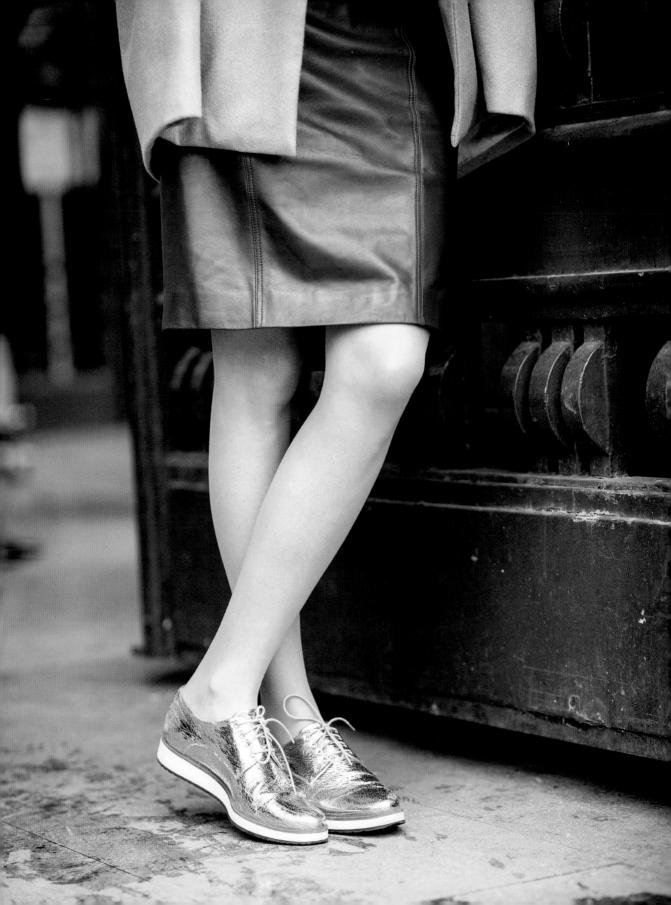

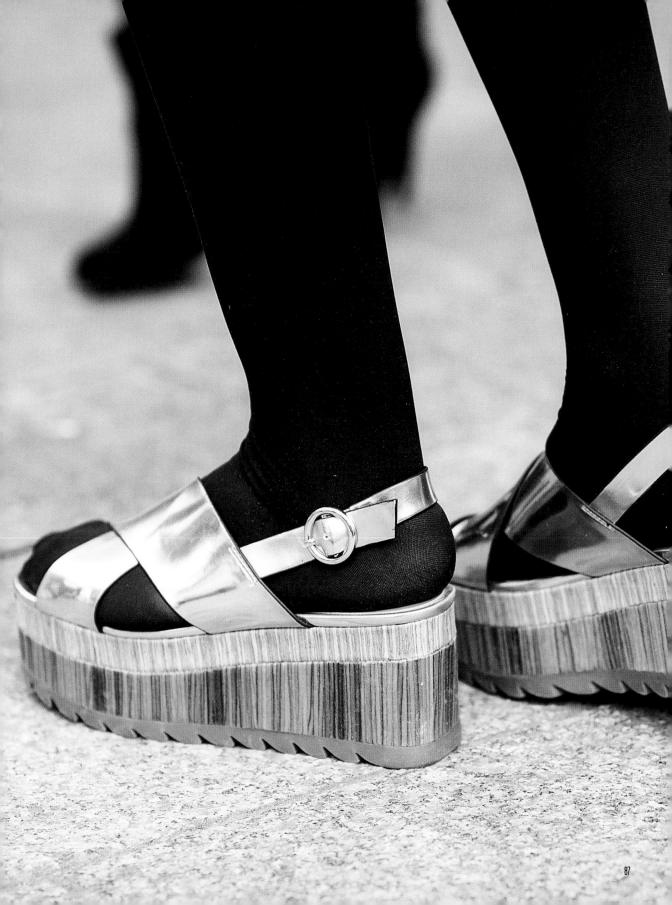

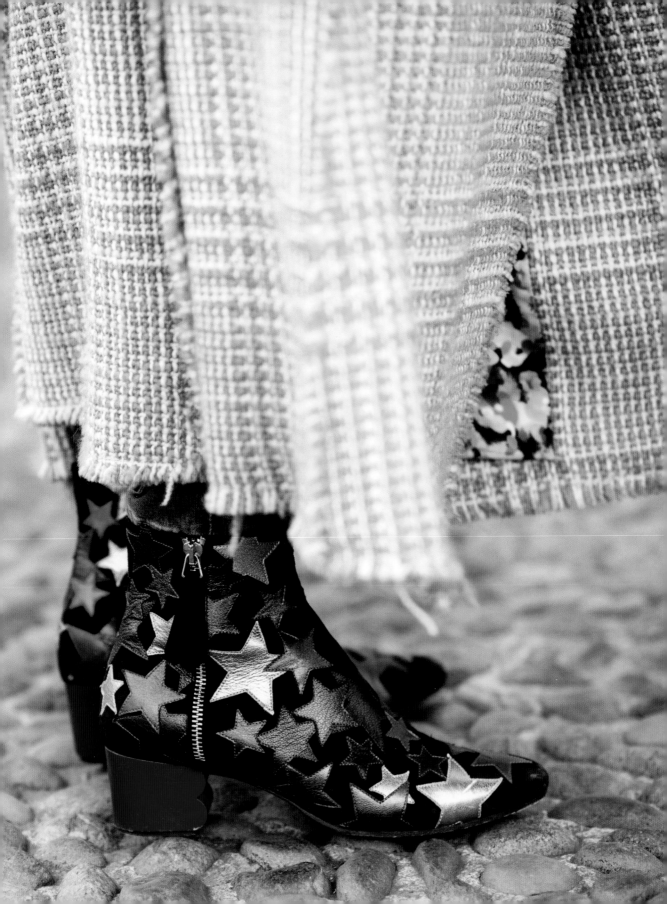

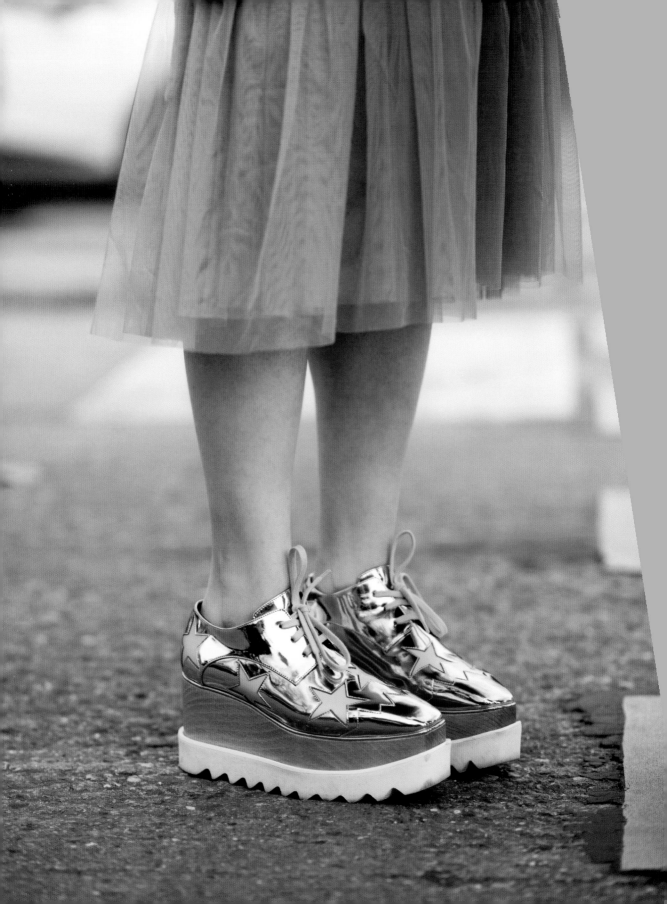

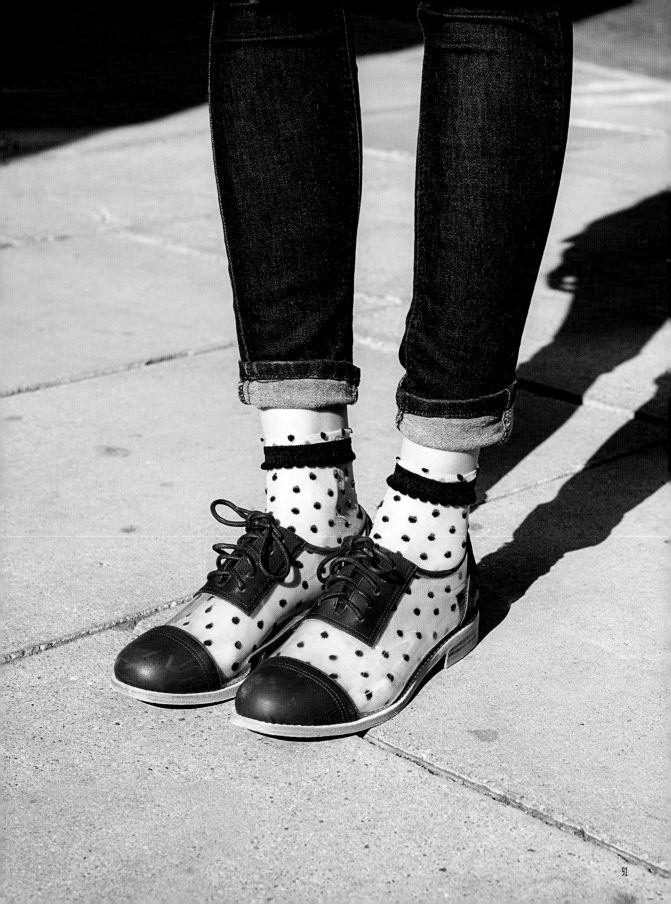

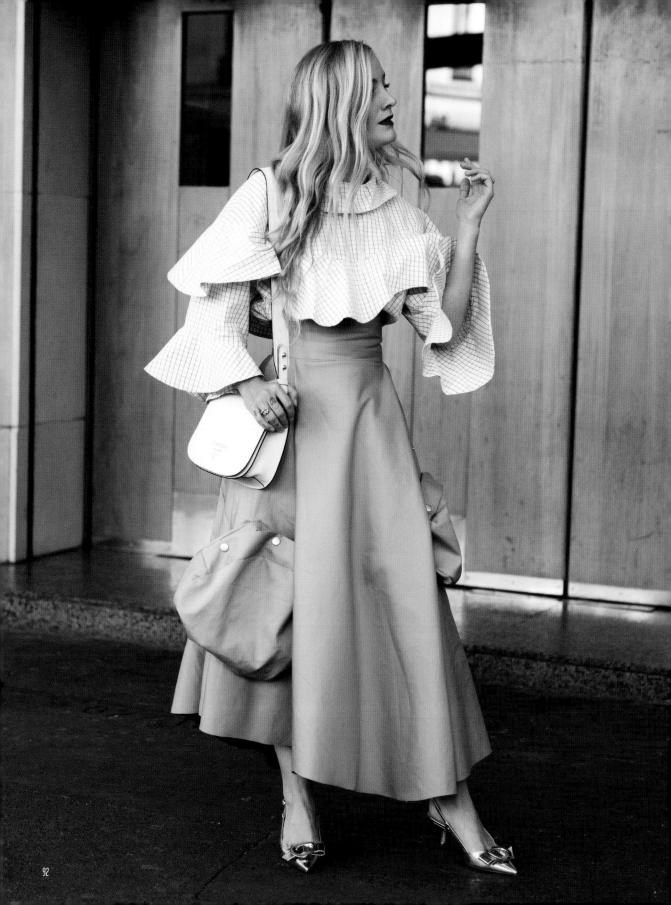

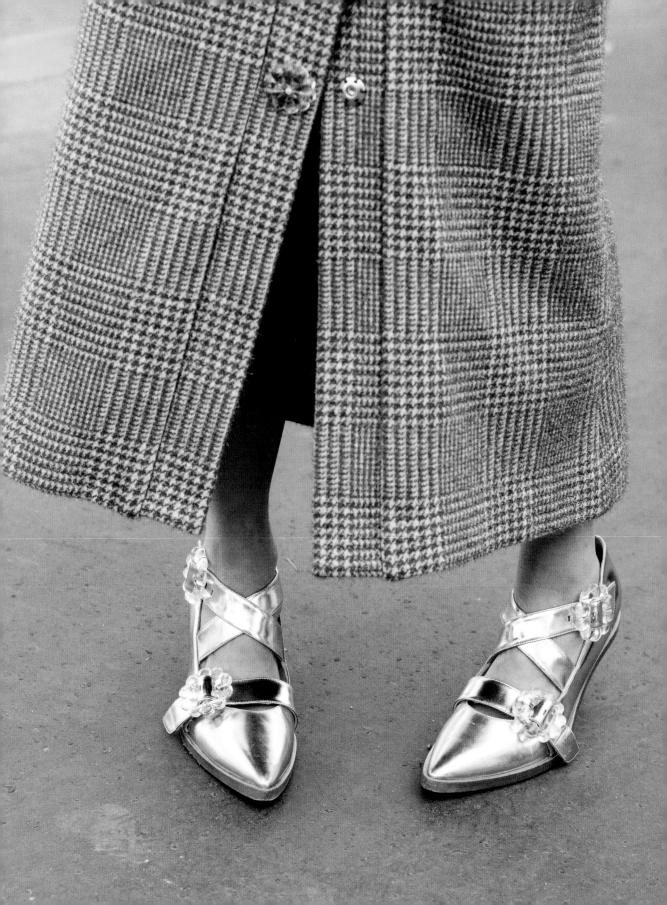

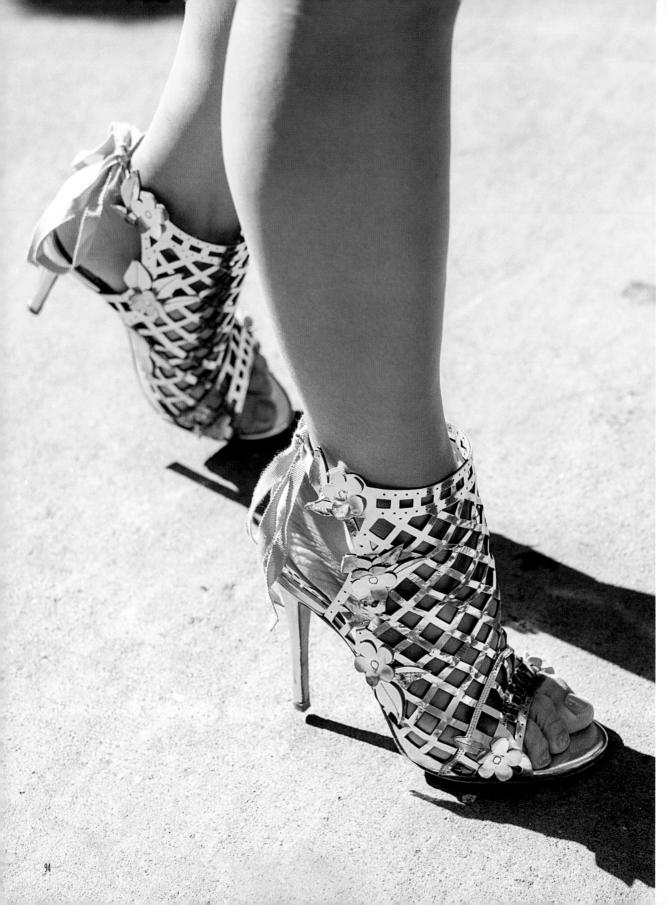

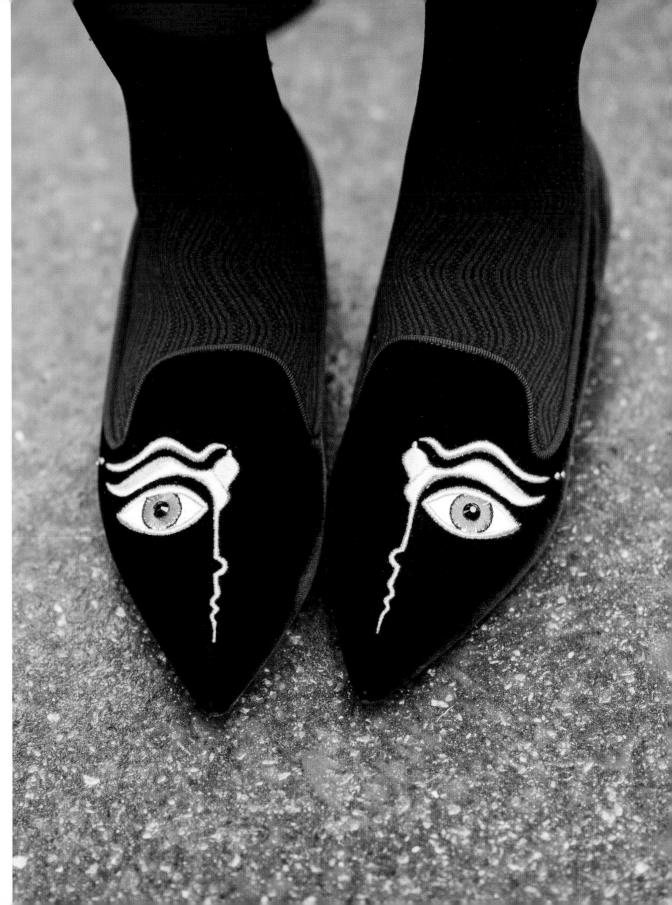

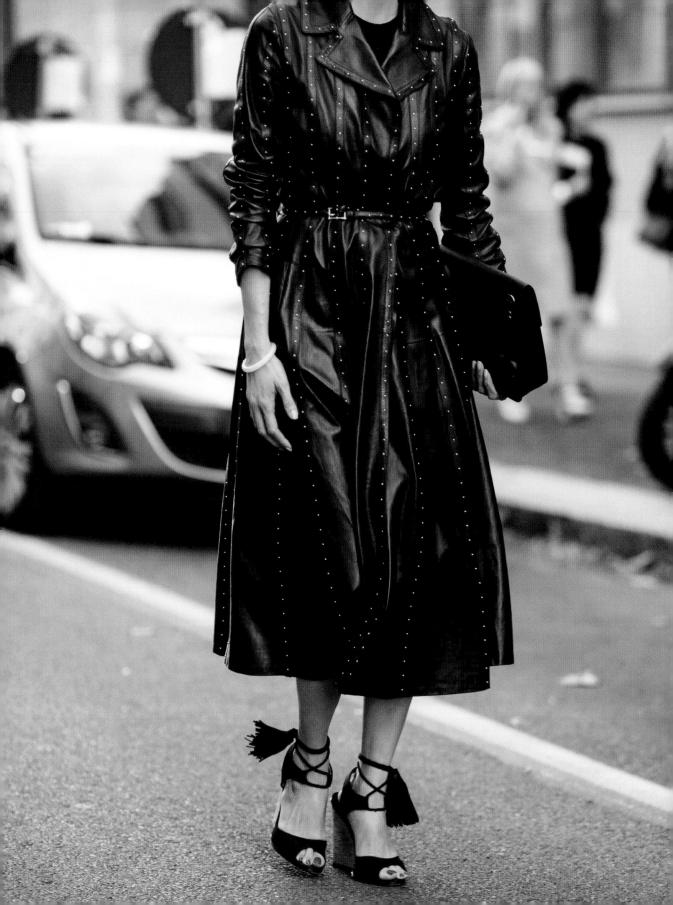

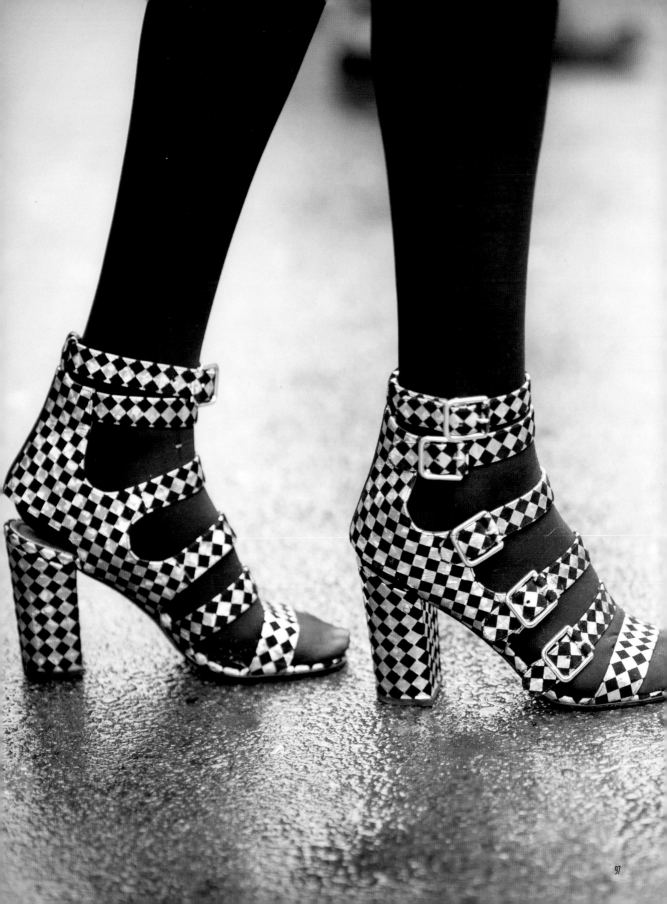

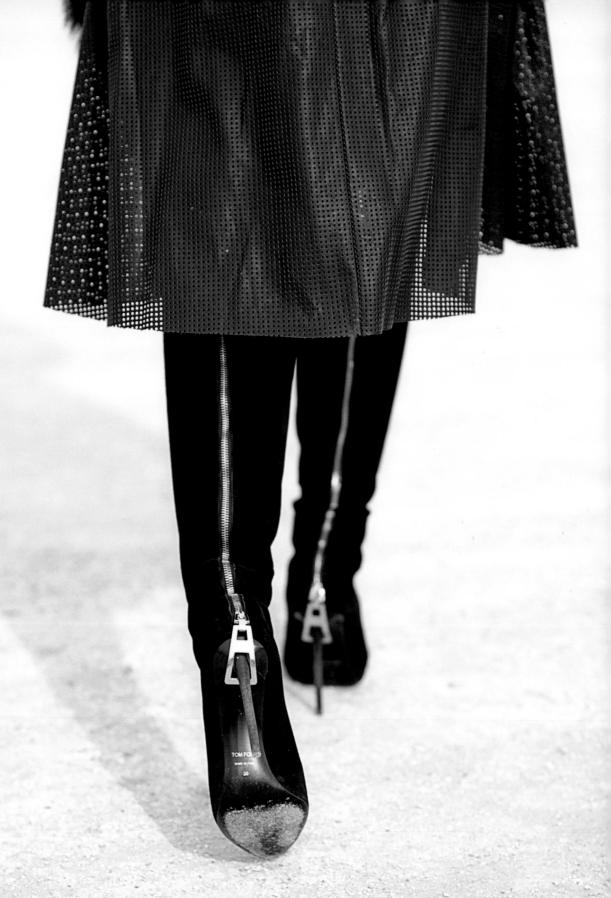

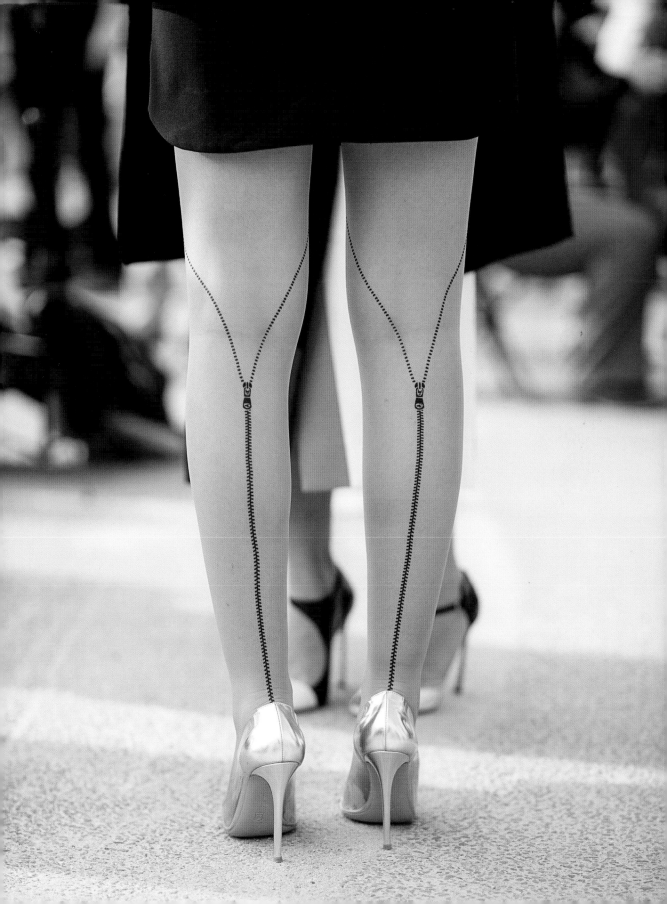

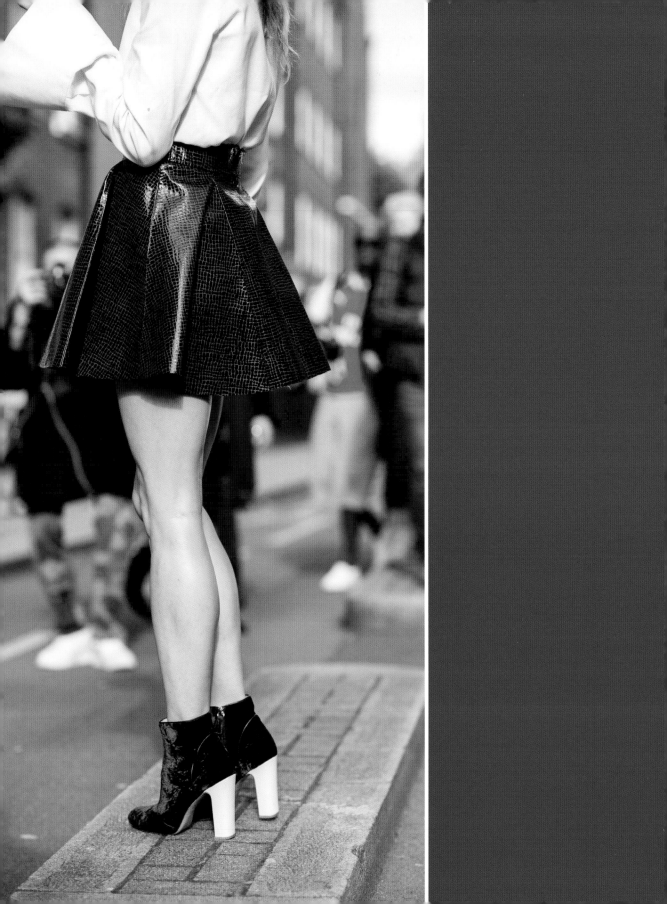

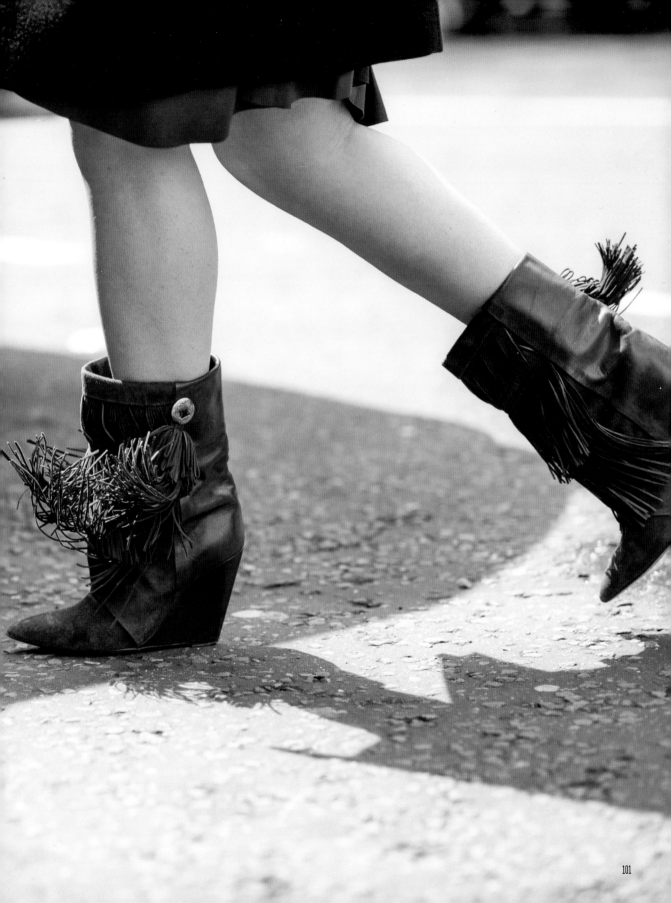

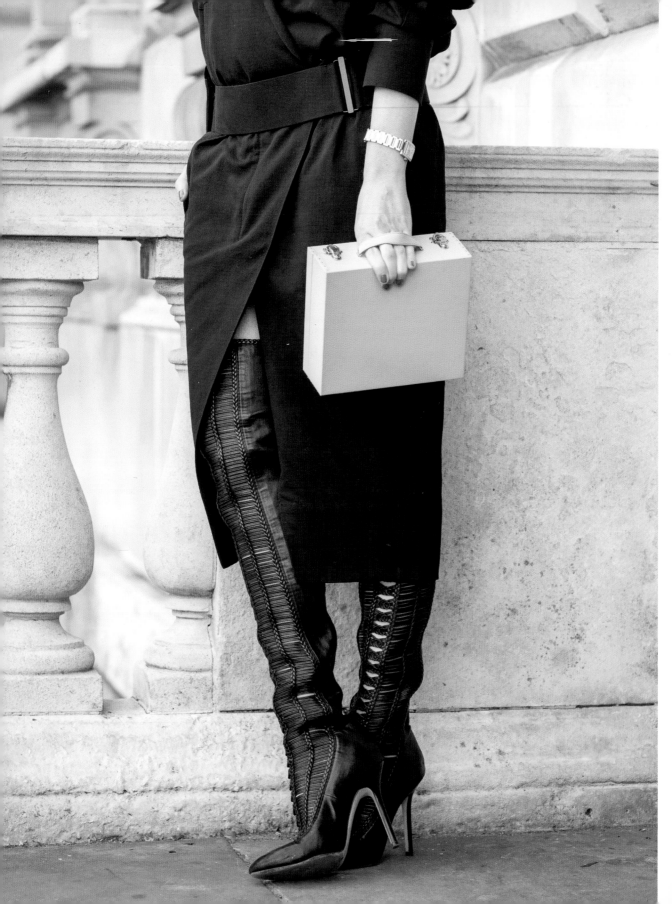

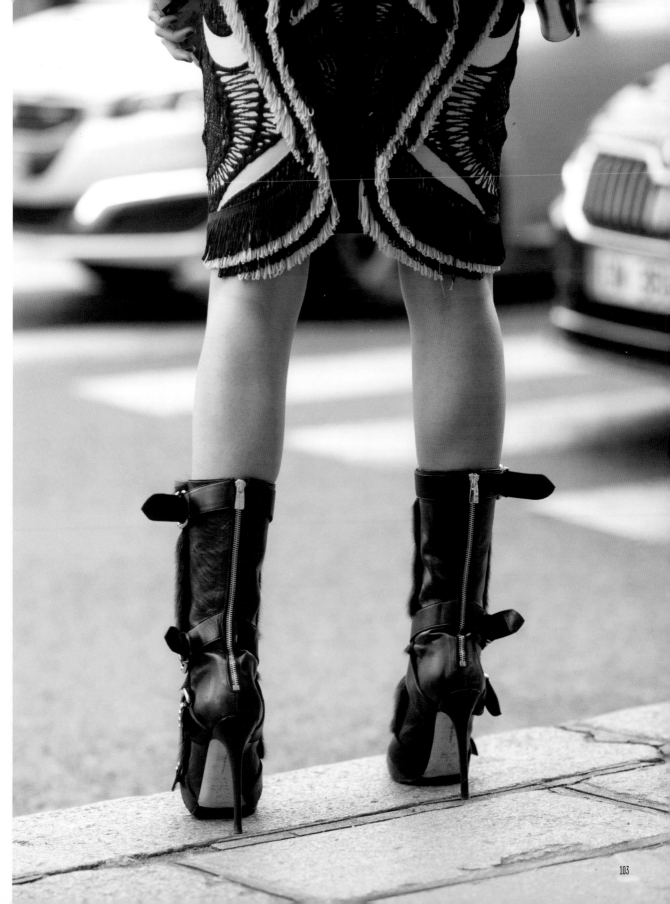

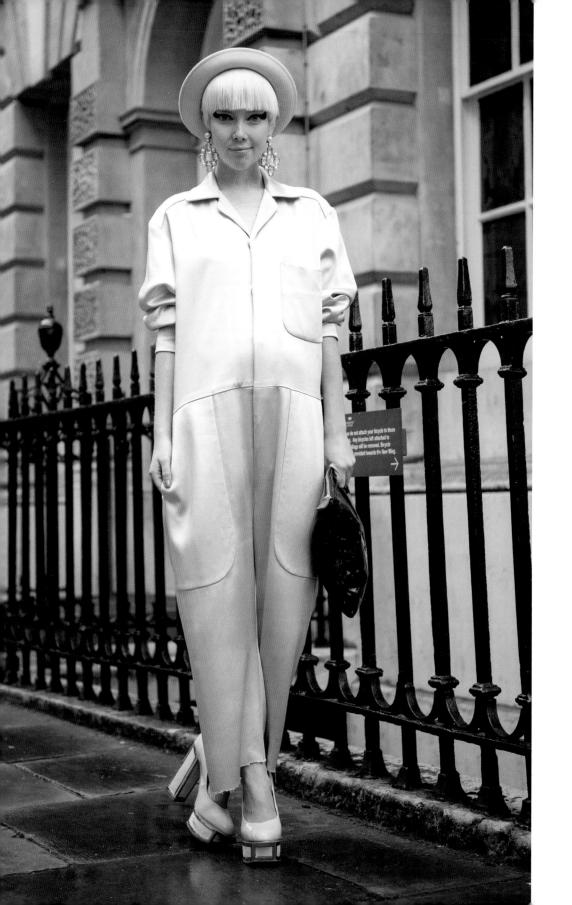

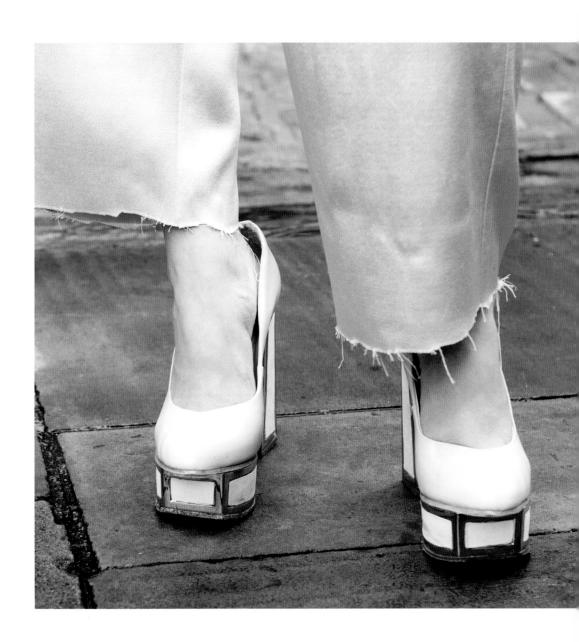

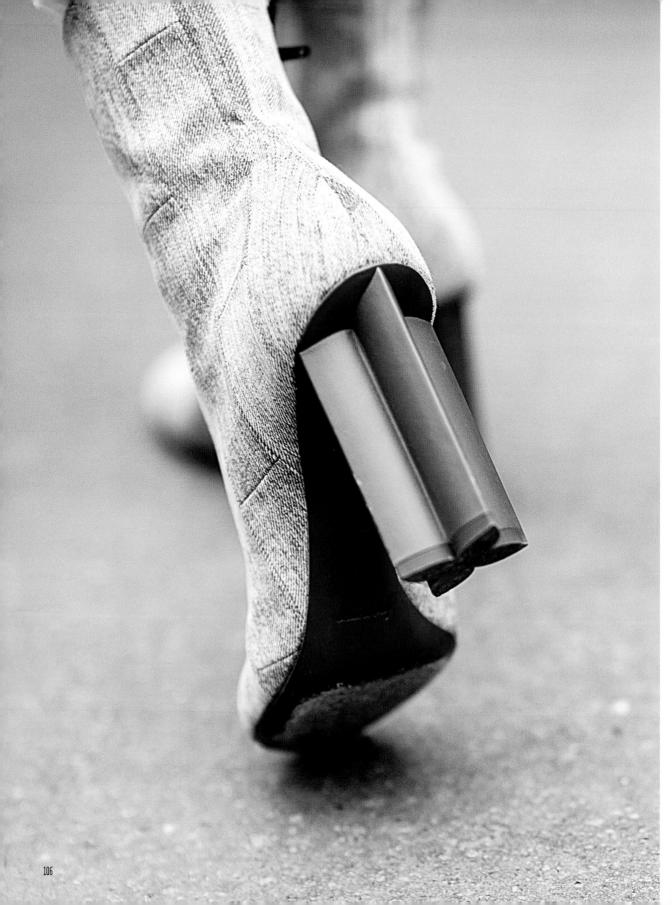

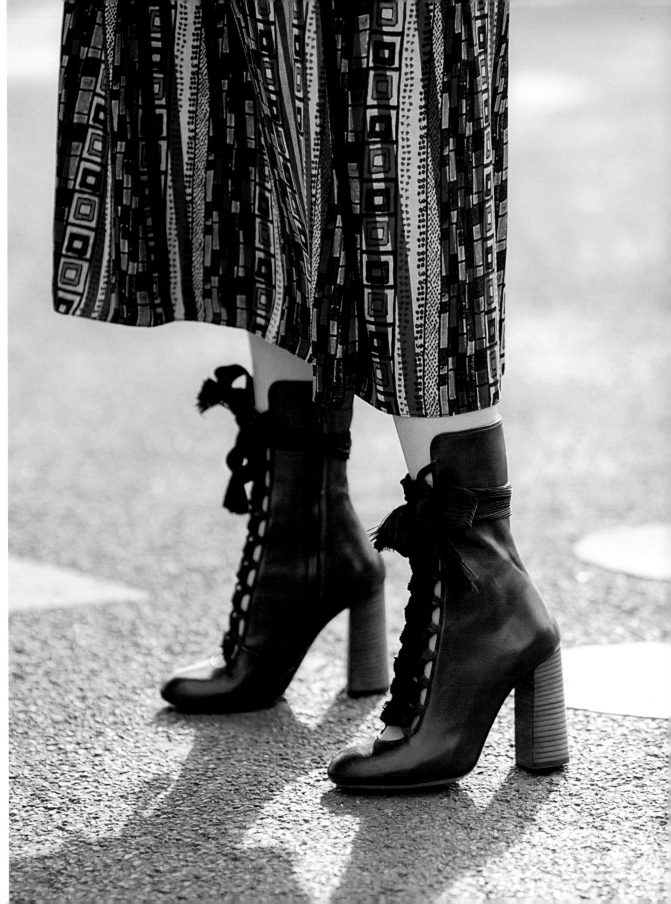

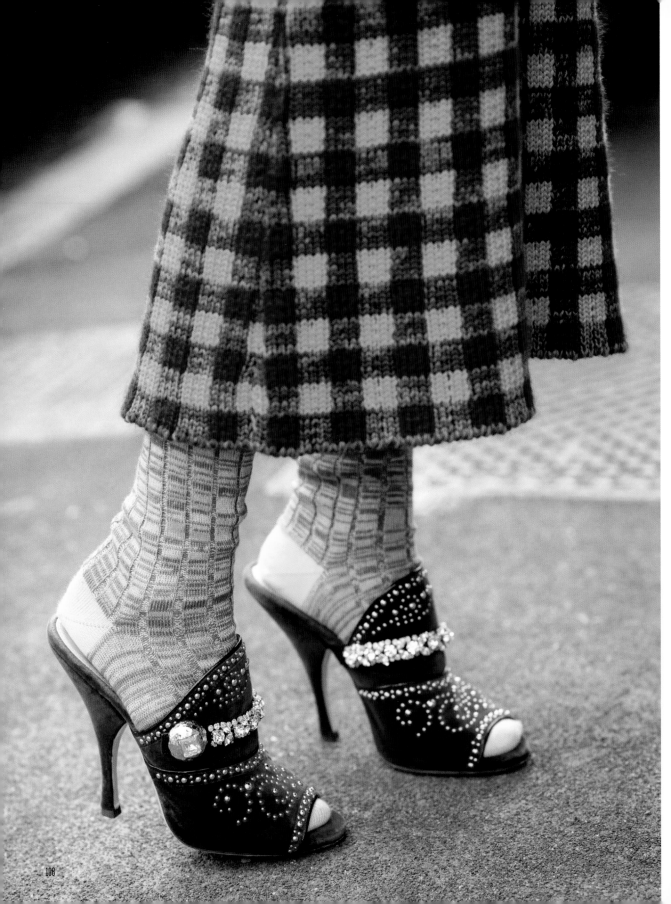

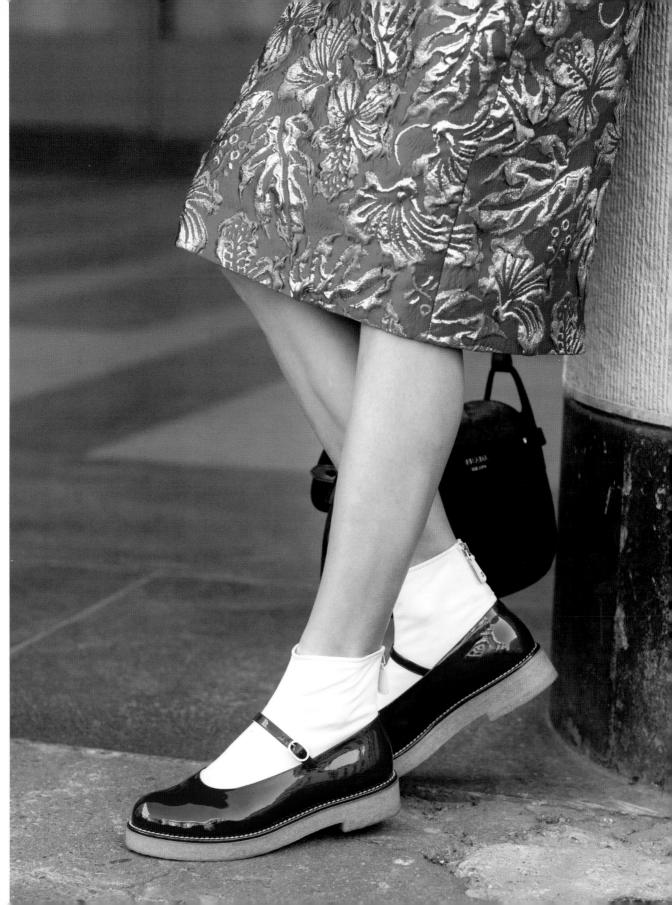

"THERE'S NOTHING
A MAN CAN DO,
THAT I CAN'T DO BETTER
AND IN HEELS."

- Ginger Rogers

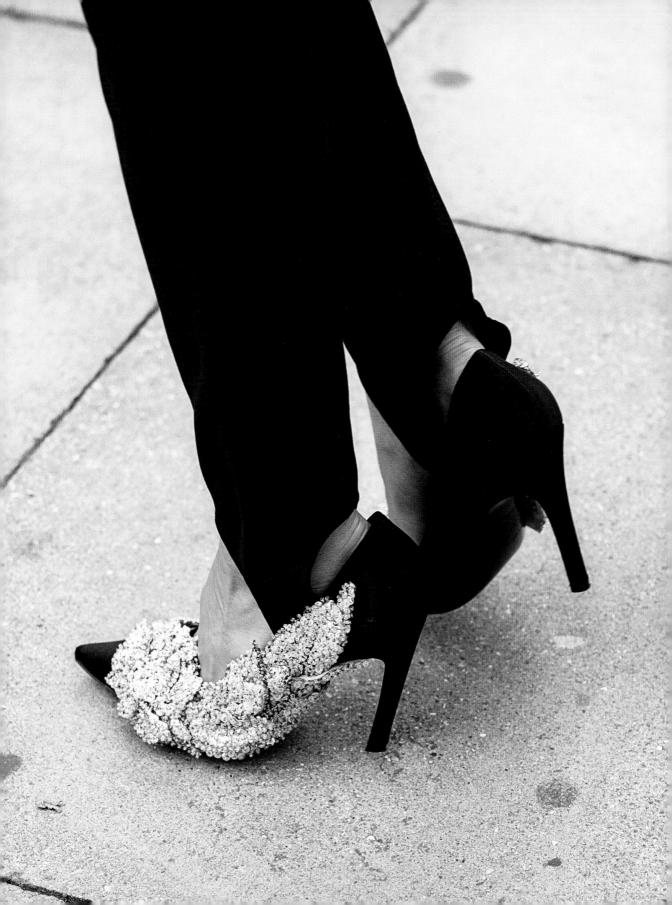

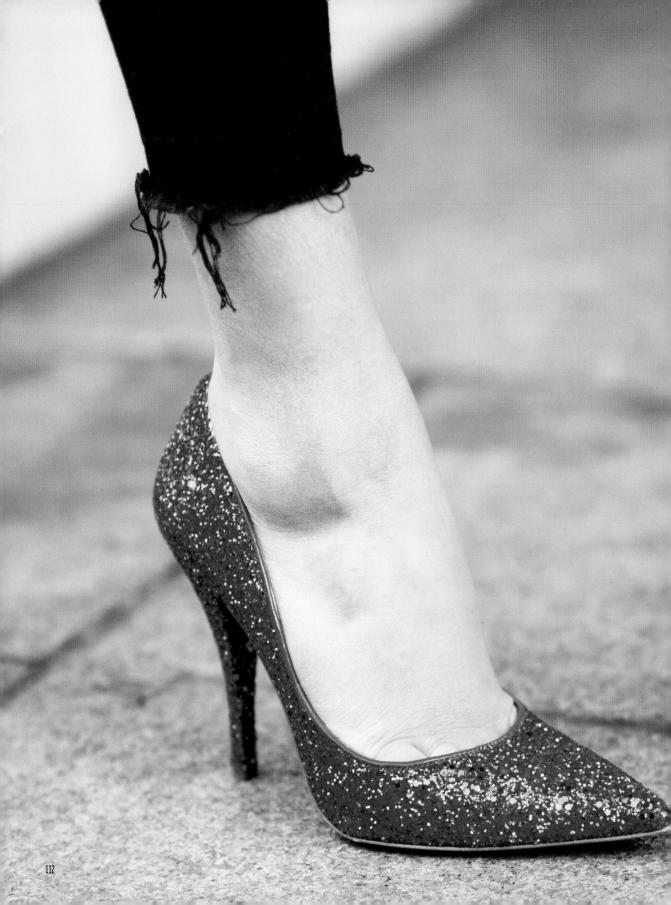

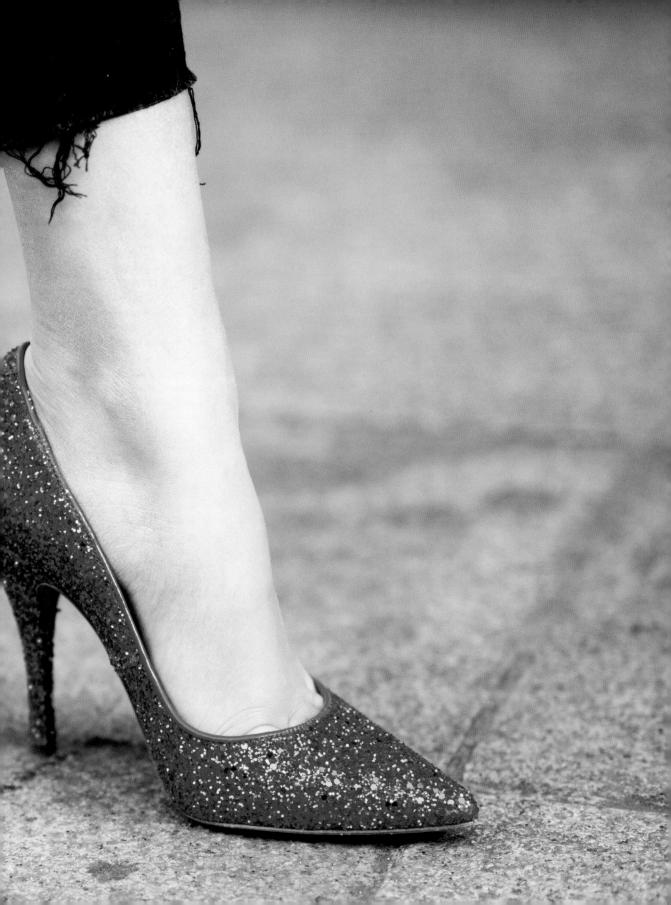

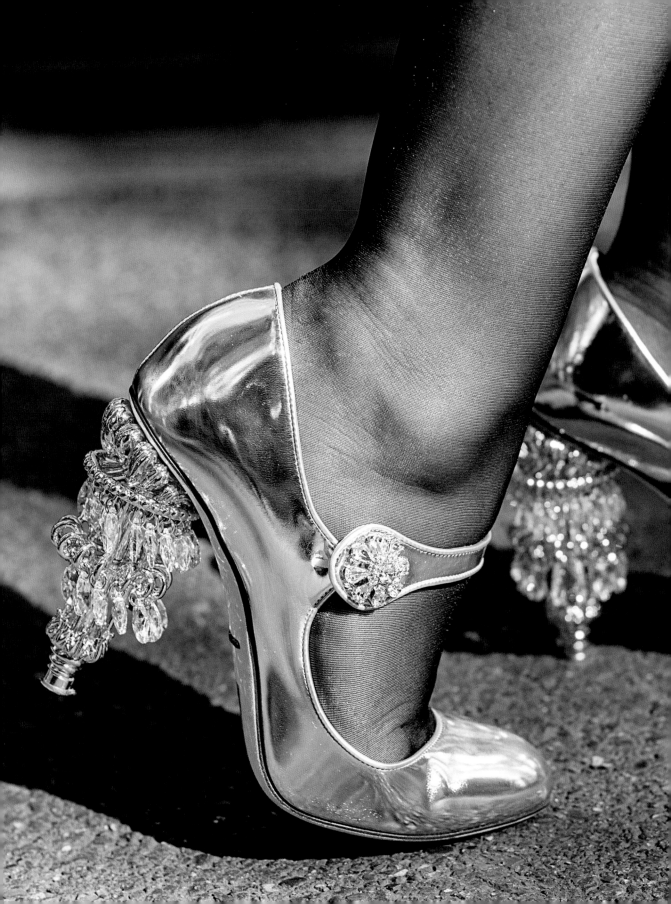

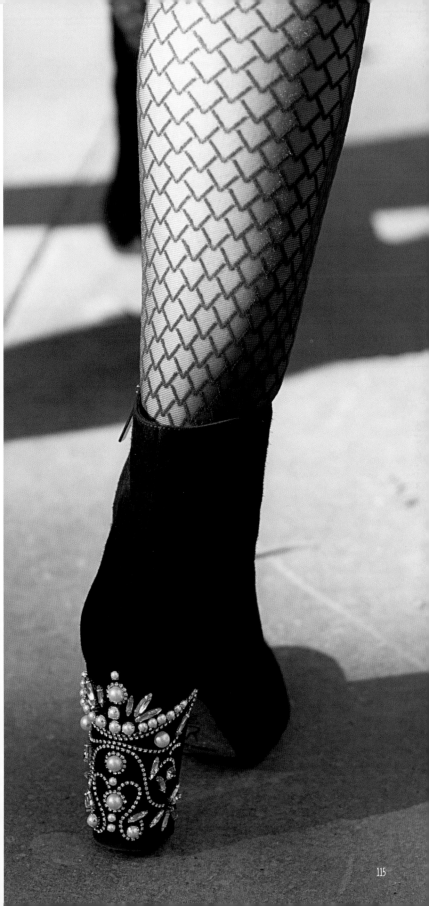

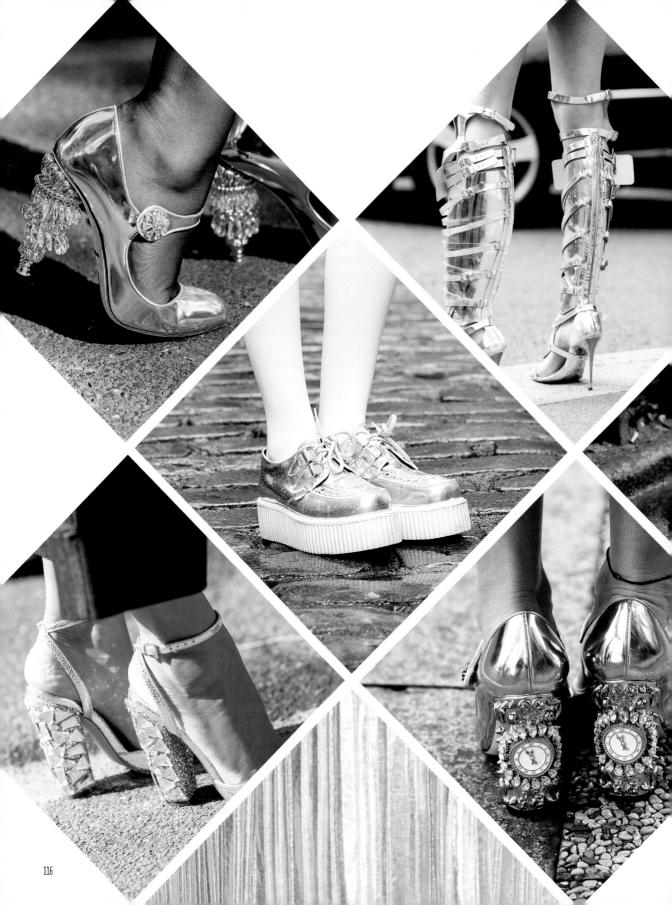

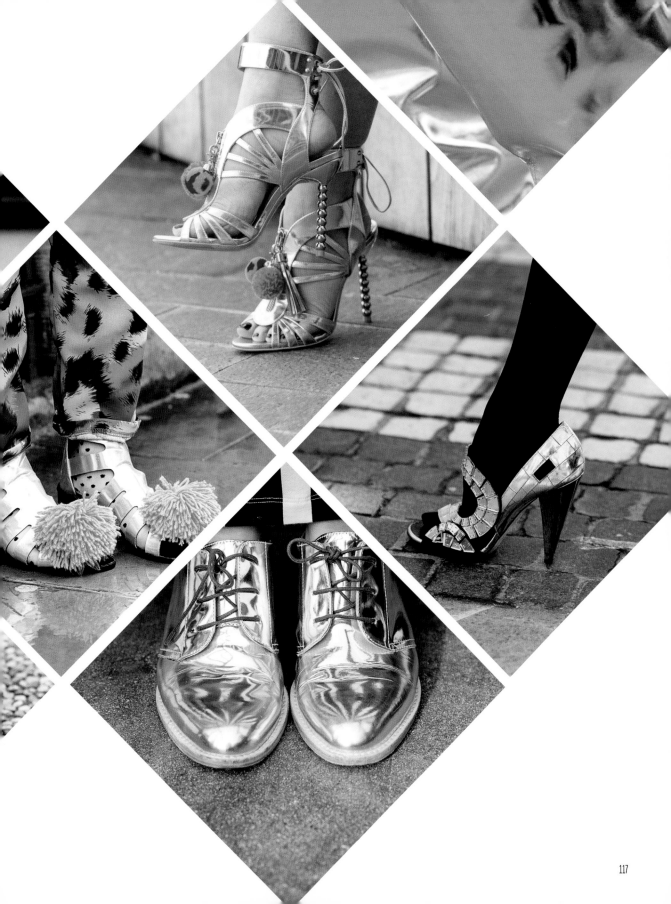

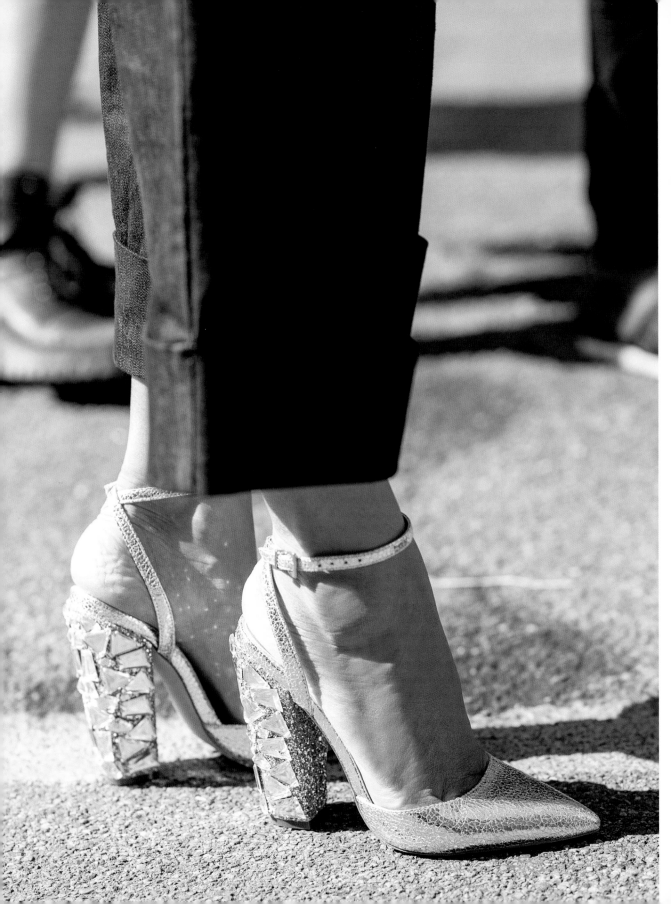

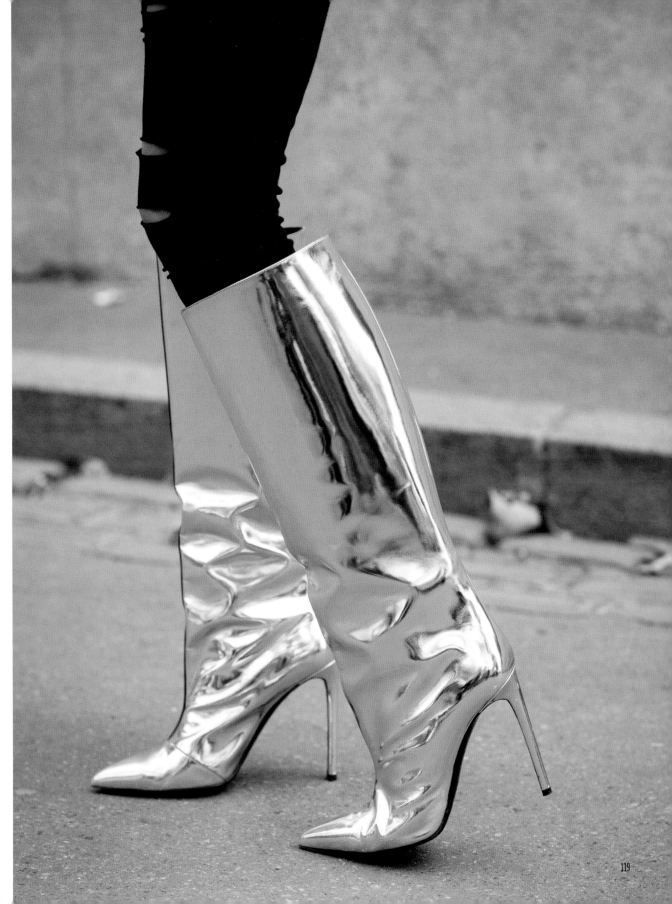

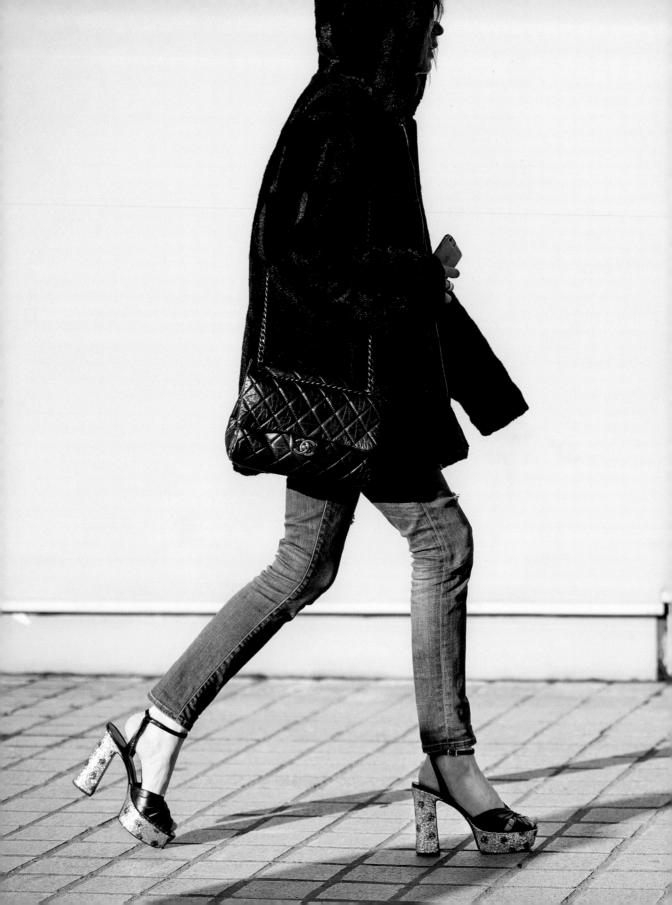

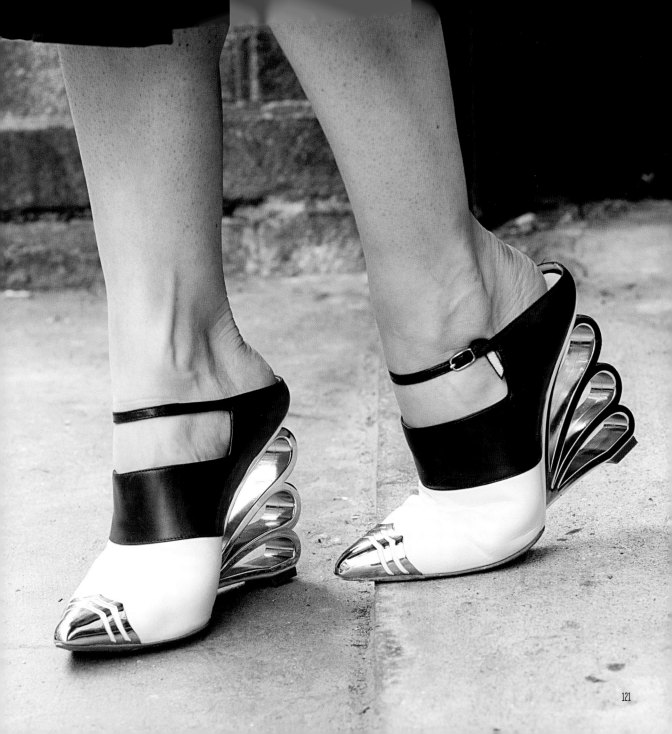

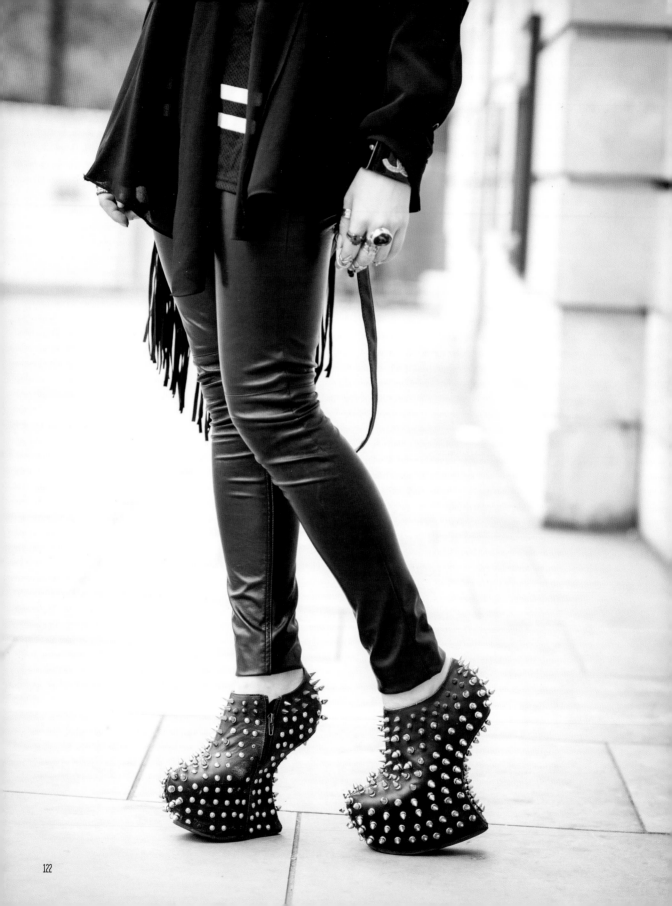

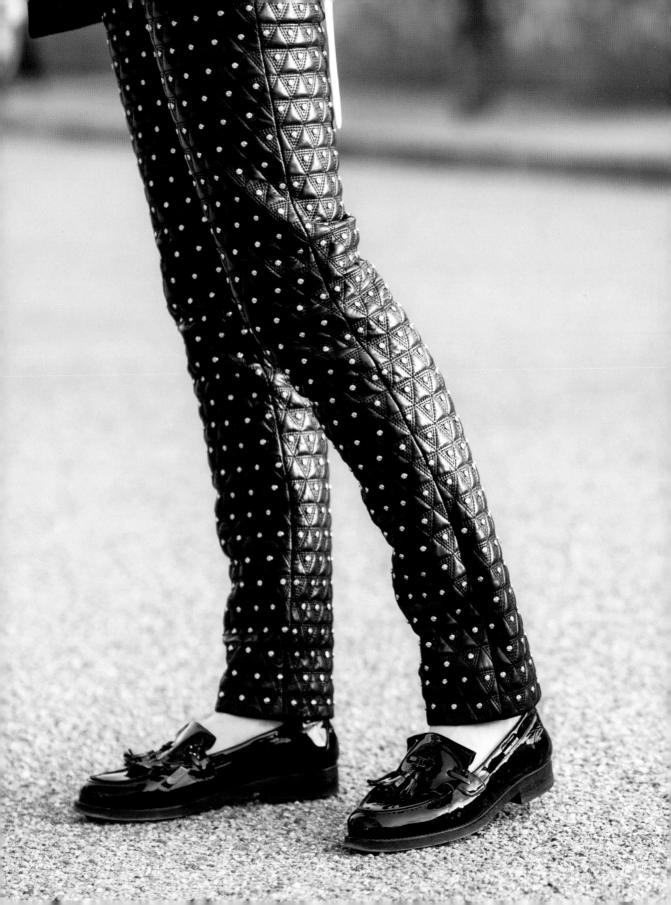

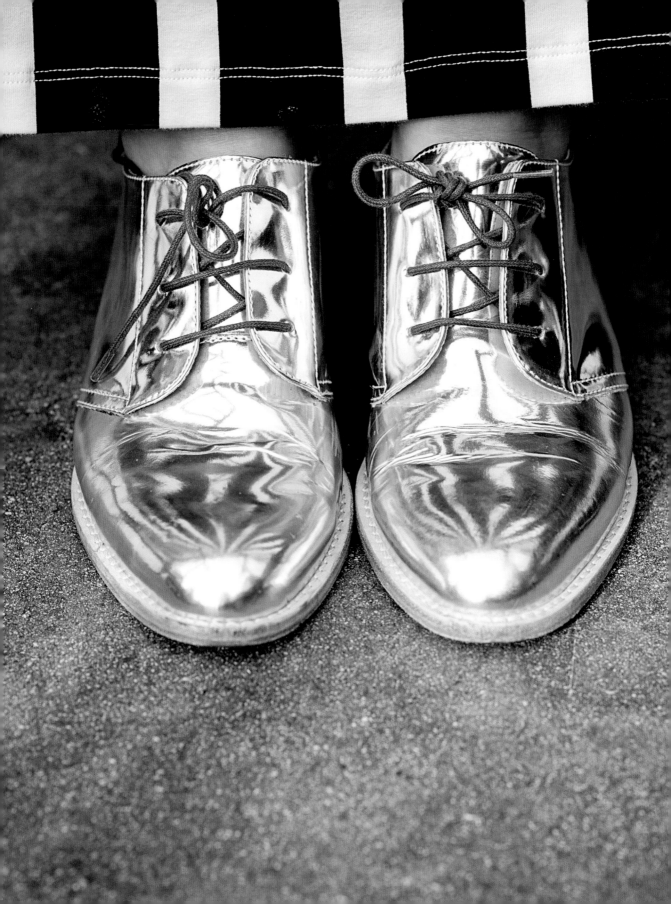

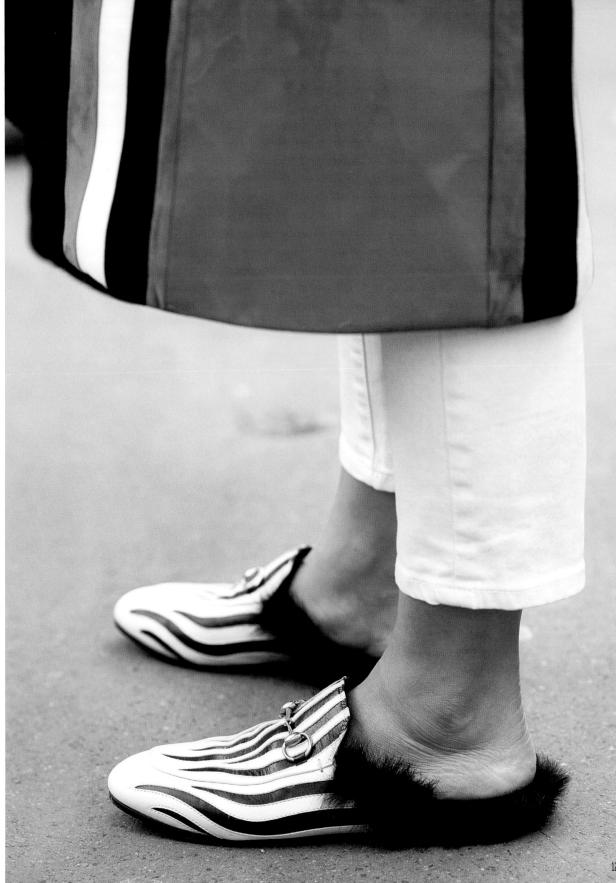

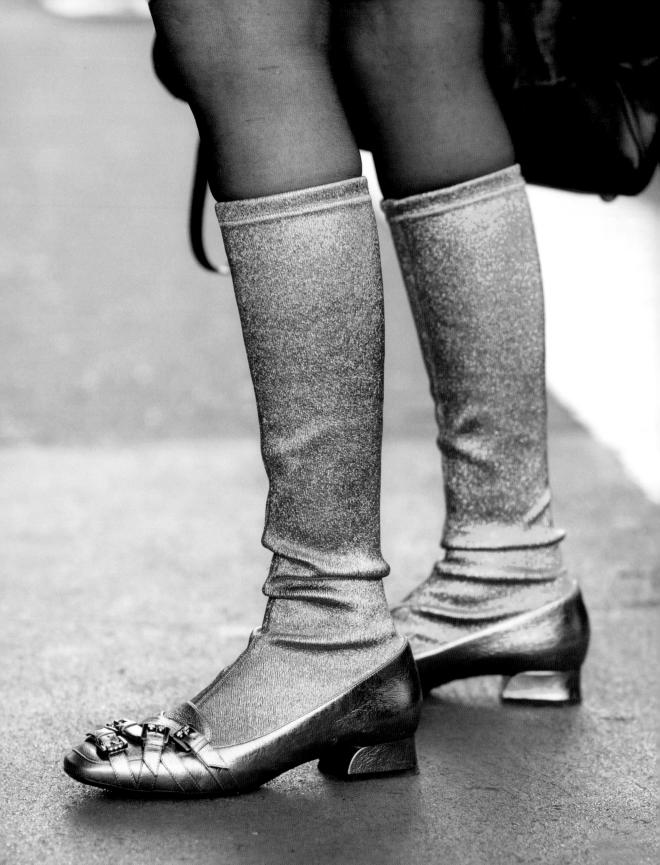

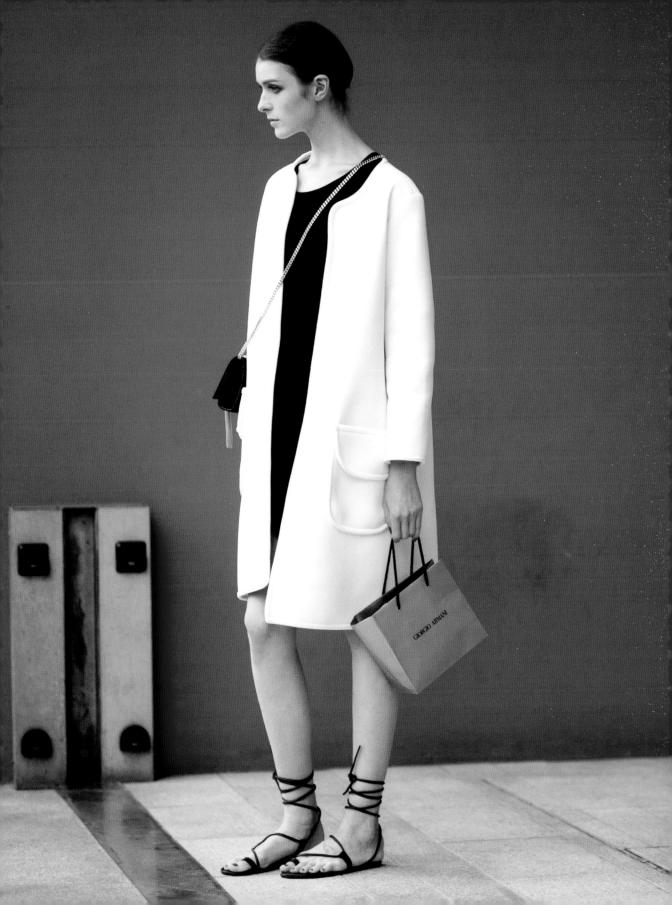

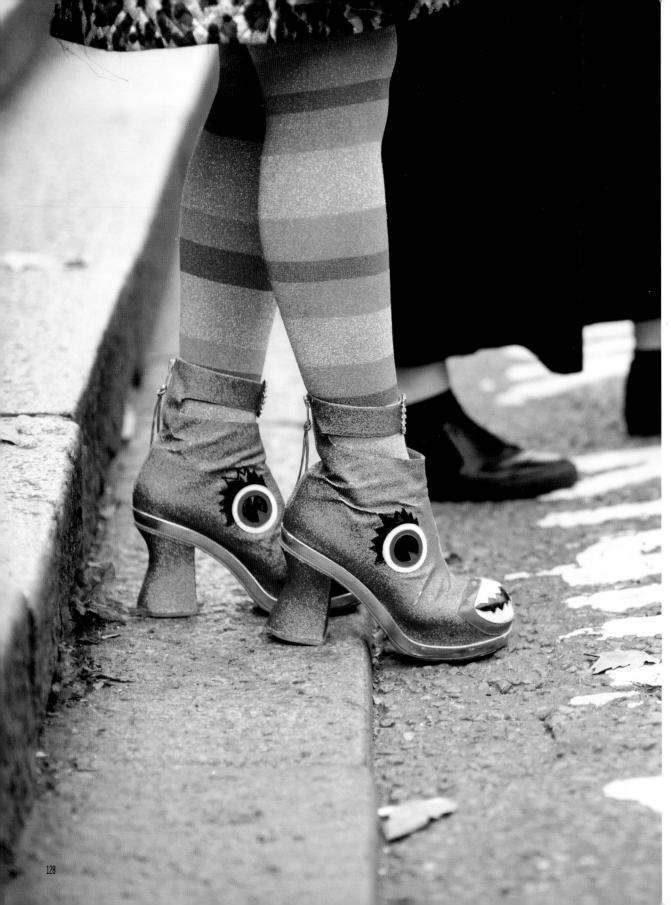

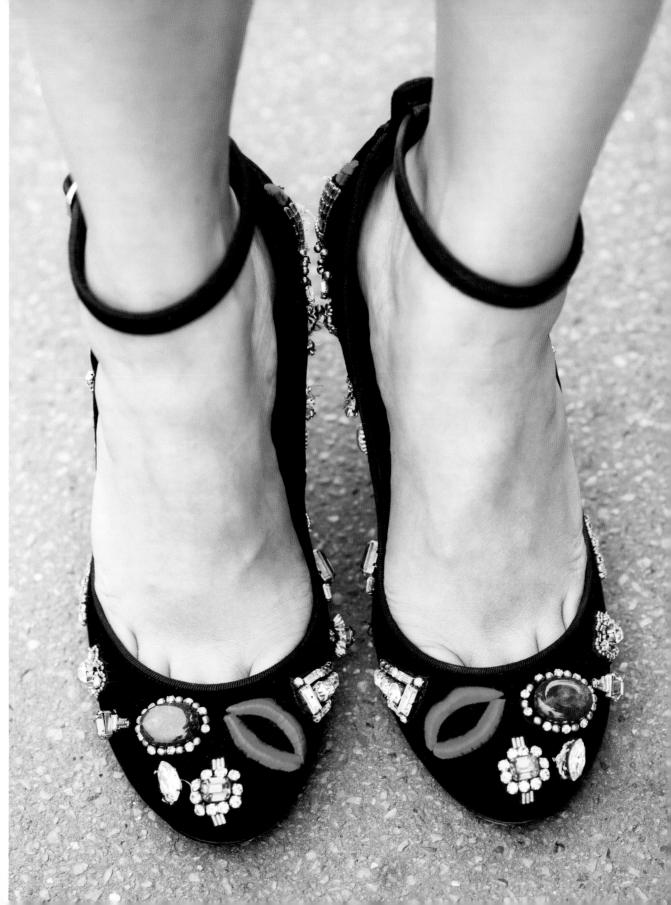

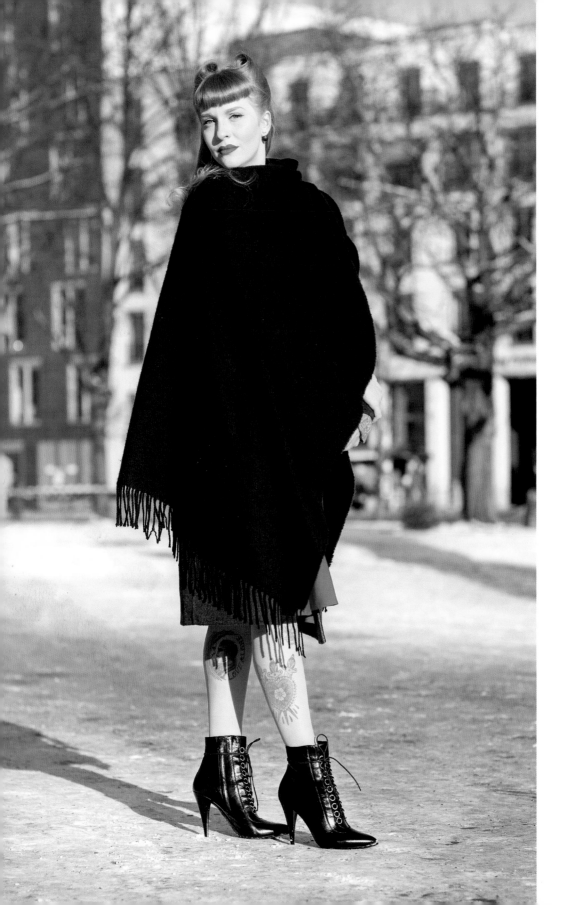

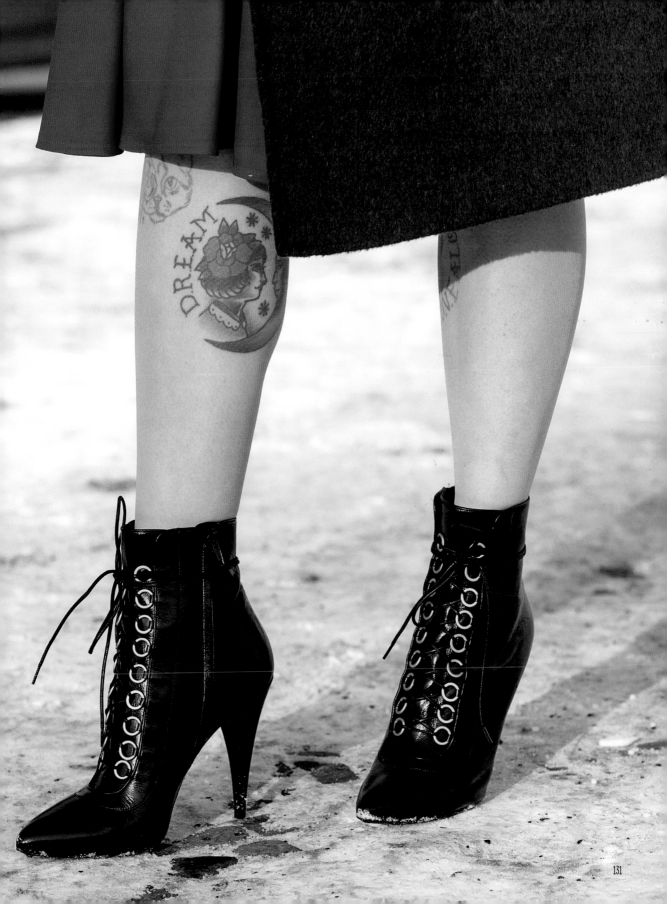

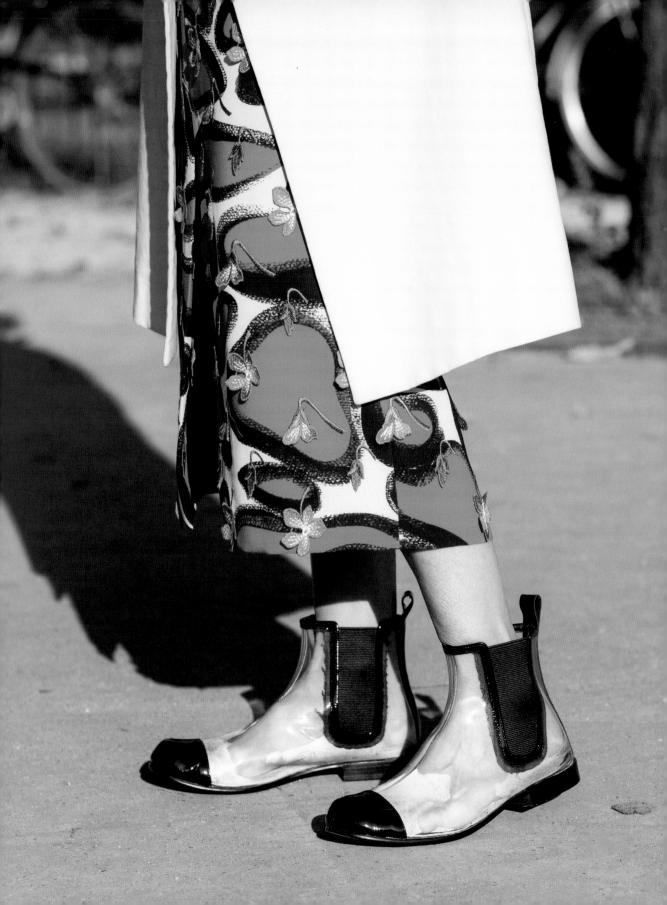

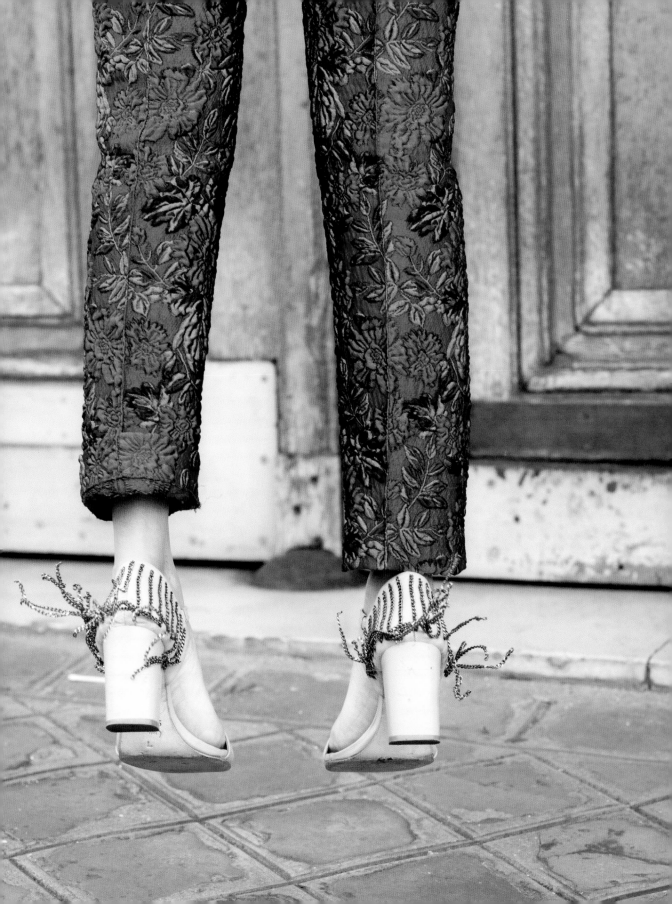

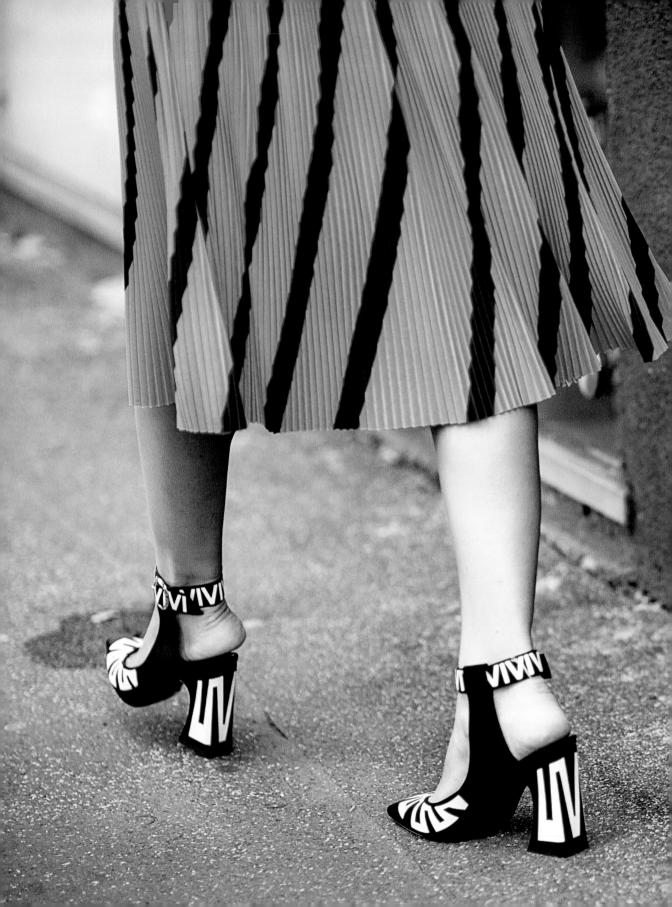

"OH MY GOD!
LOOK AT THOSE
SHOES!"

- Bill Cunningham

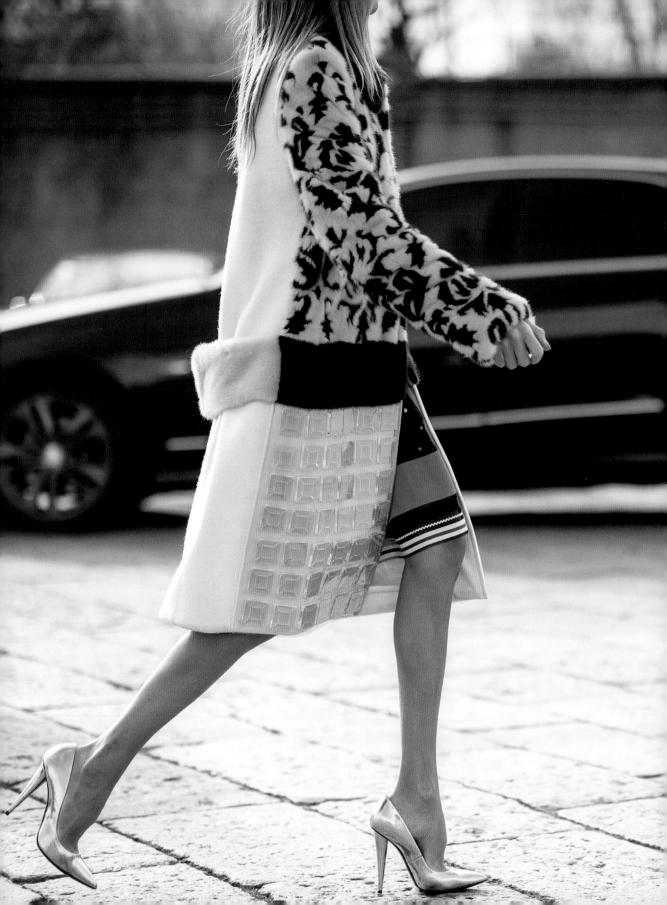

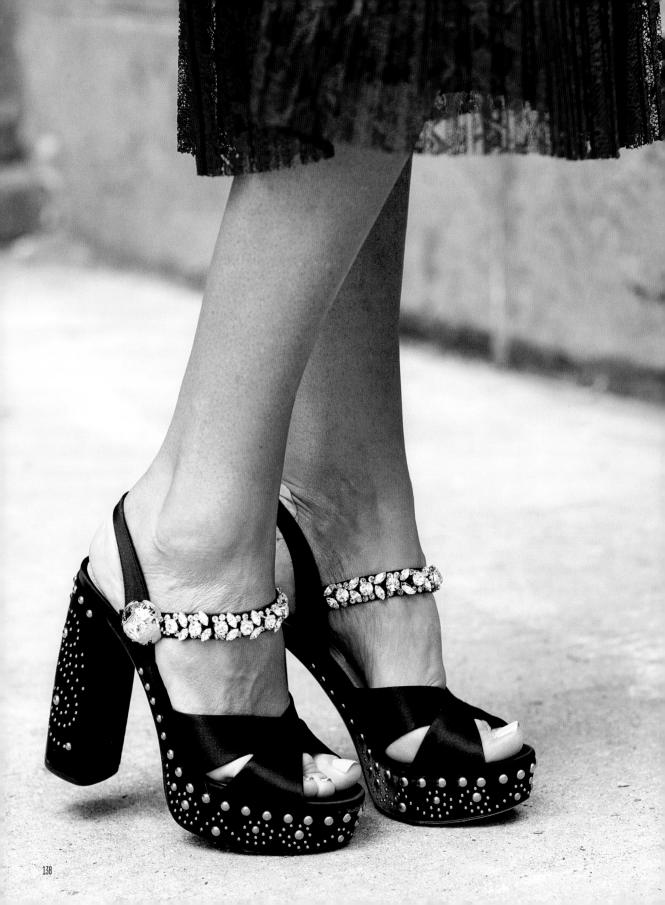

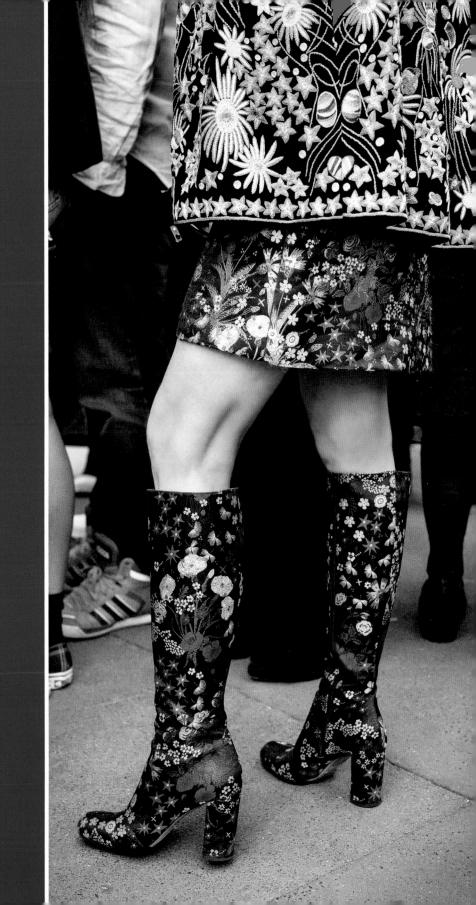

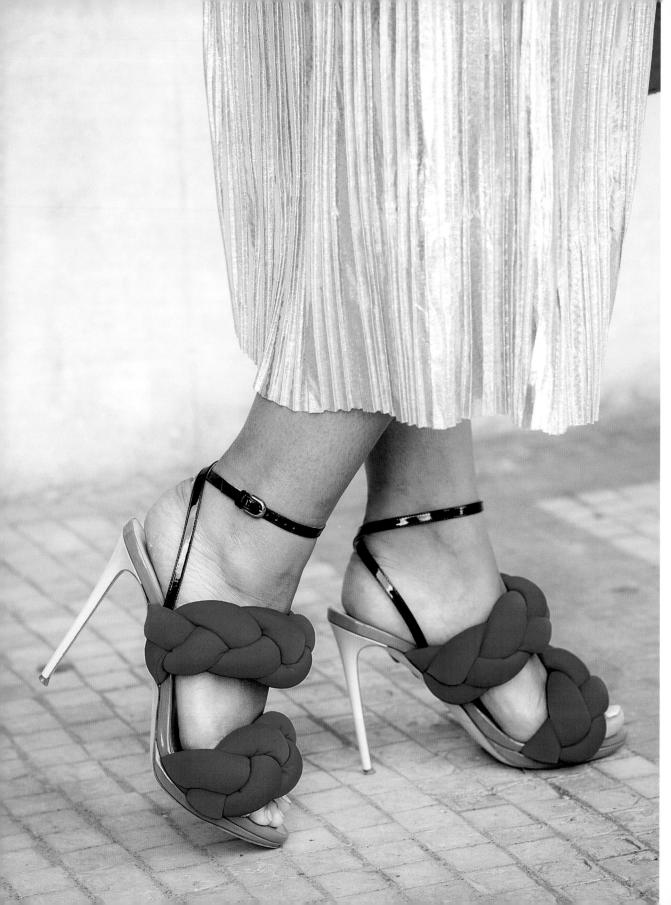

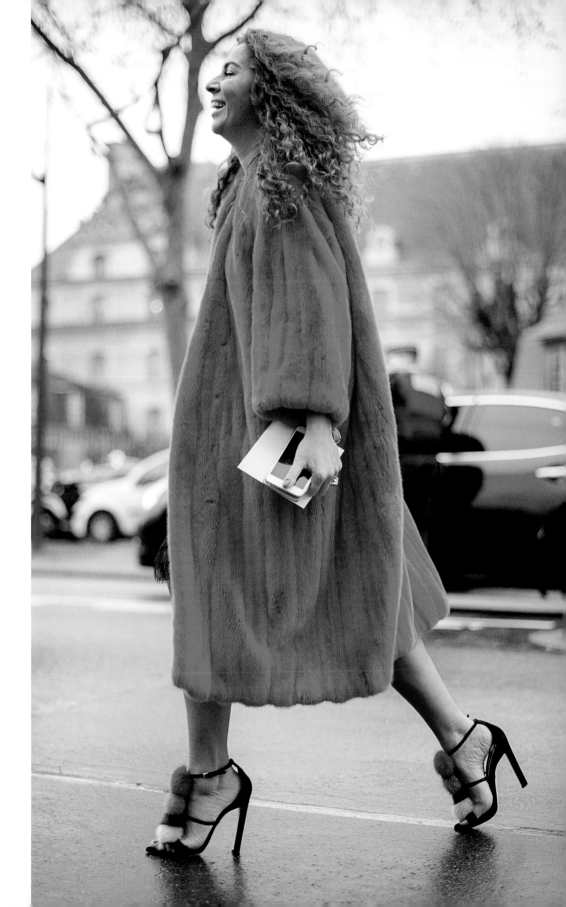

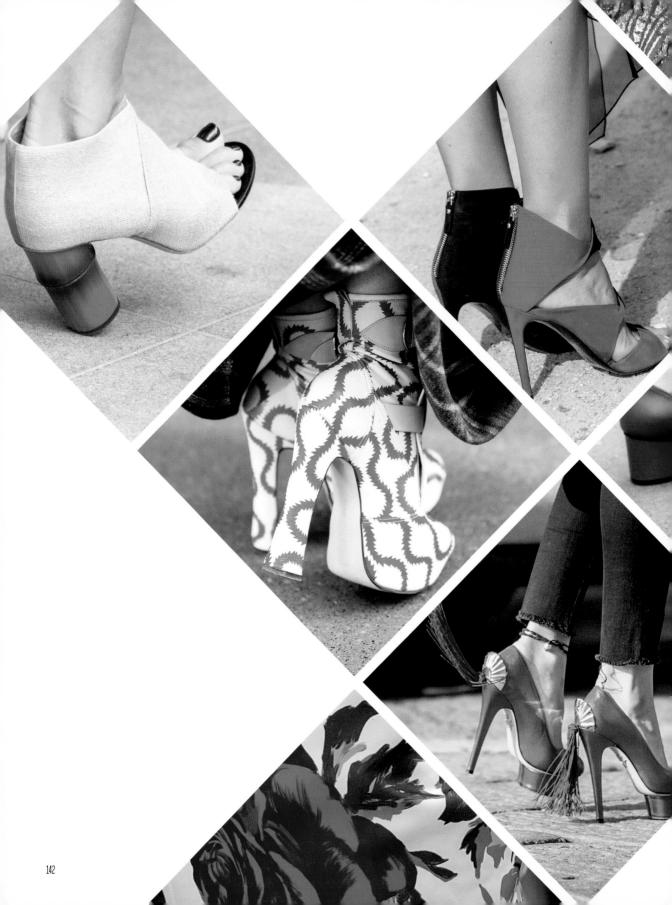

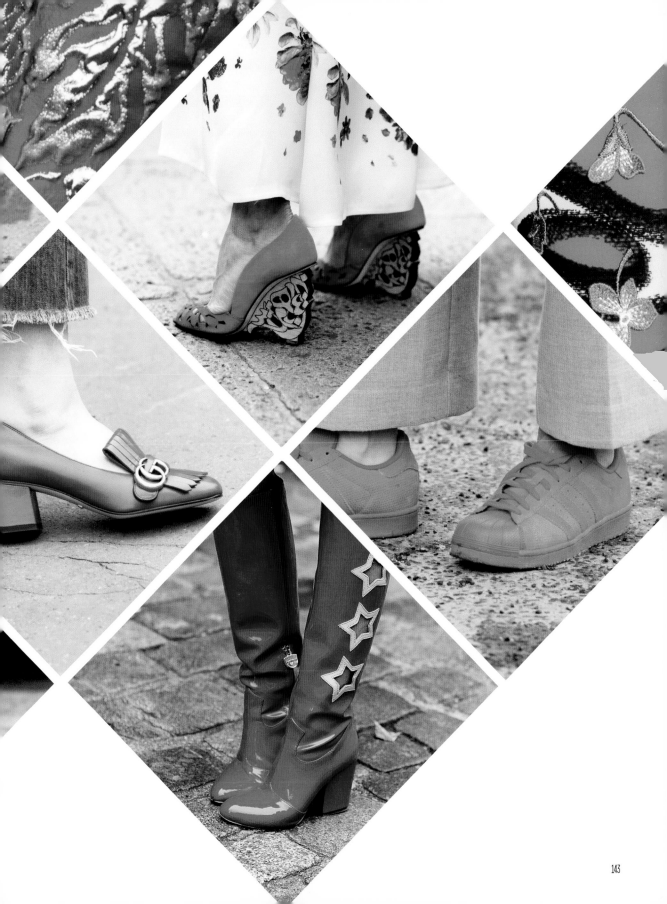

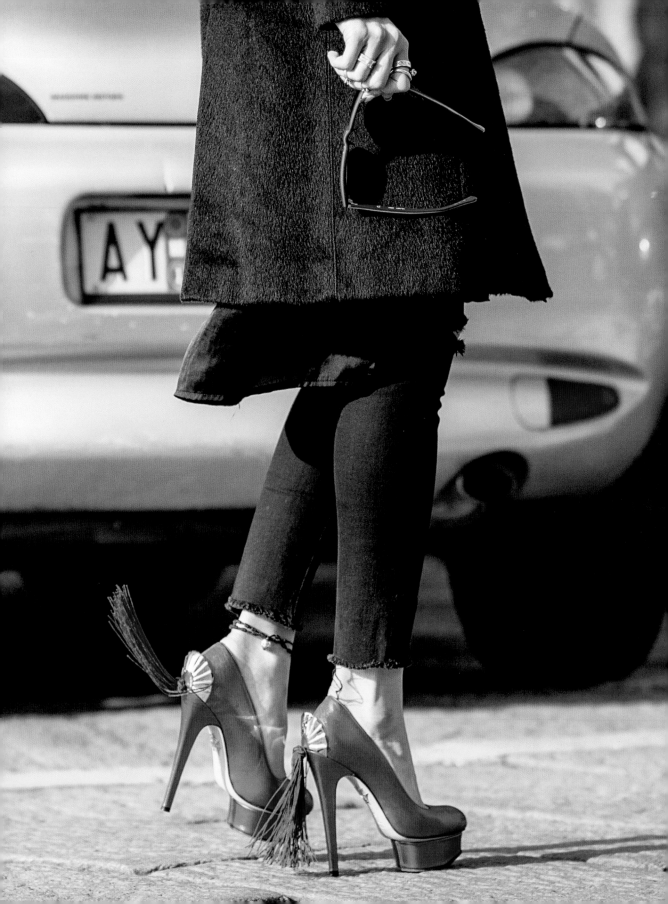

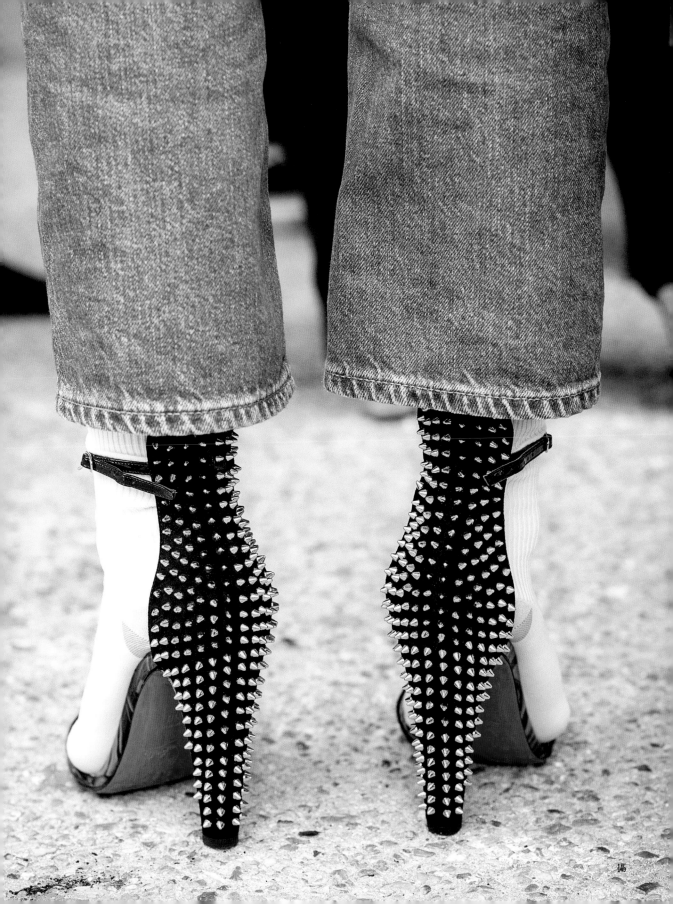

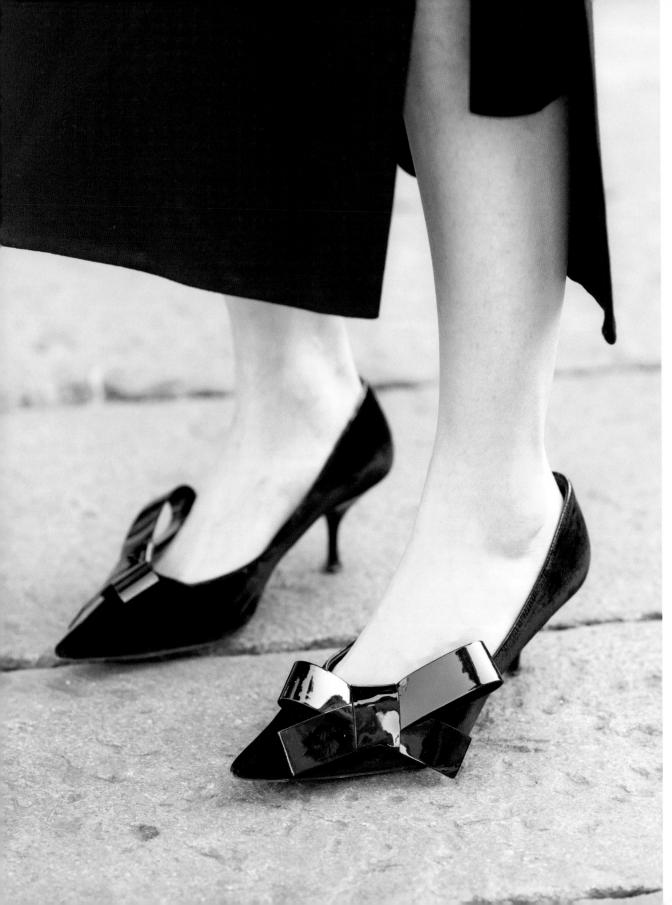

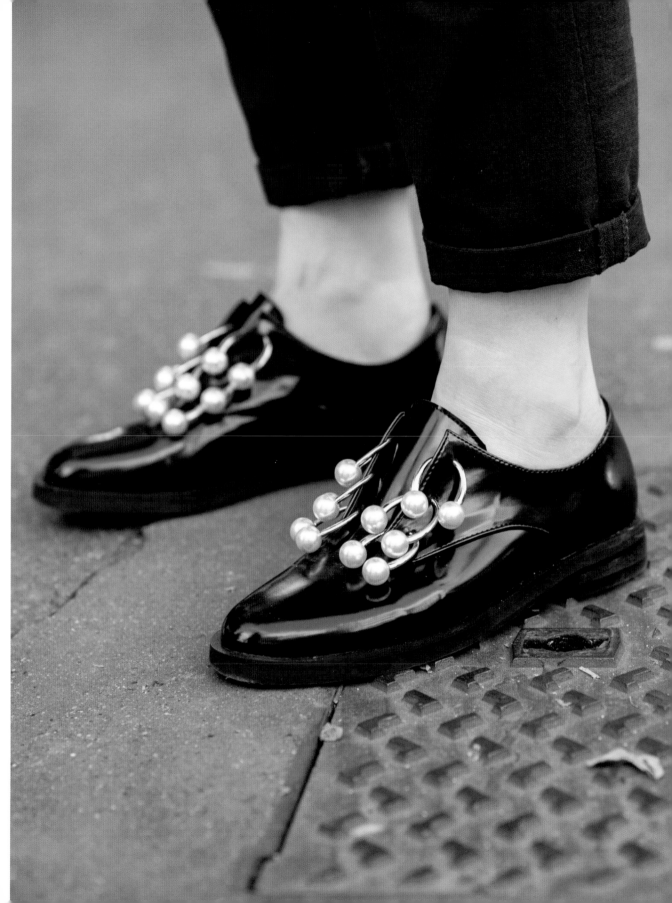

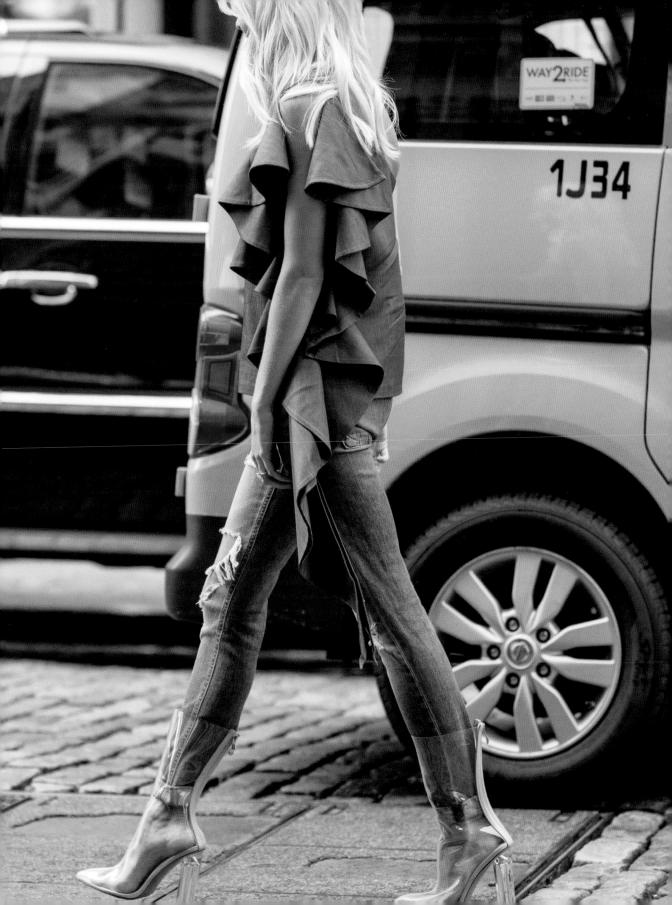

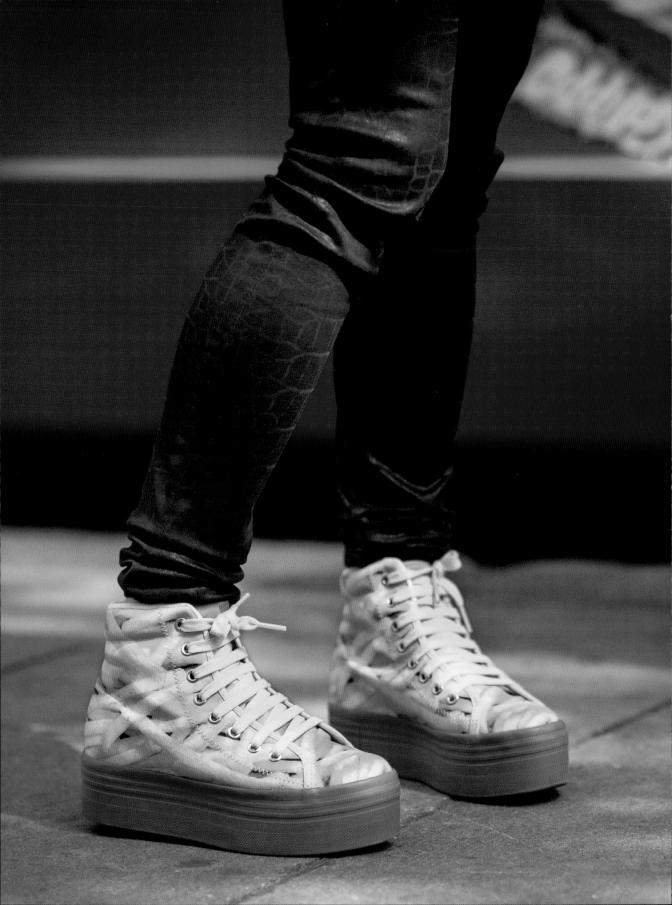

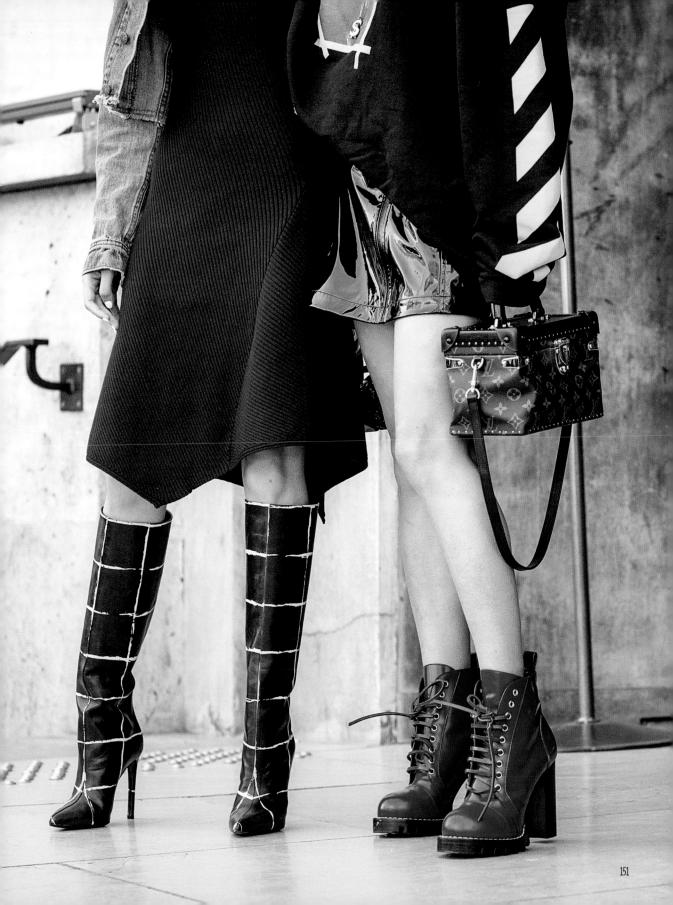

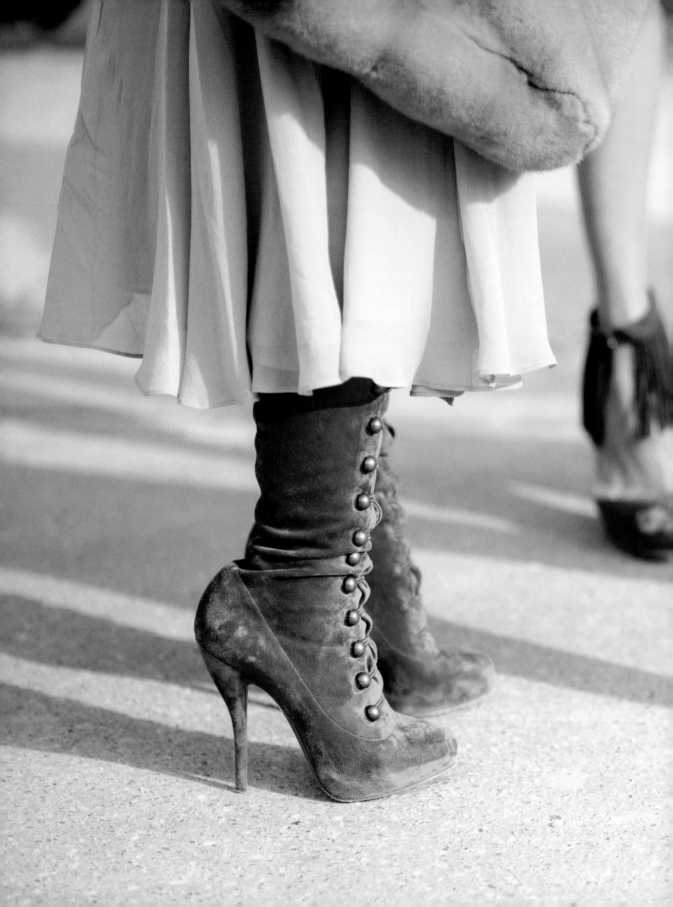

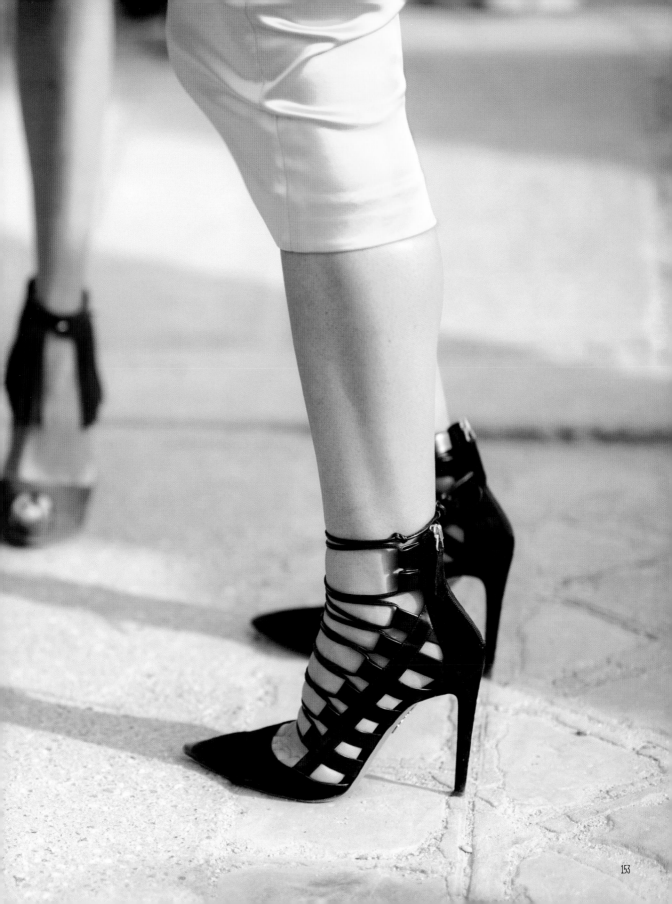

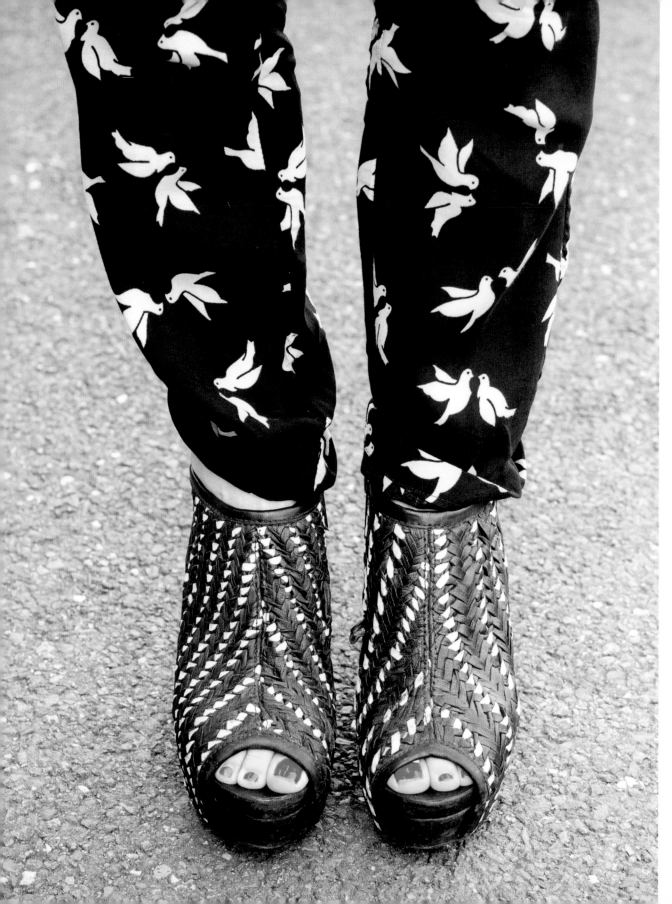

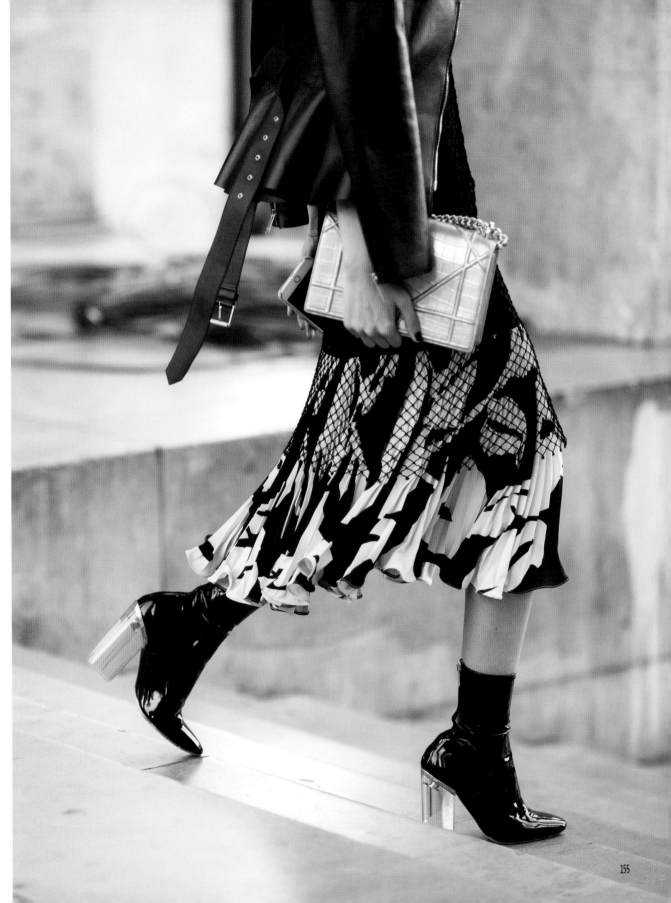

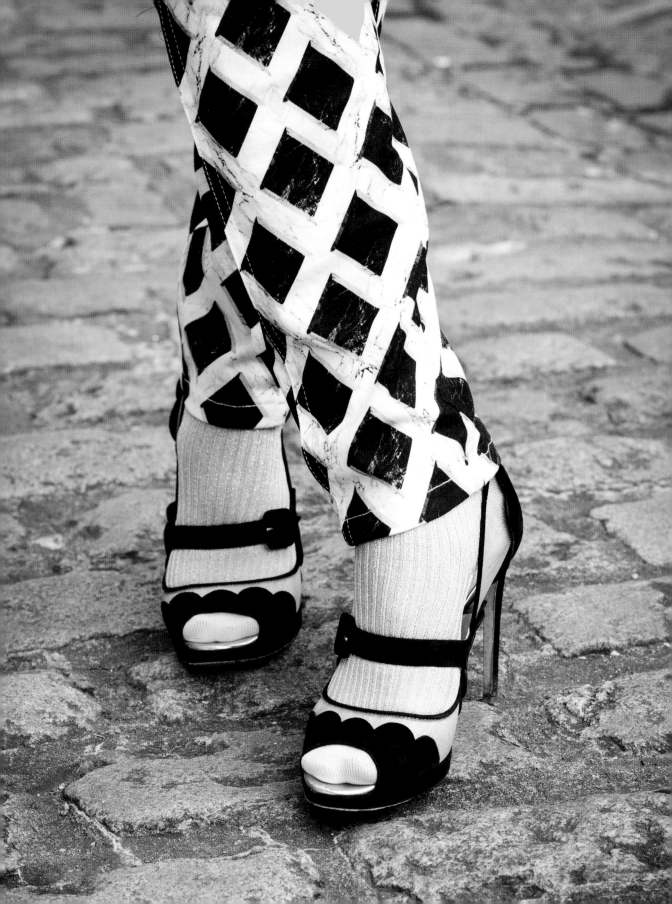

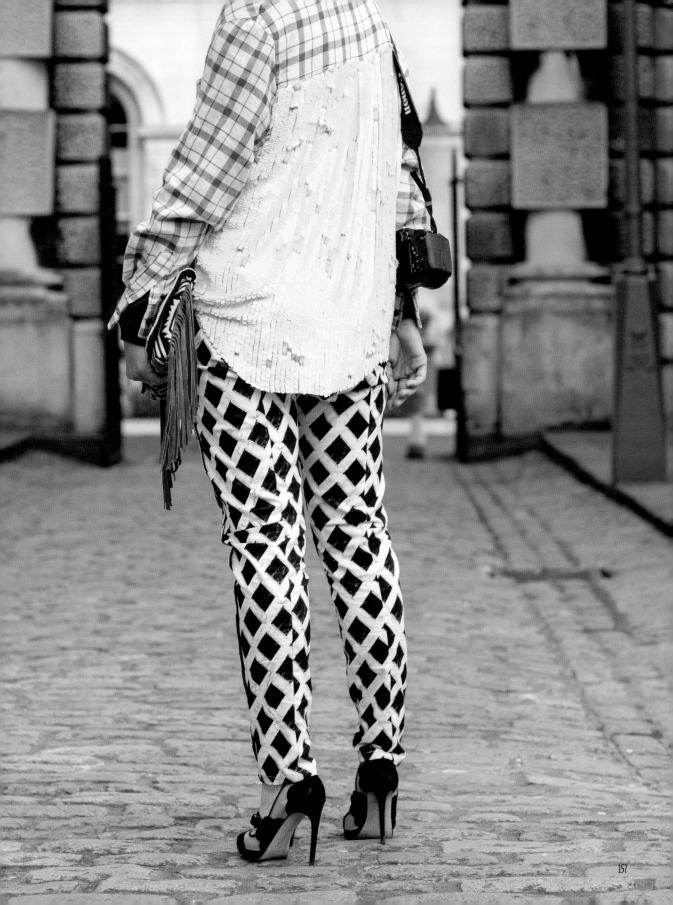

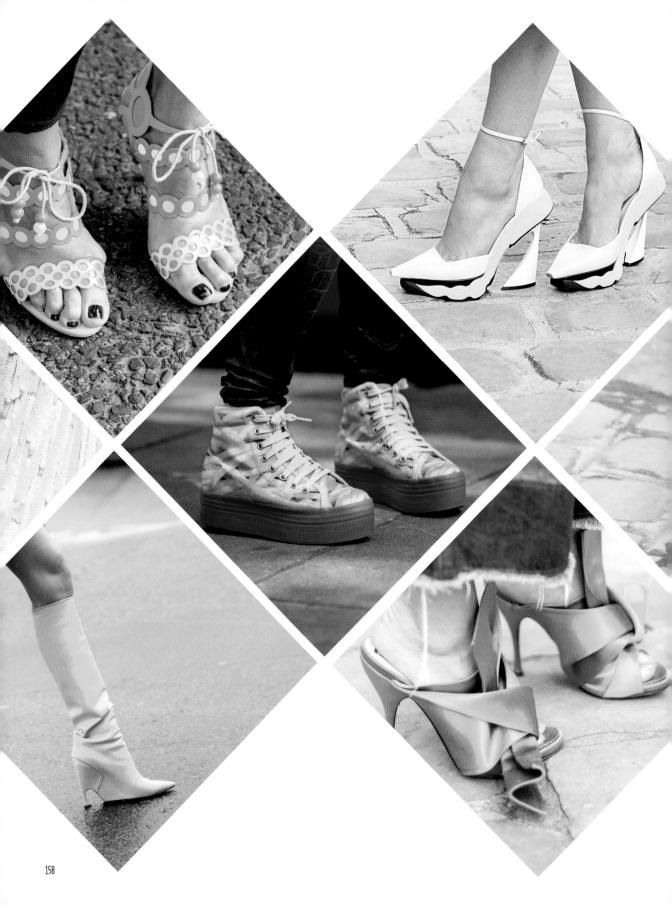

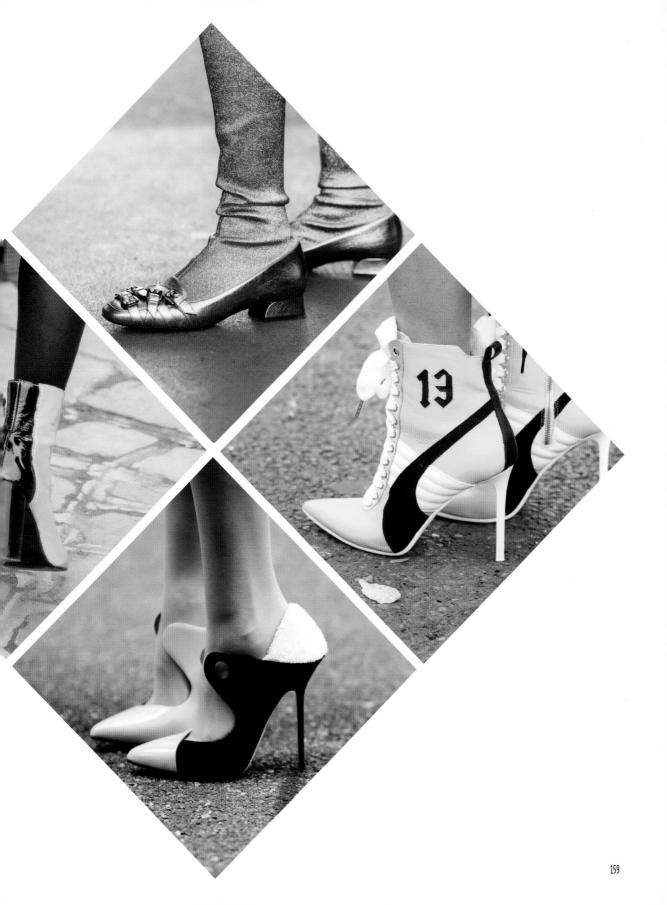

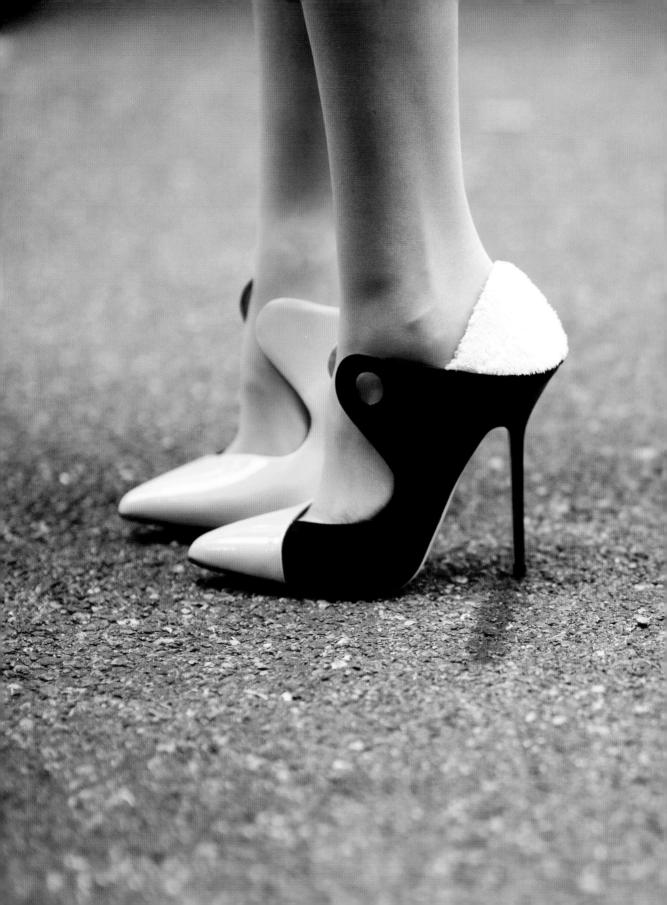

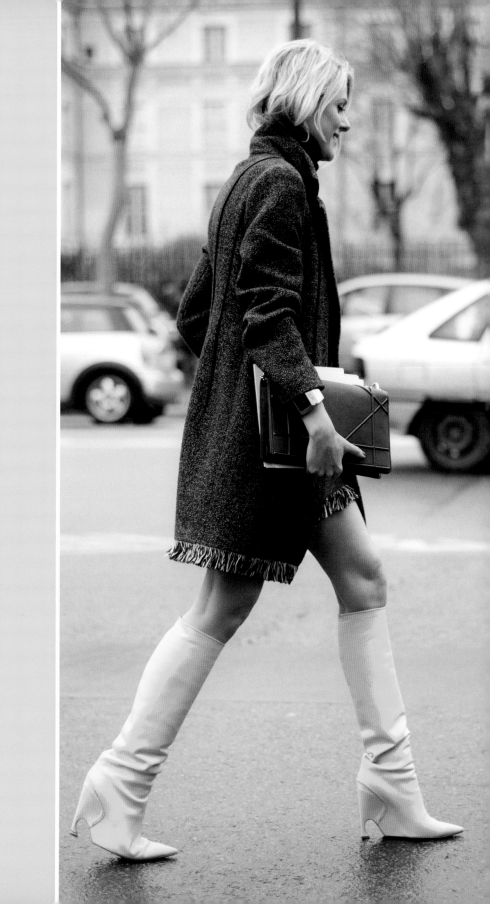

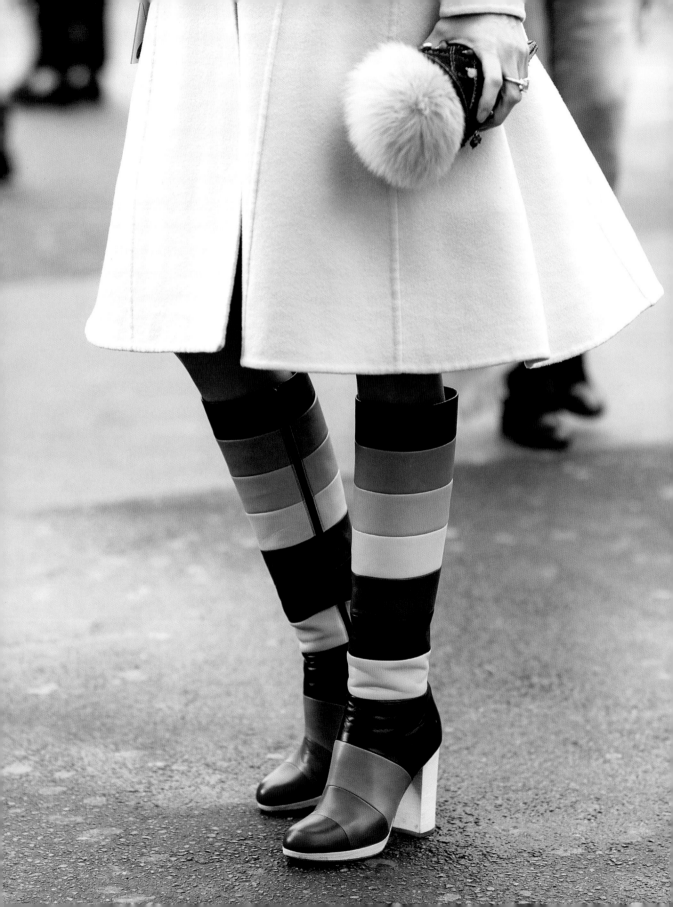

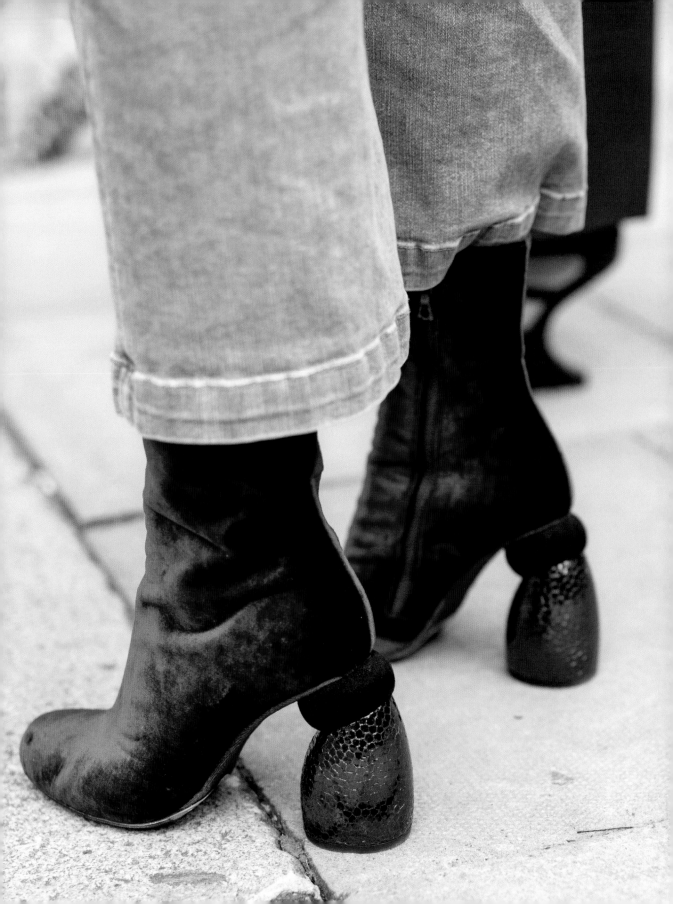

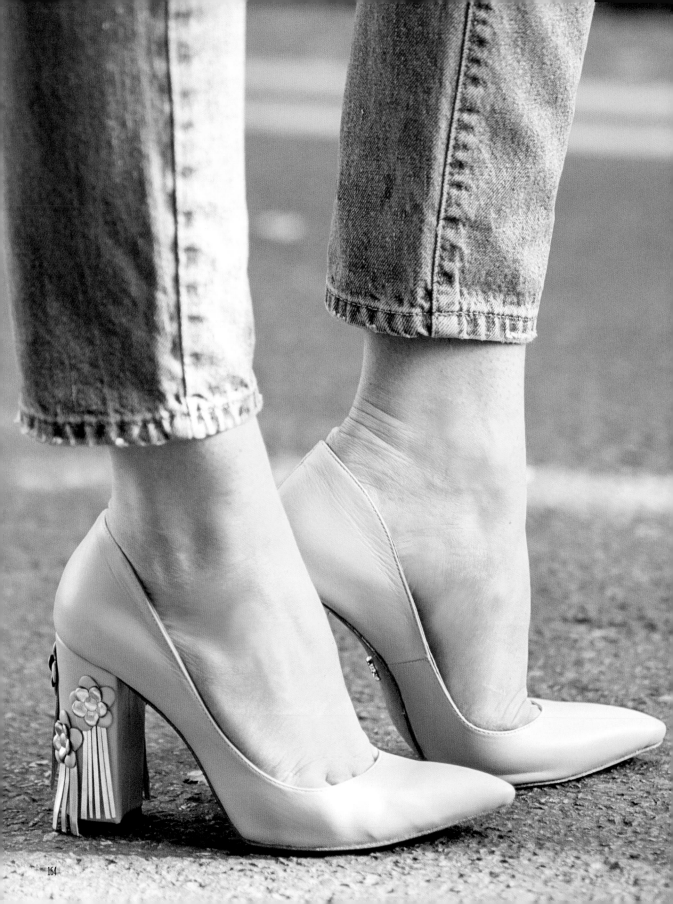

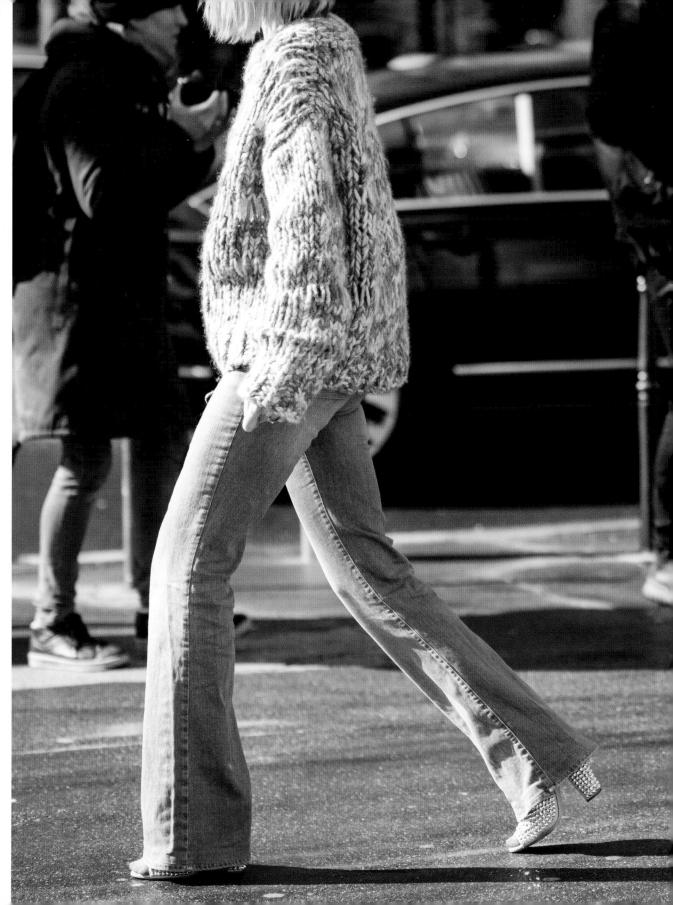

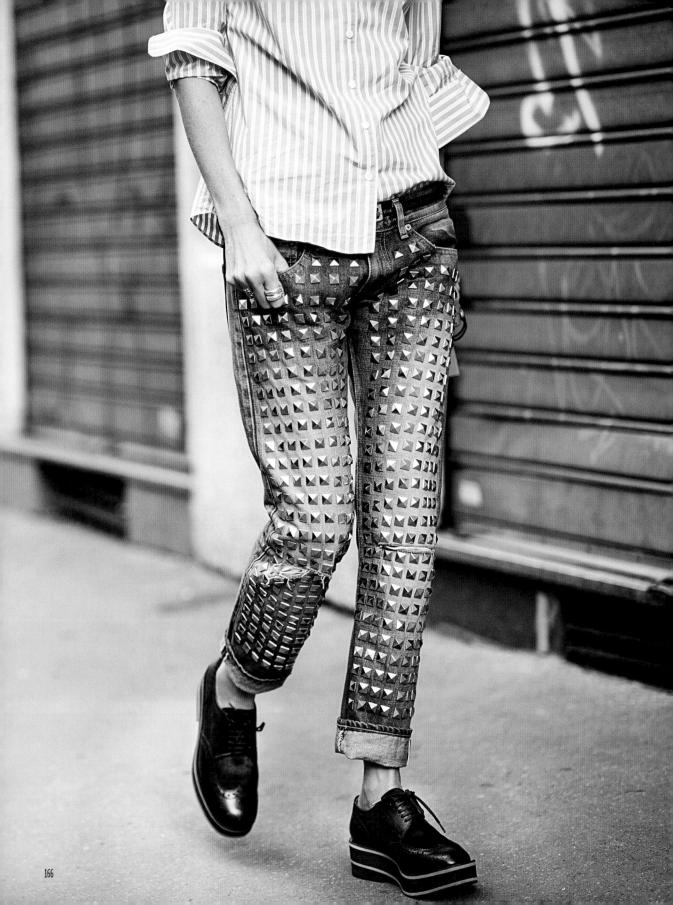

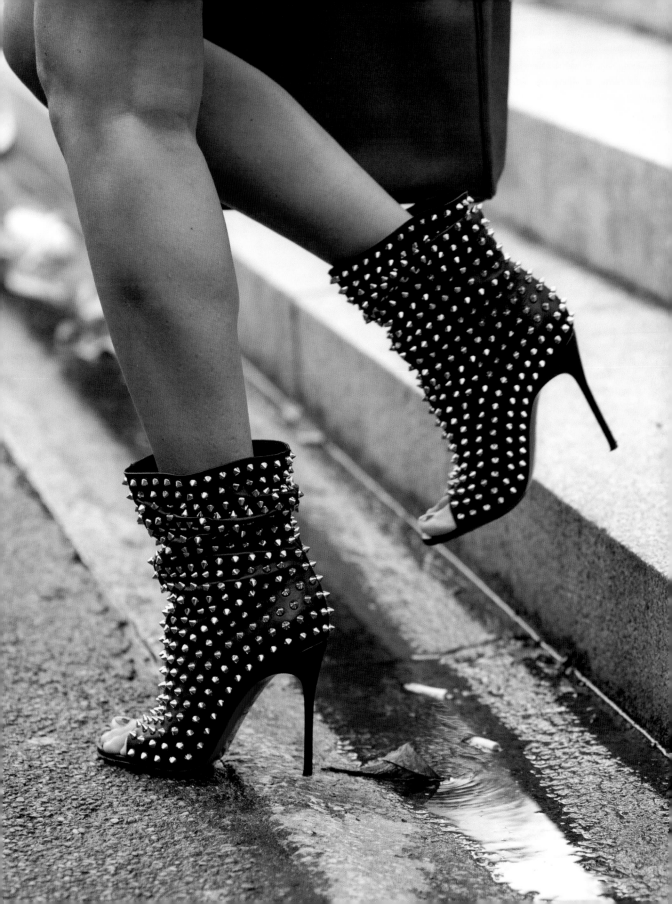

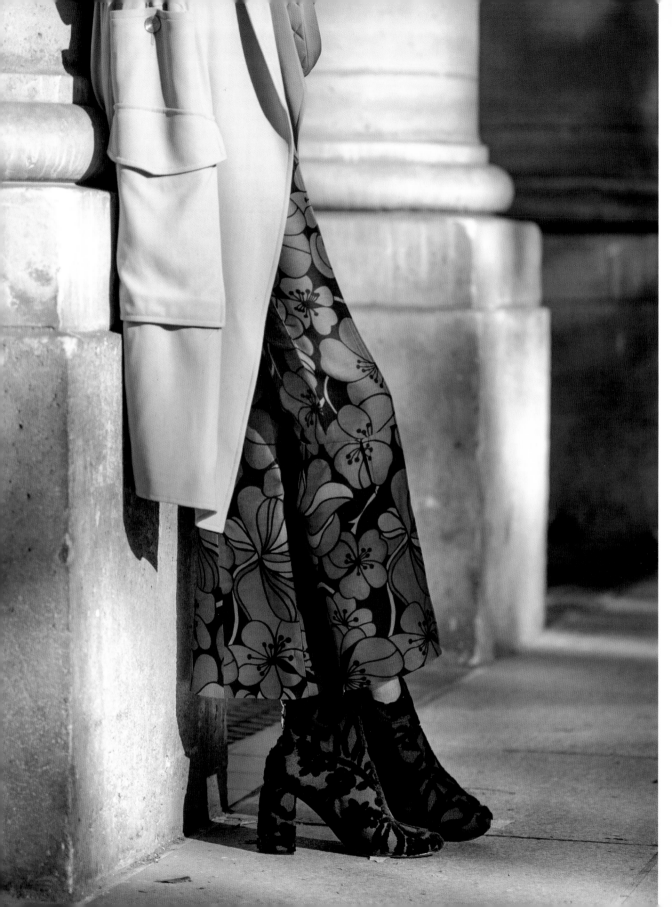

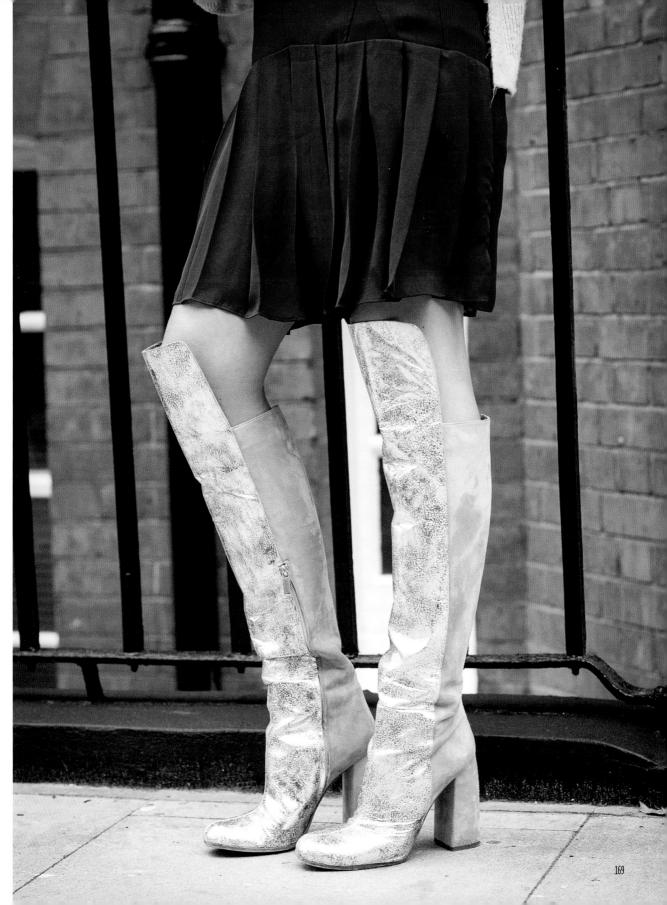

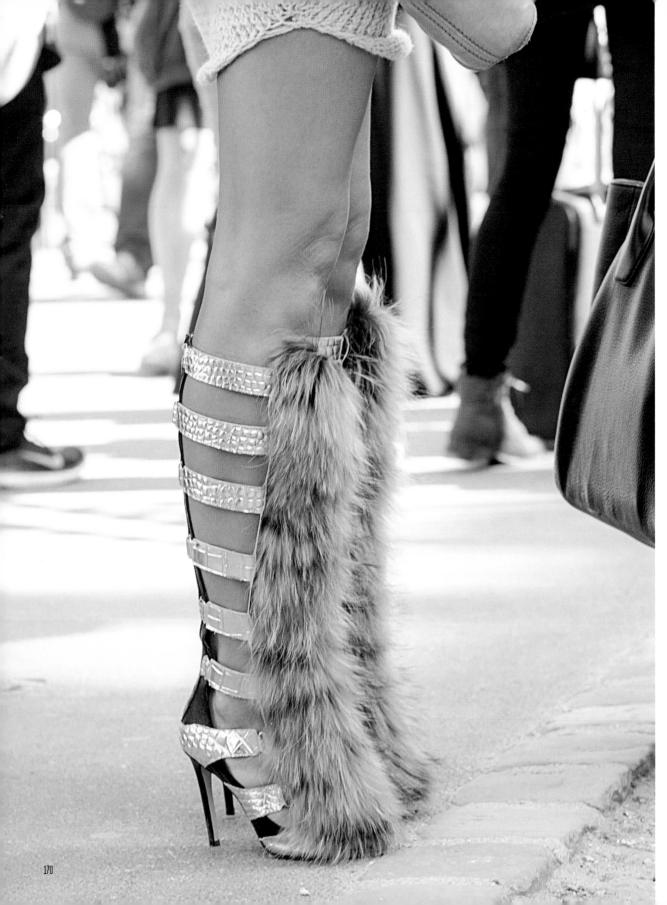

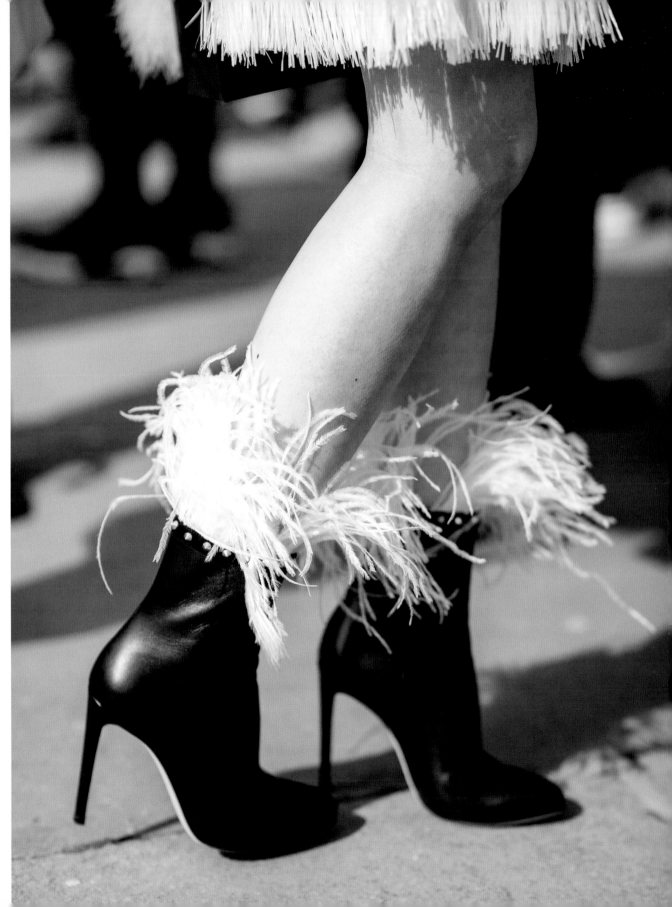

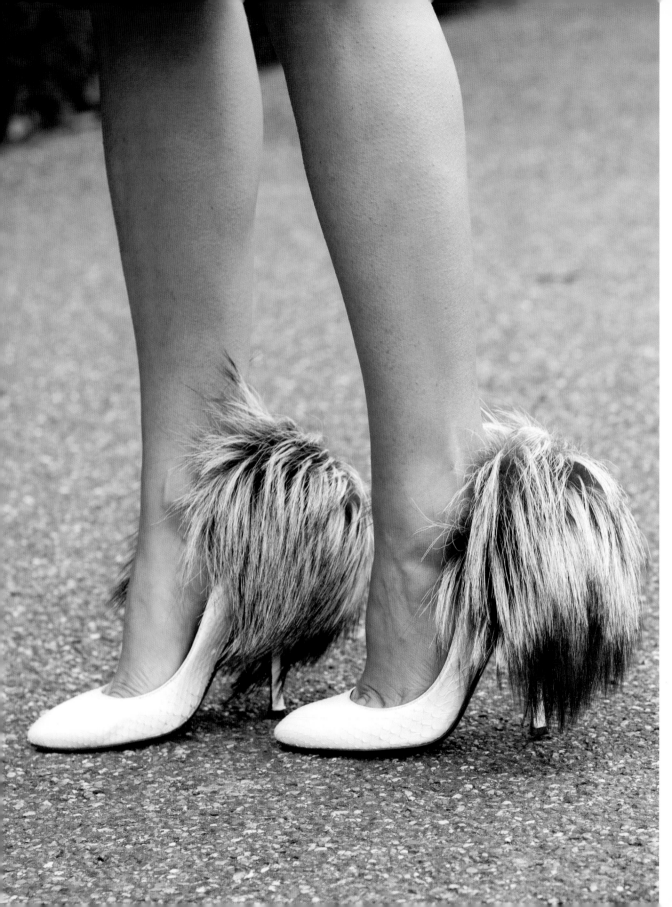

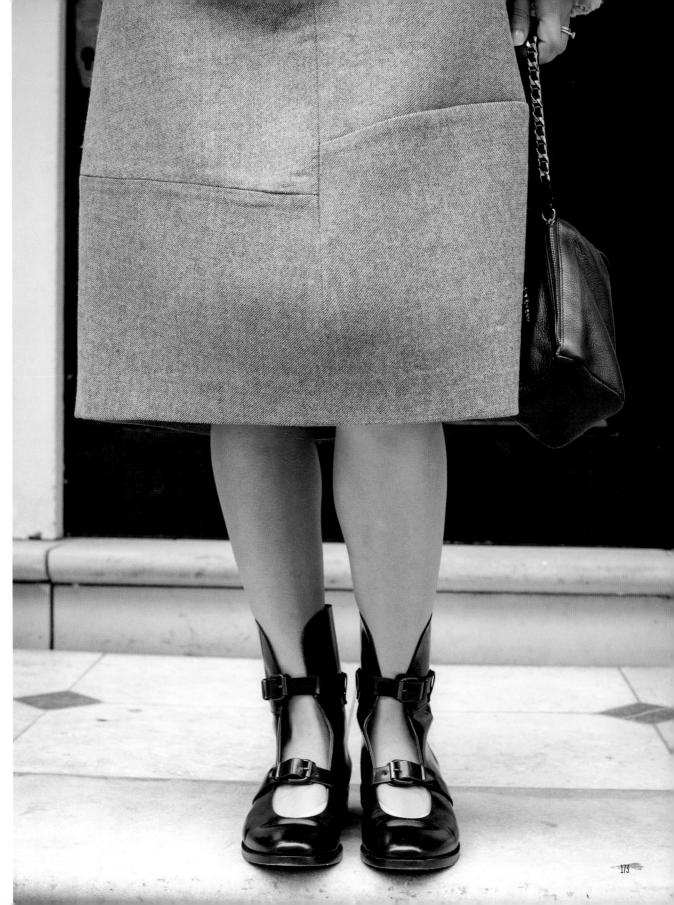

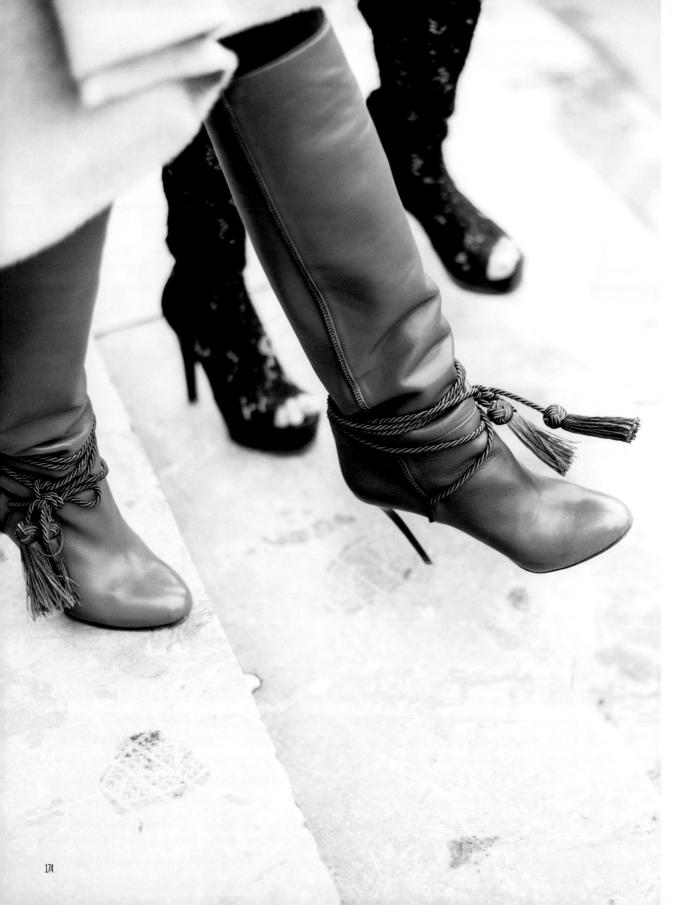

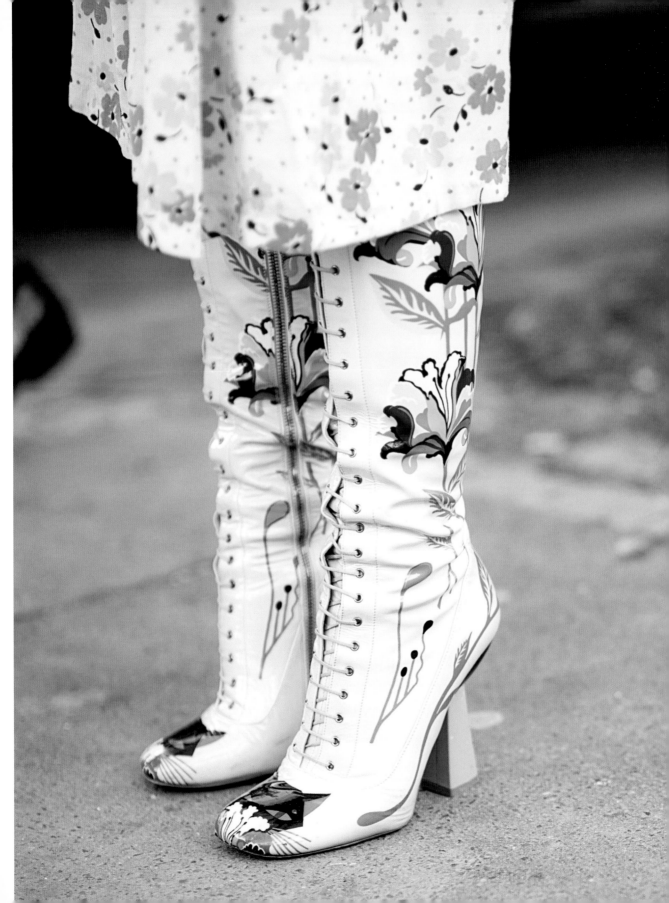

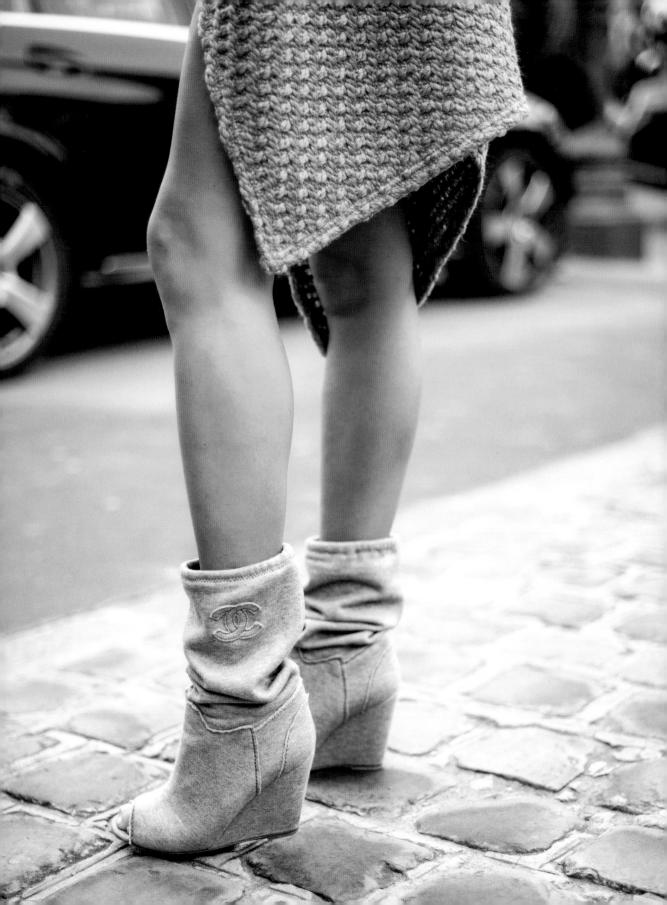

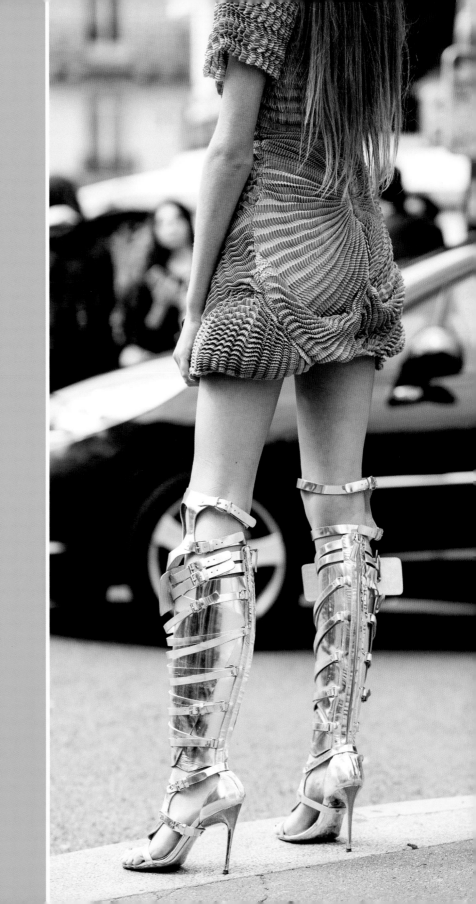

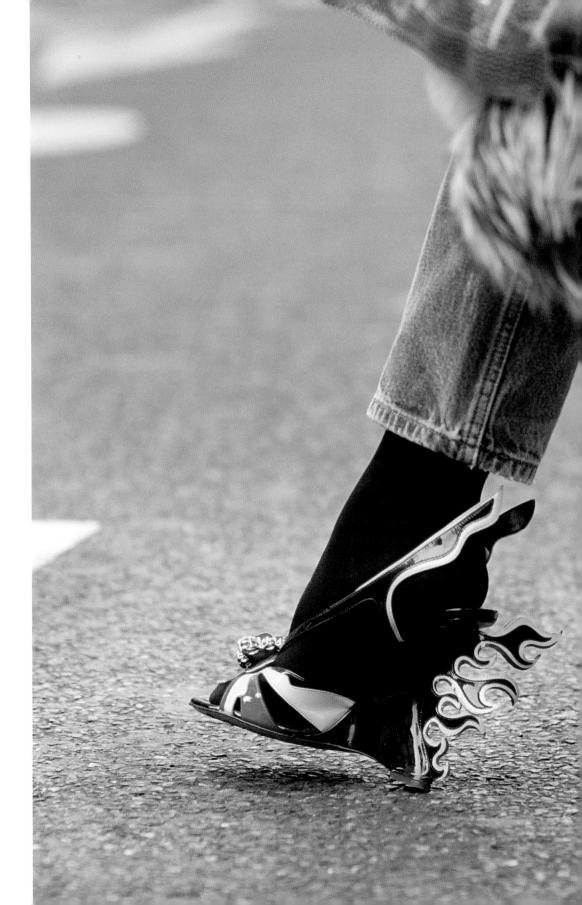

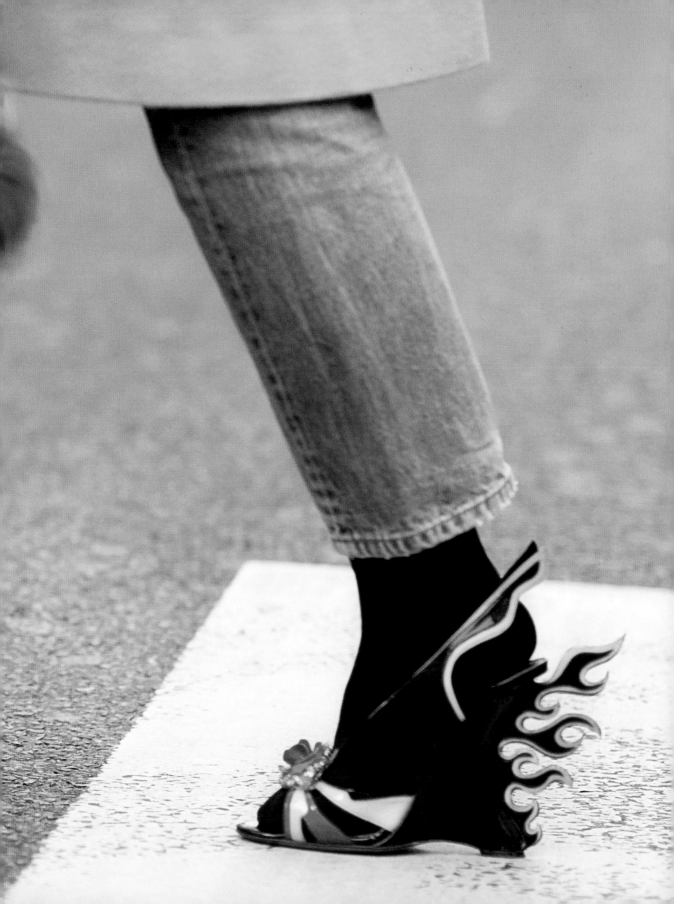

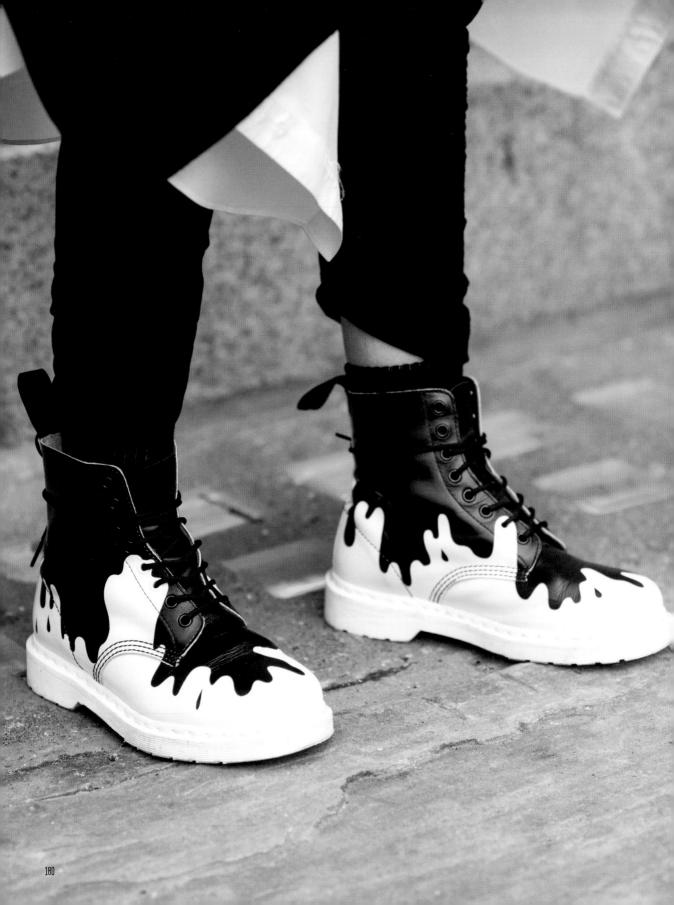

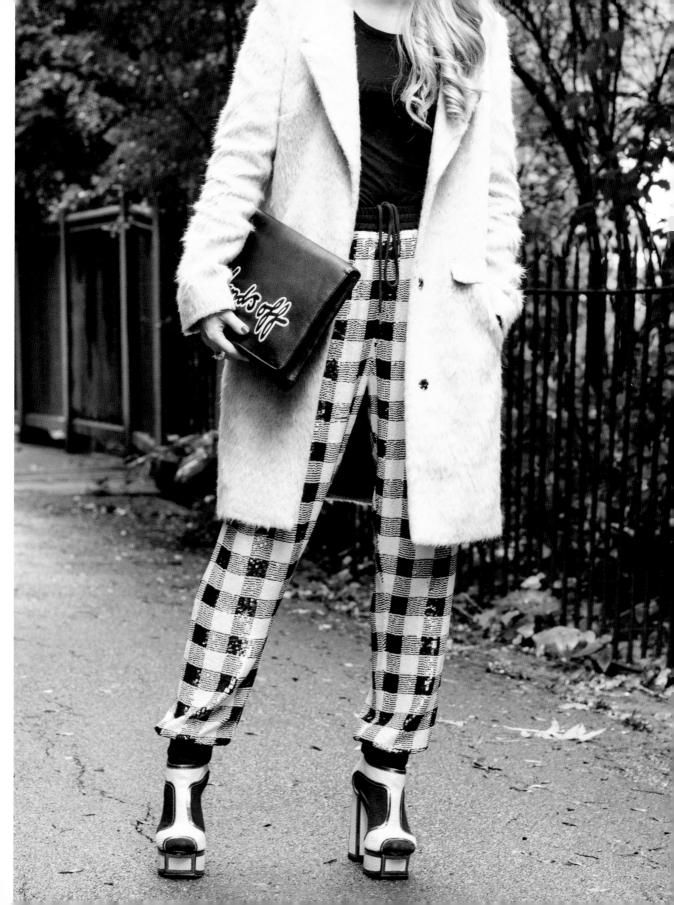

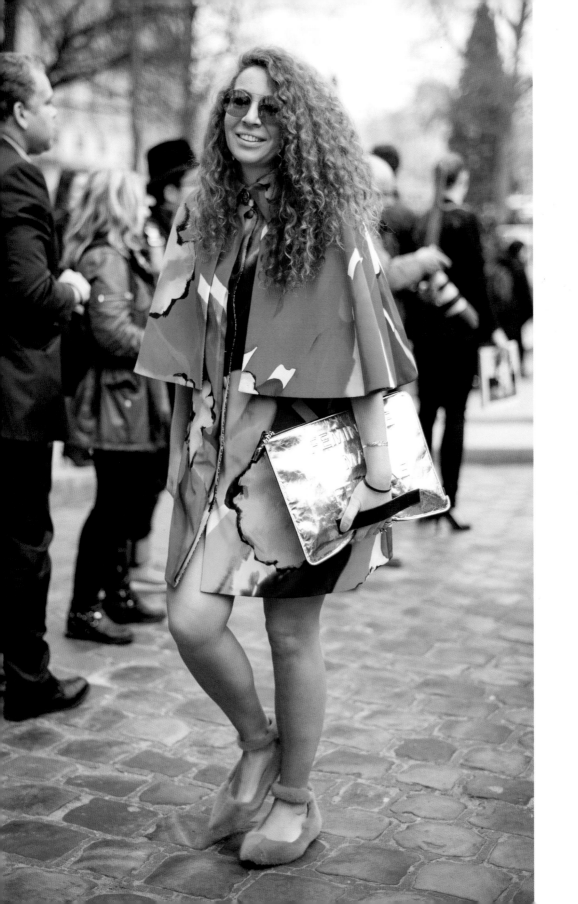

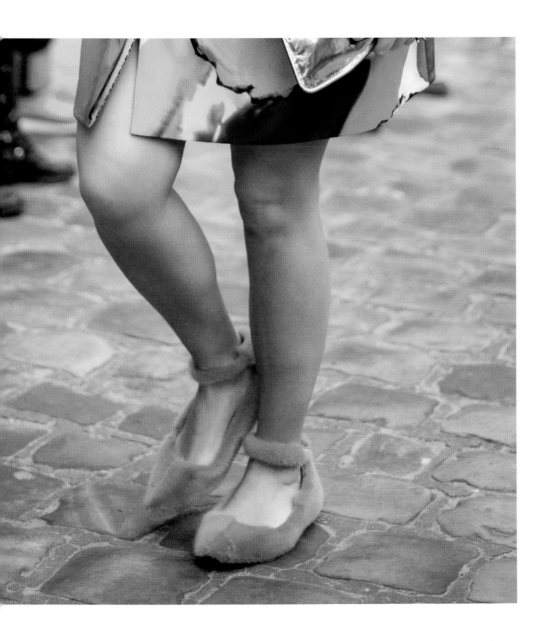

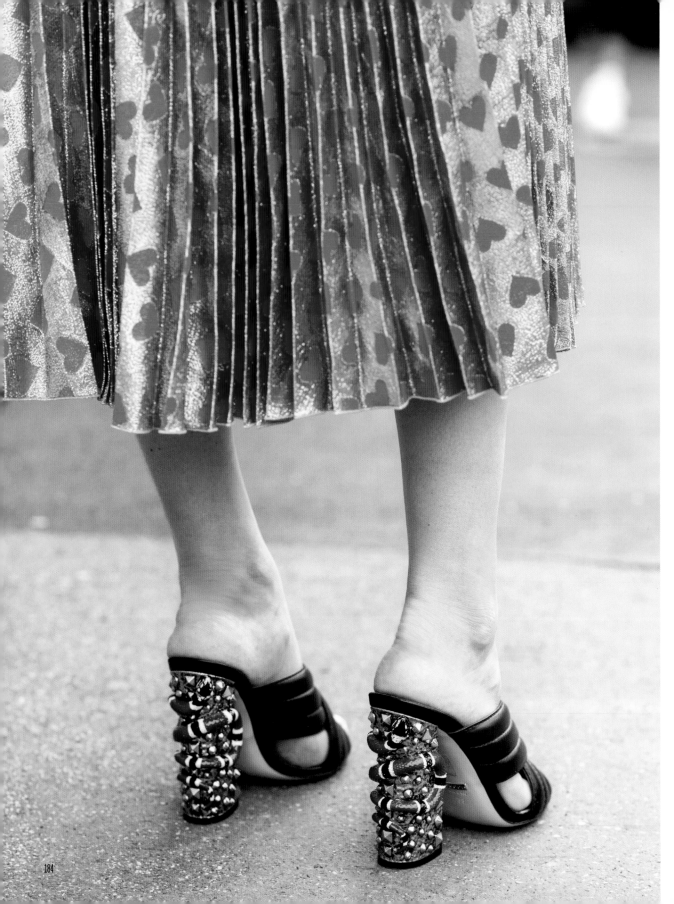

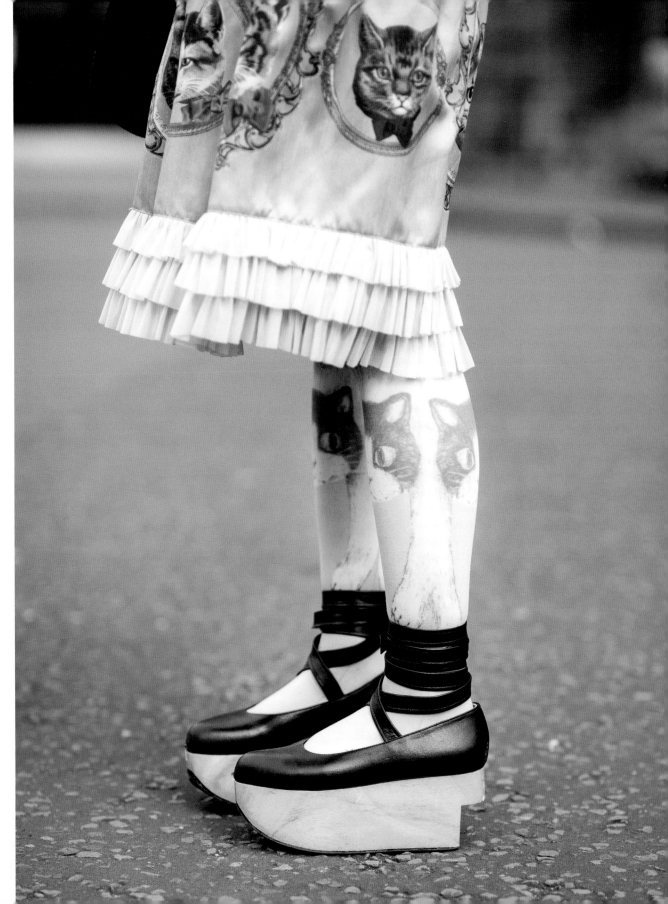

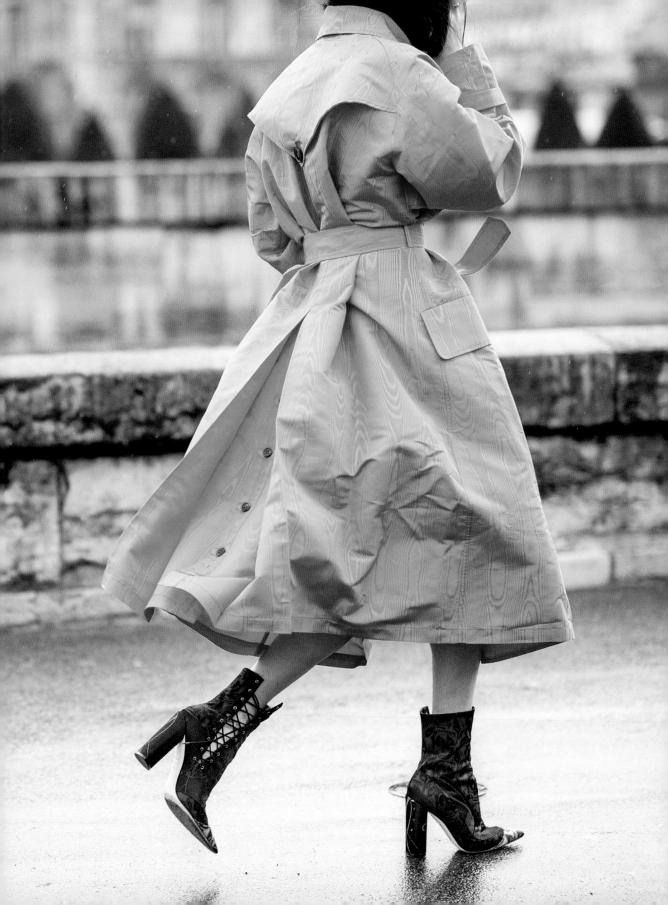

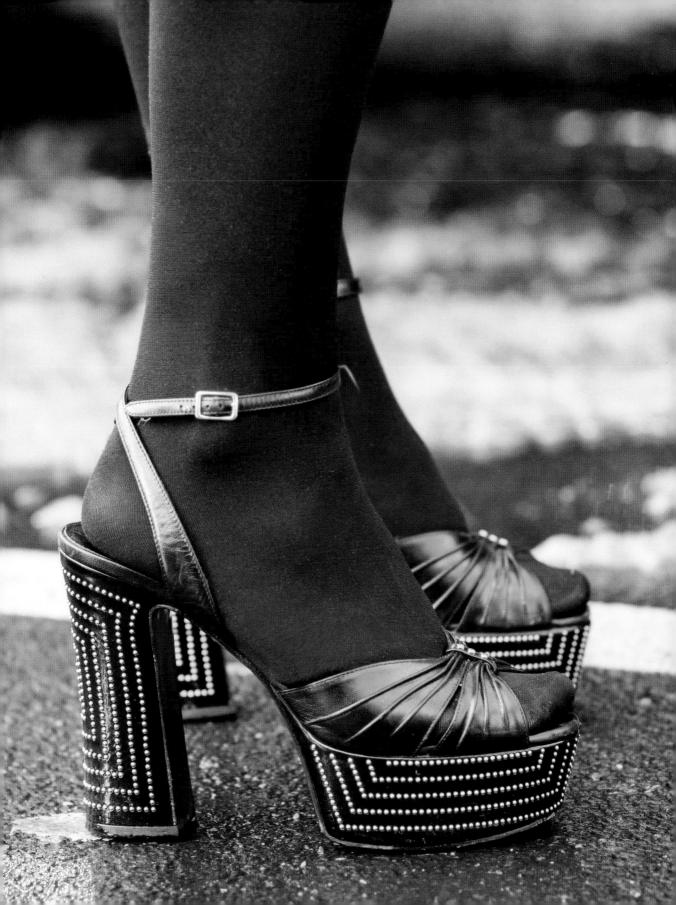

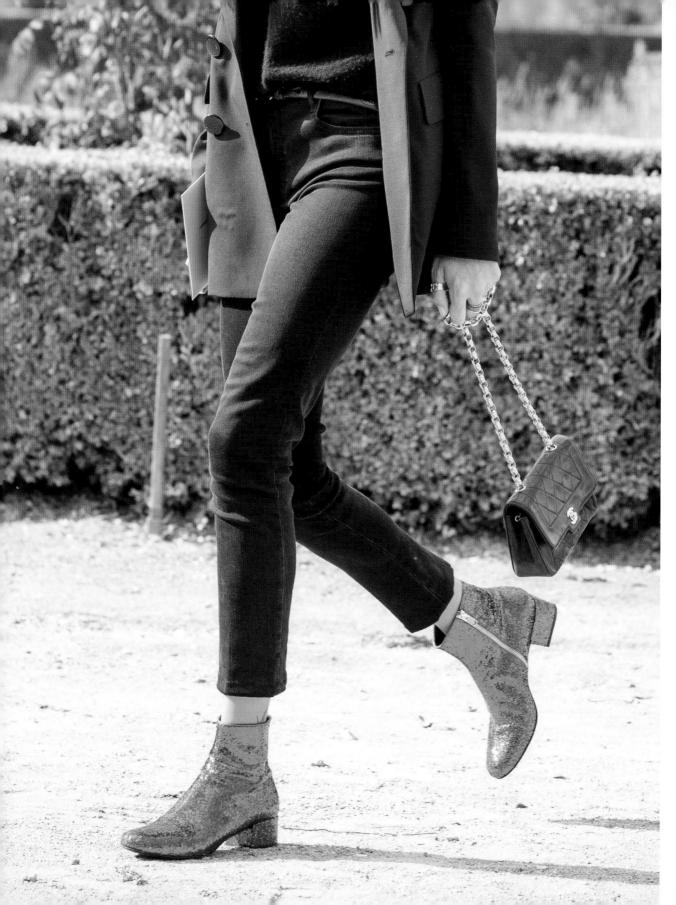

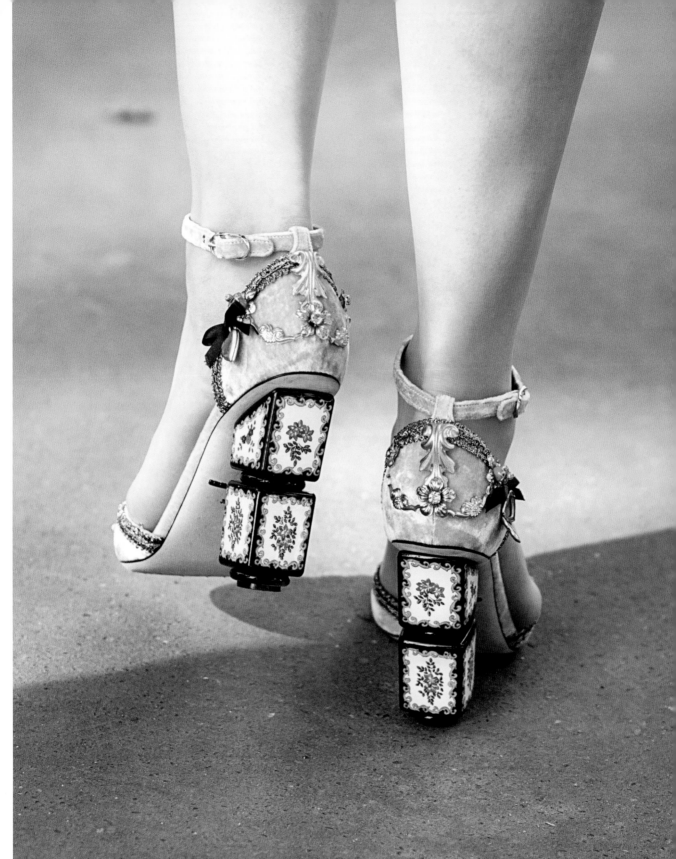

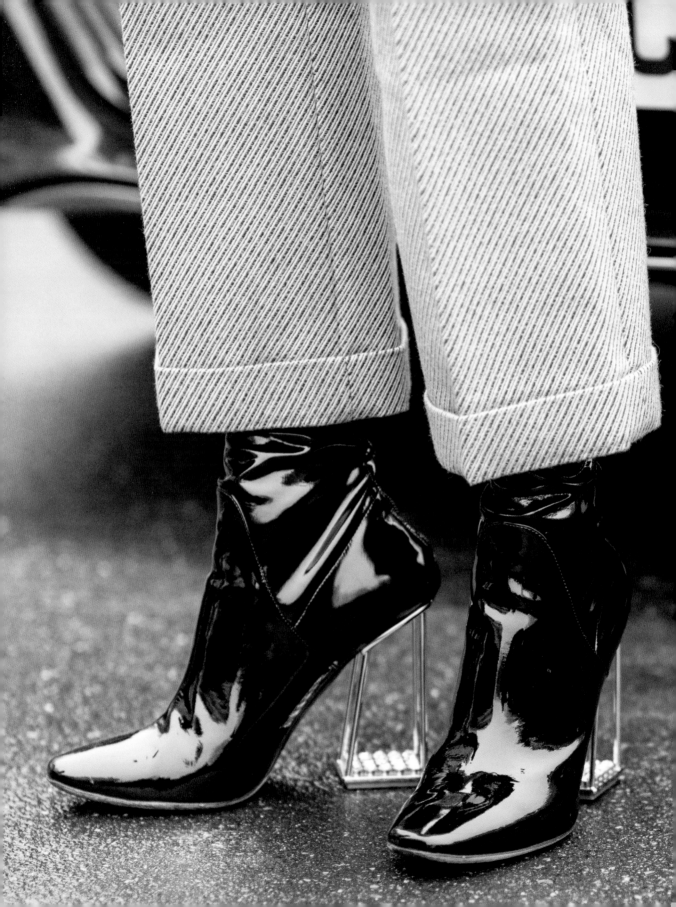

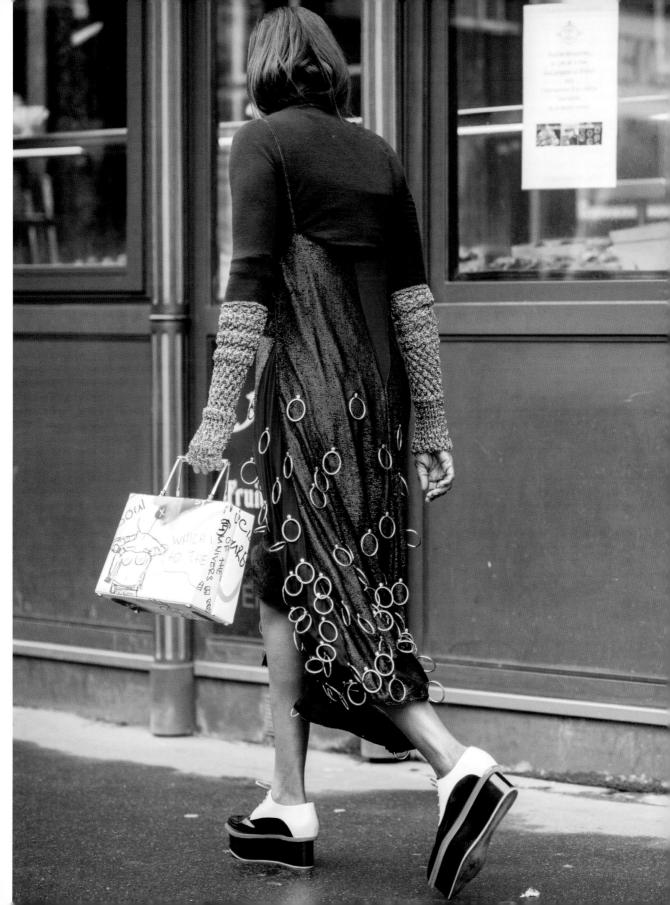

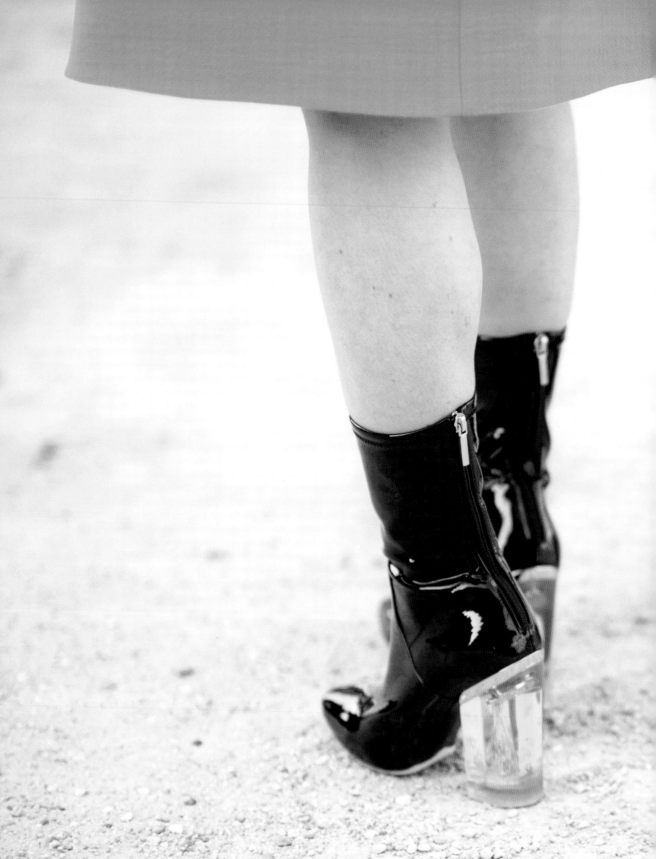

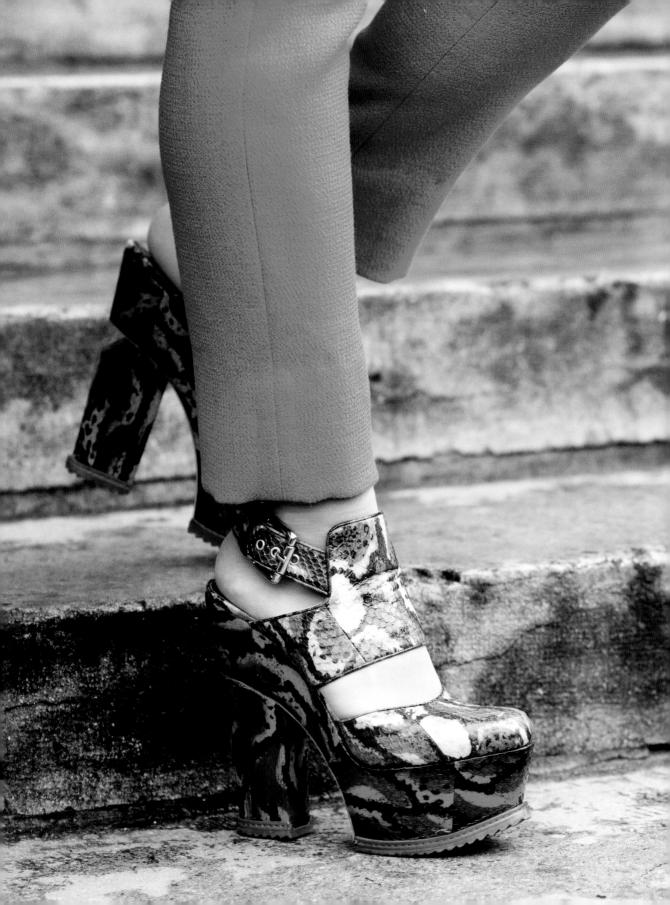

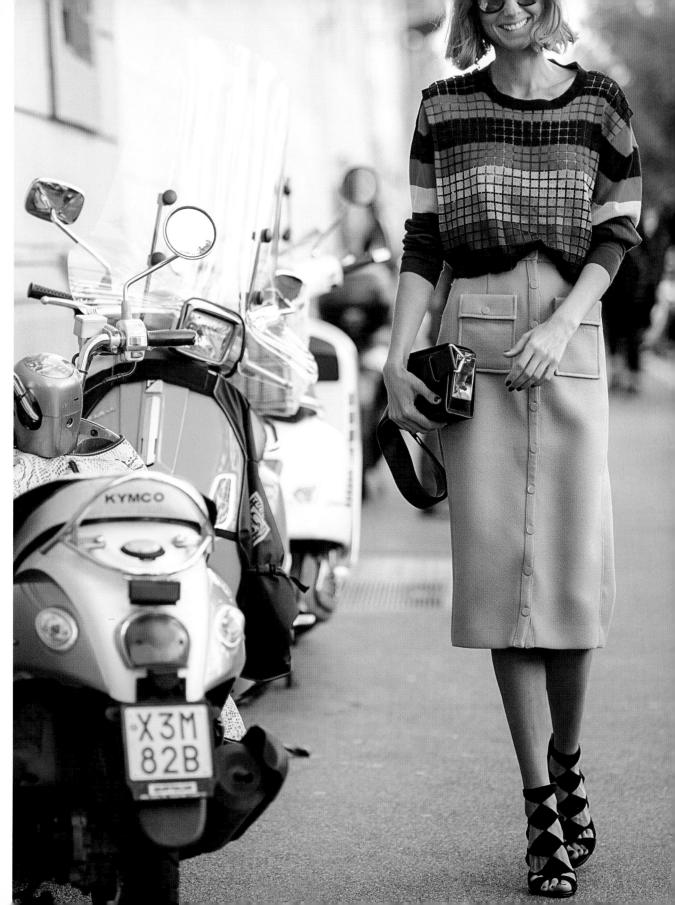

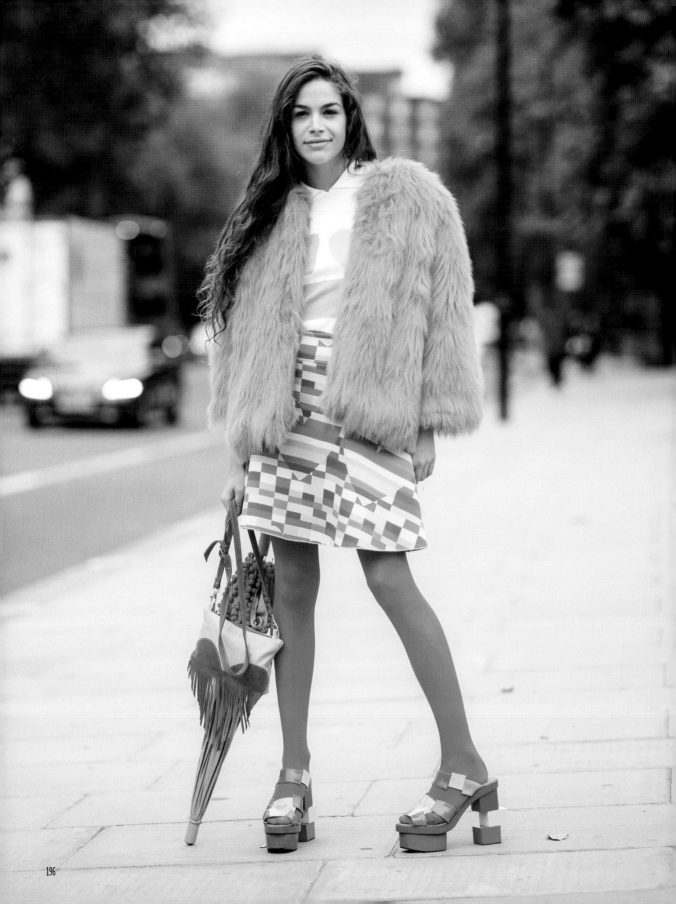

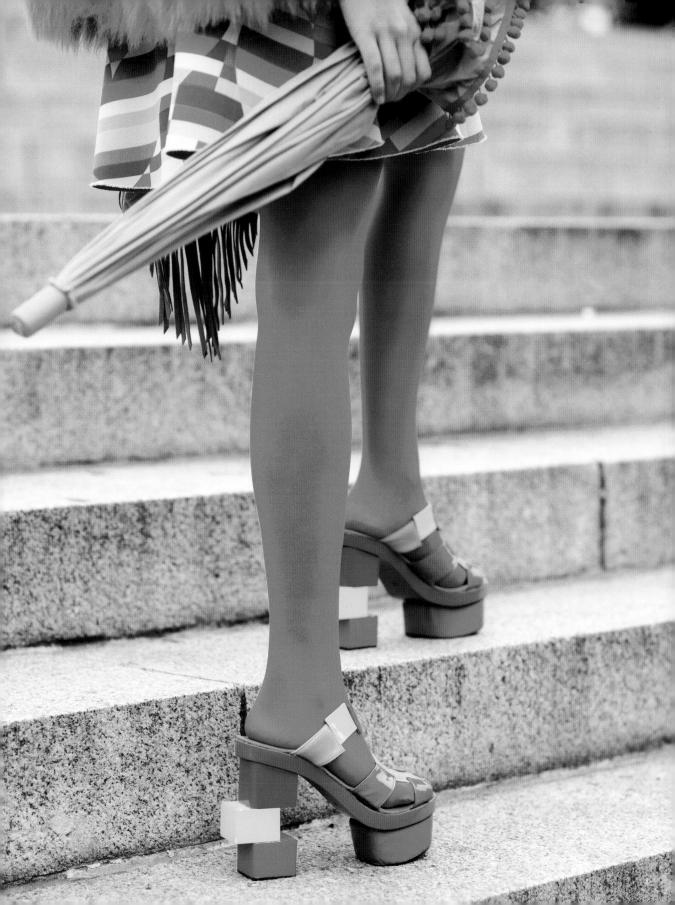

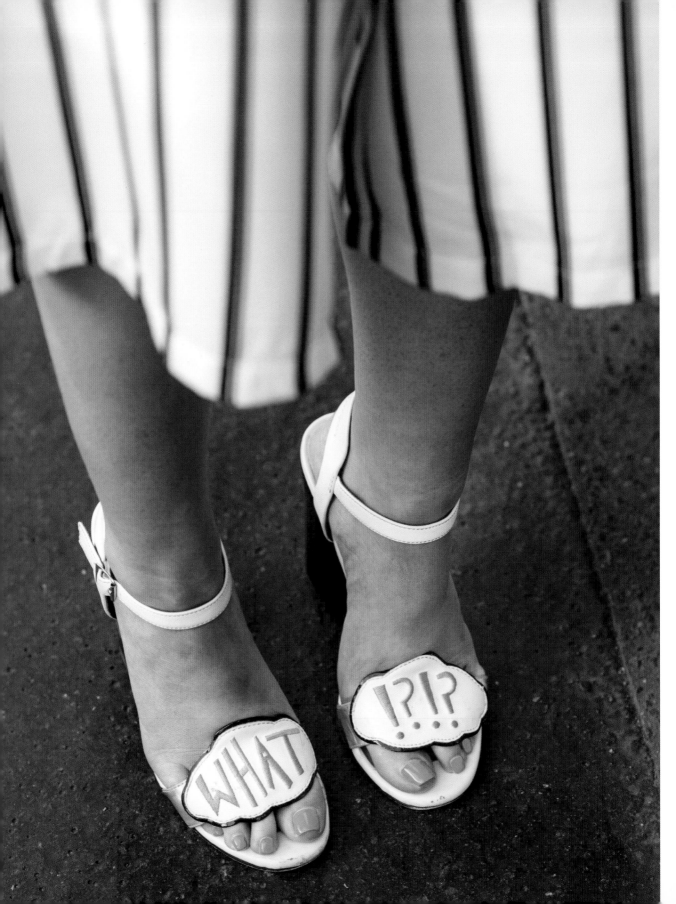

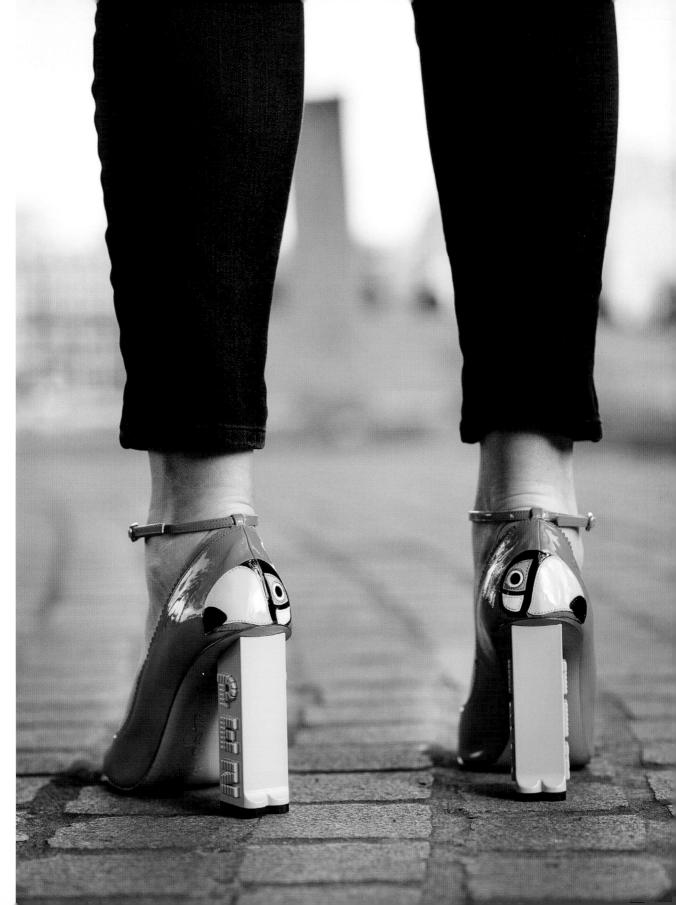

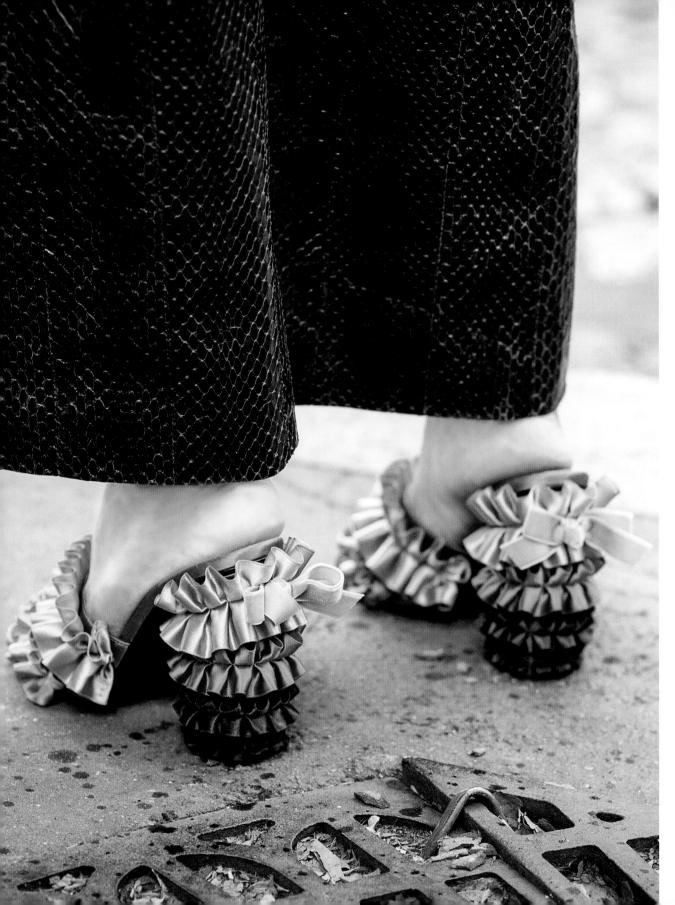

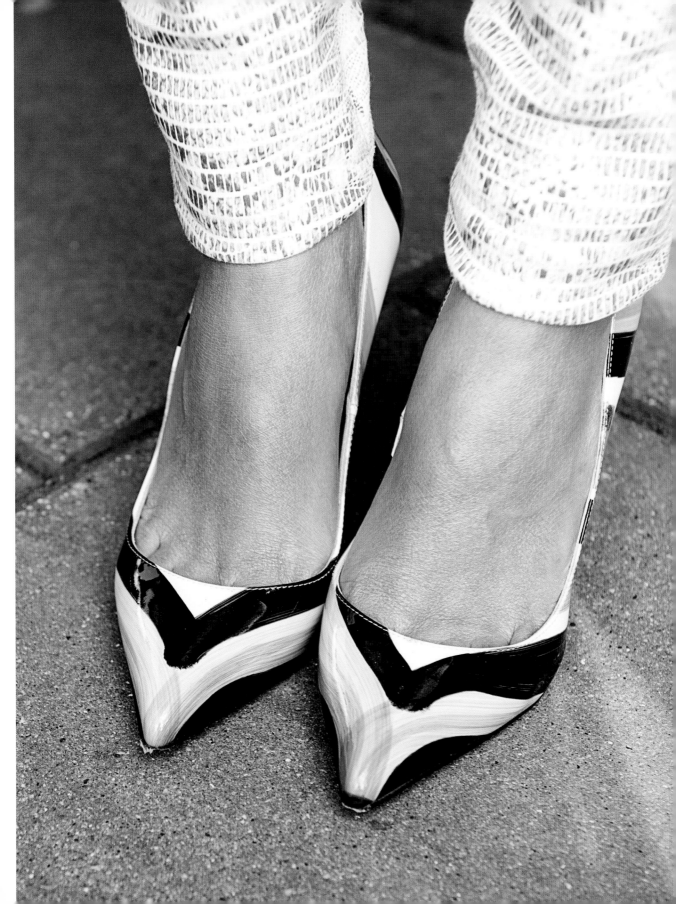

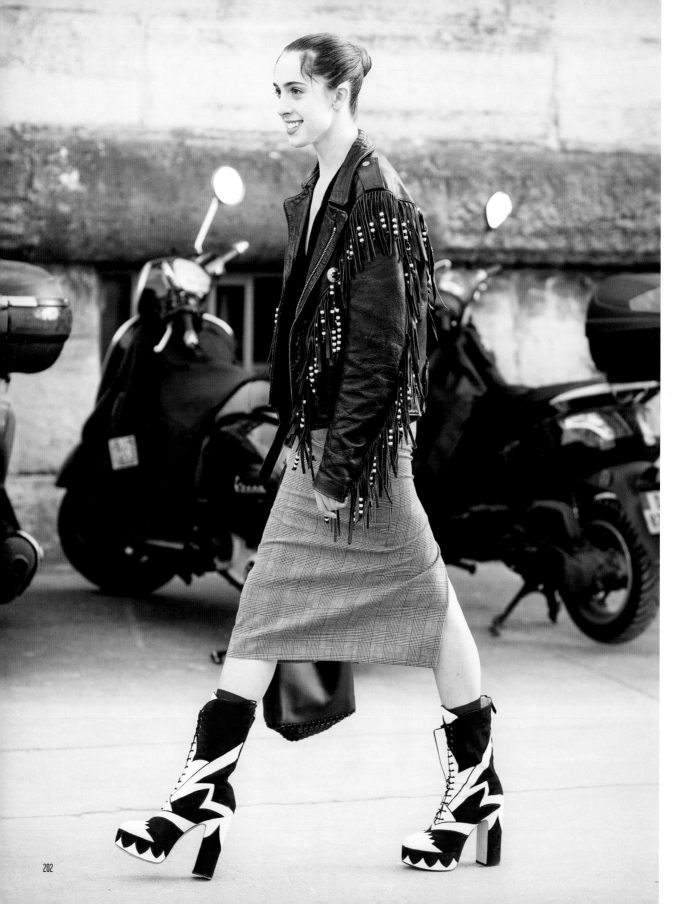

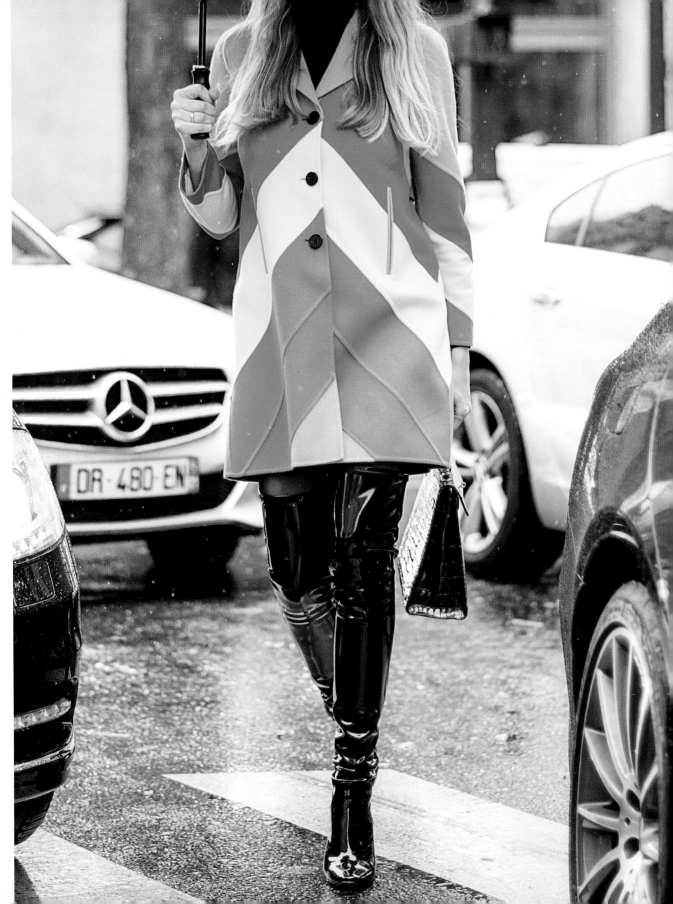

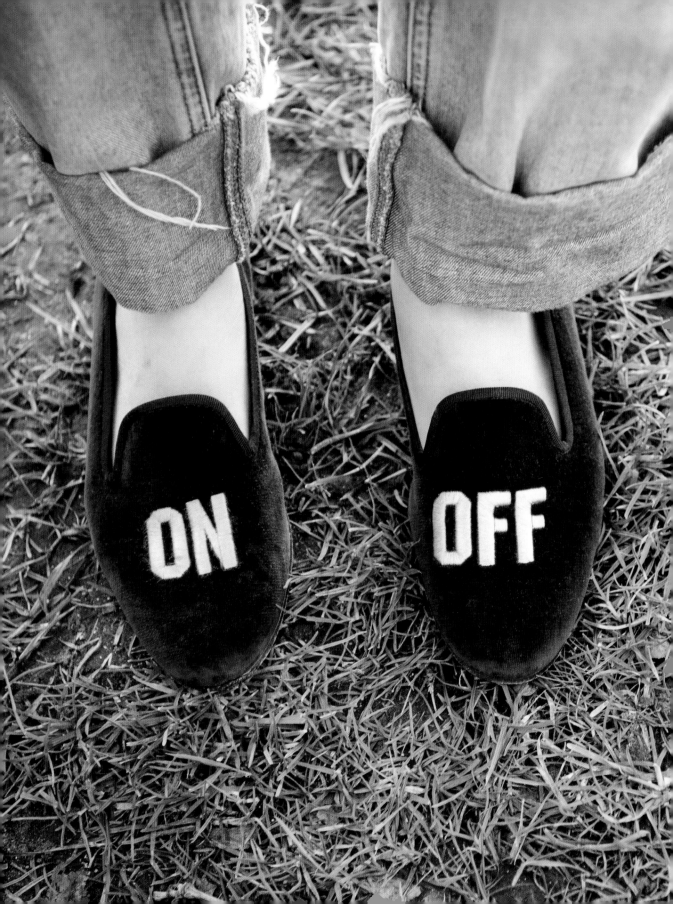

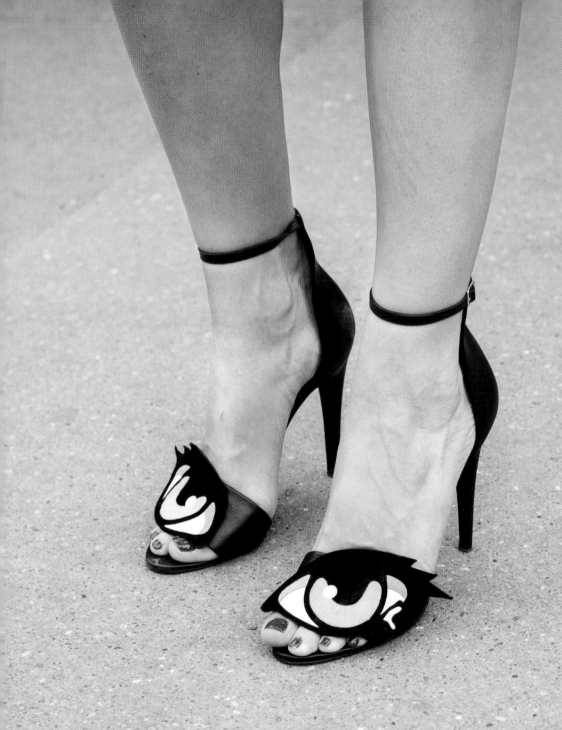

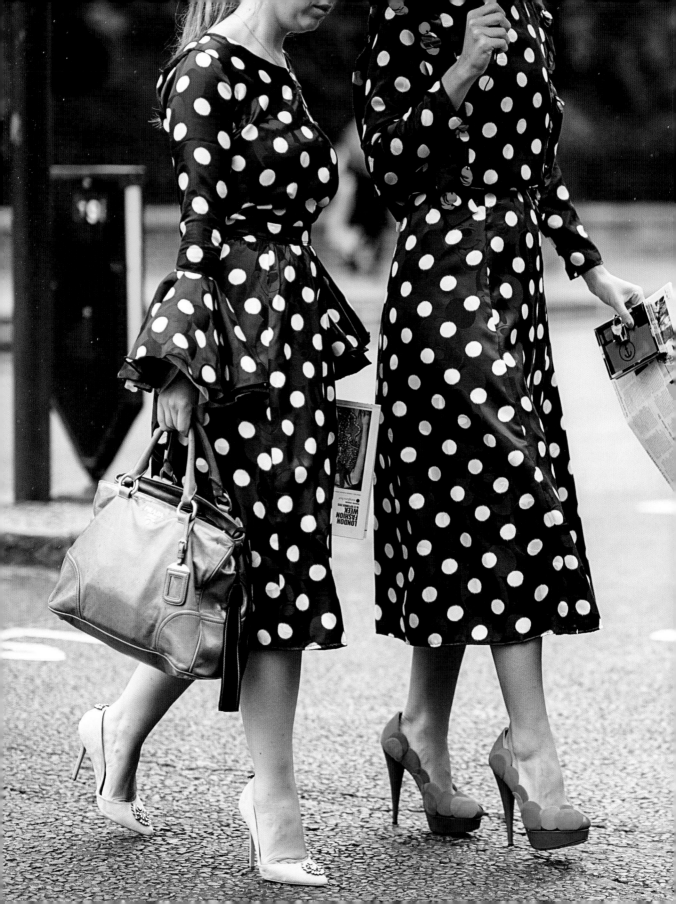

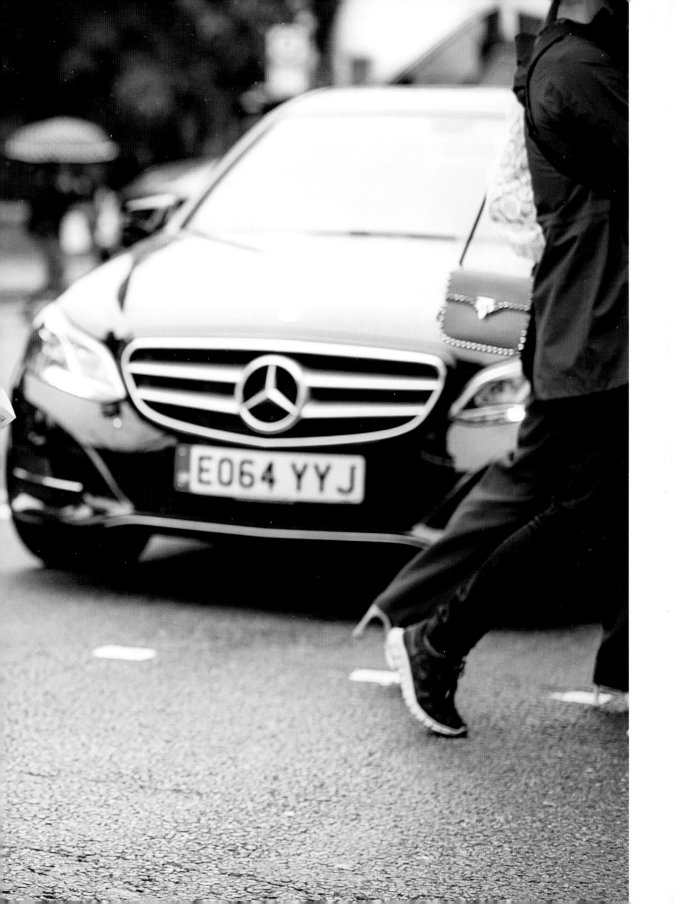

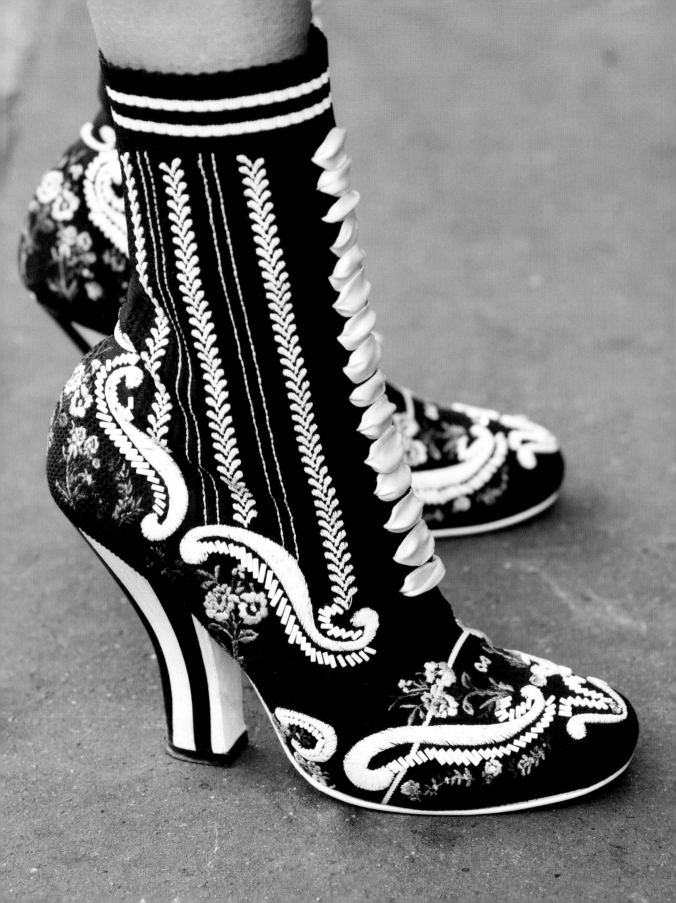

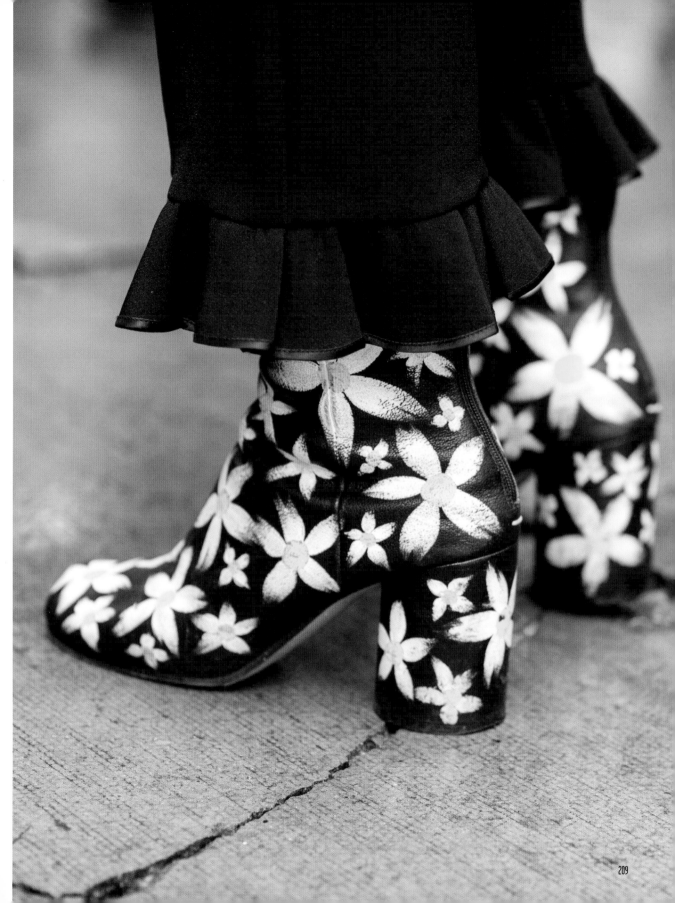

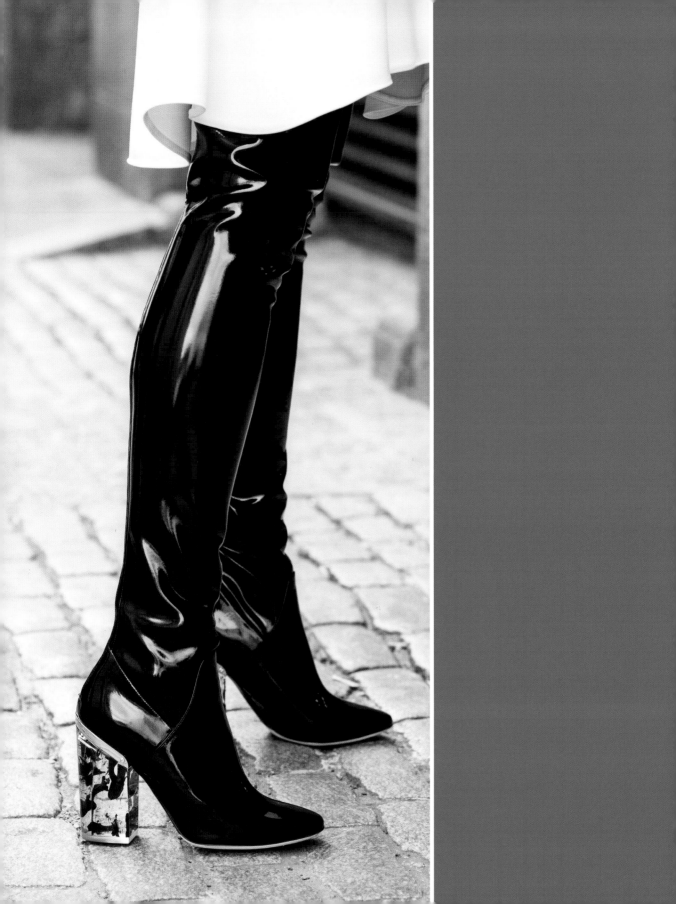

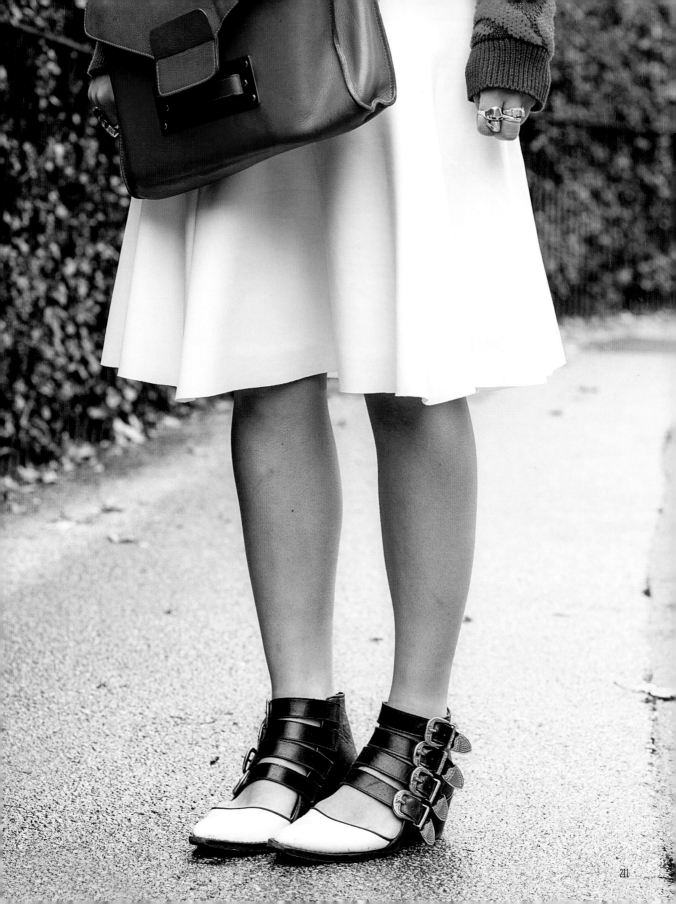

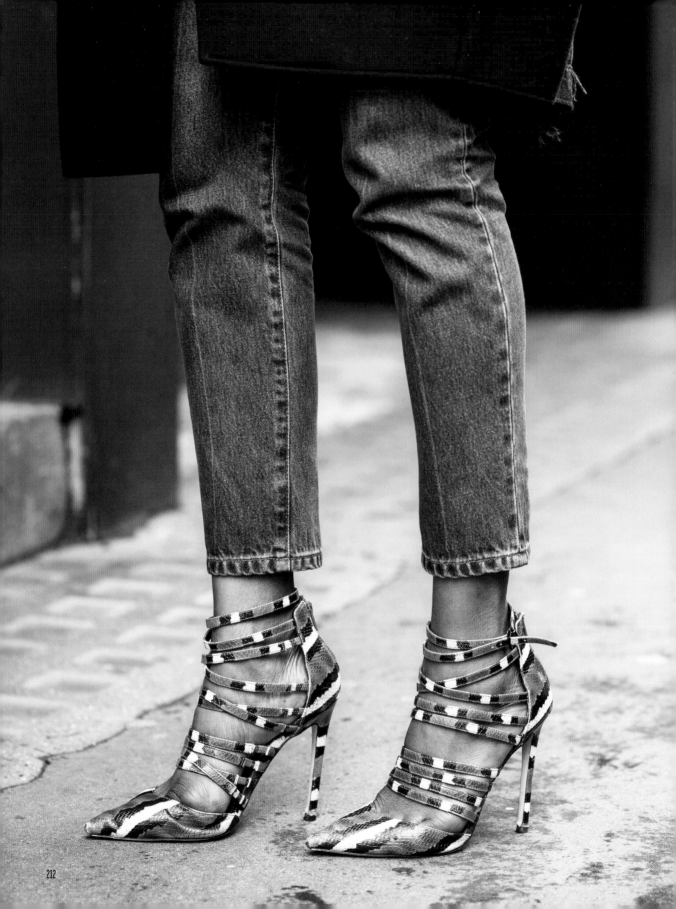

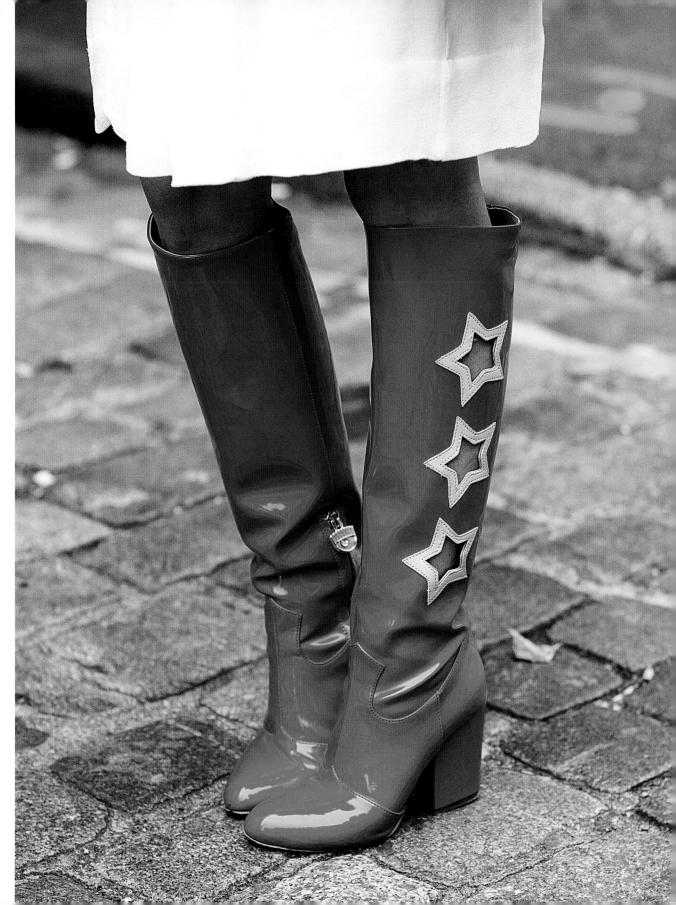

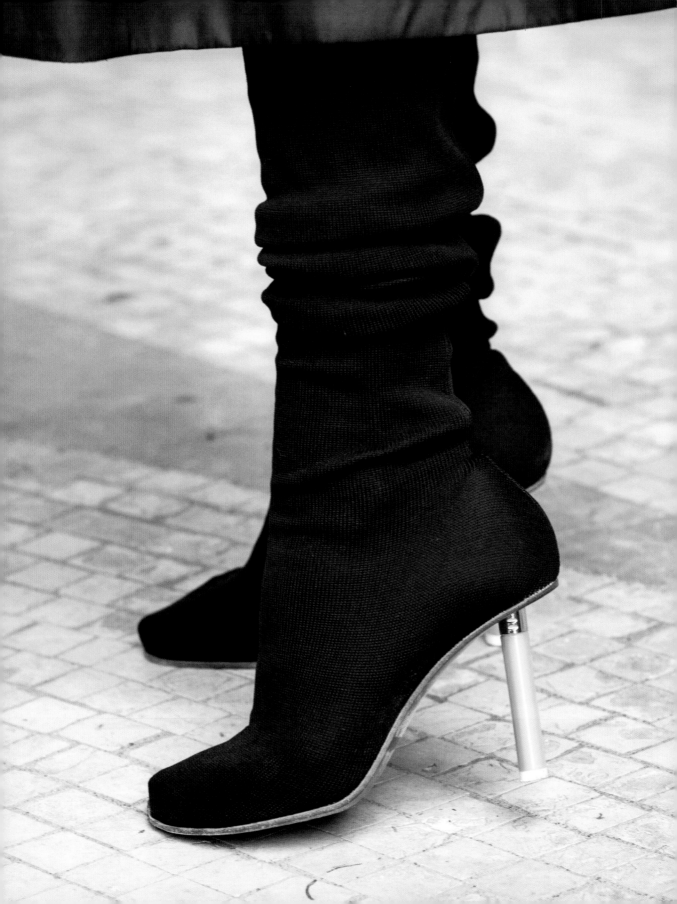

"YOU CAN NEVER TAKE TOO MUCH CARE OVER THE CHOICE OF YOUR SHOES...THE REAL PROOF OF AN ELEGANT WOMAN IS WHAT IS ON HER FEET."

- Christian Dior

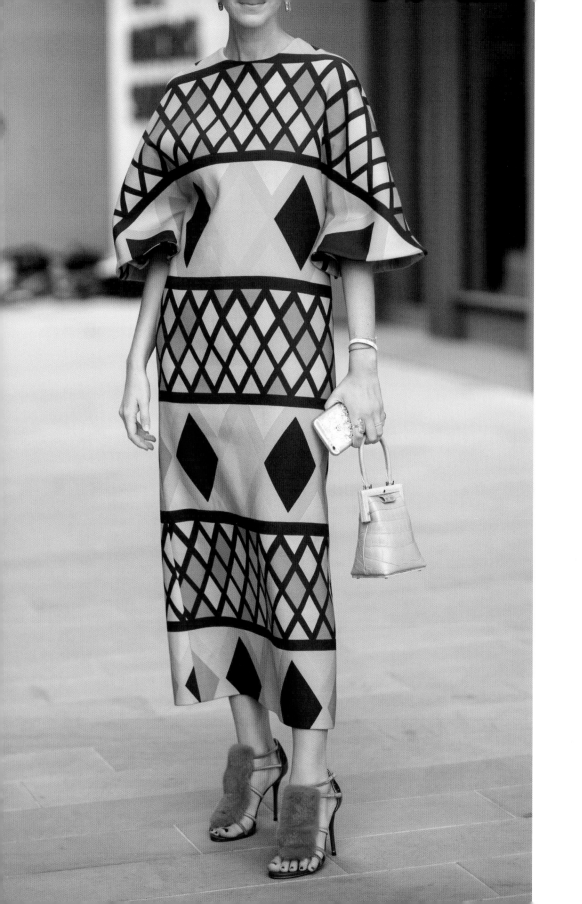

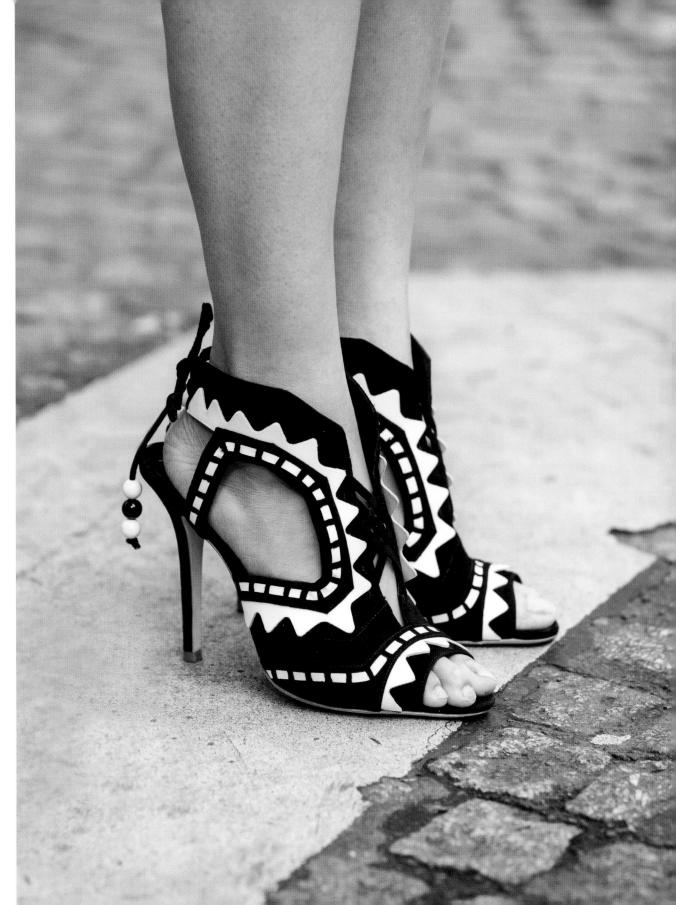

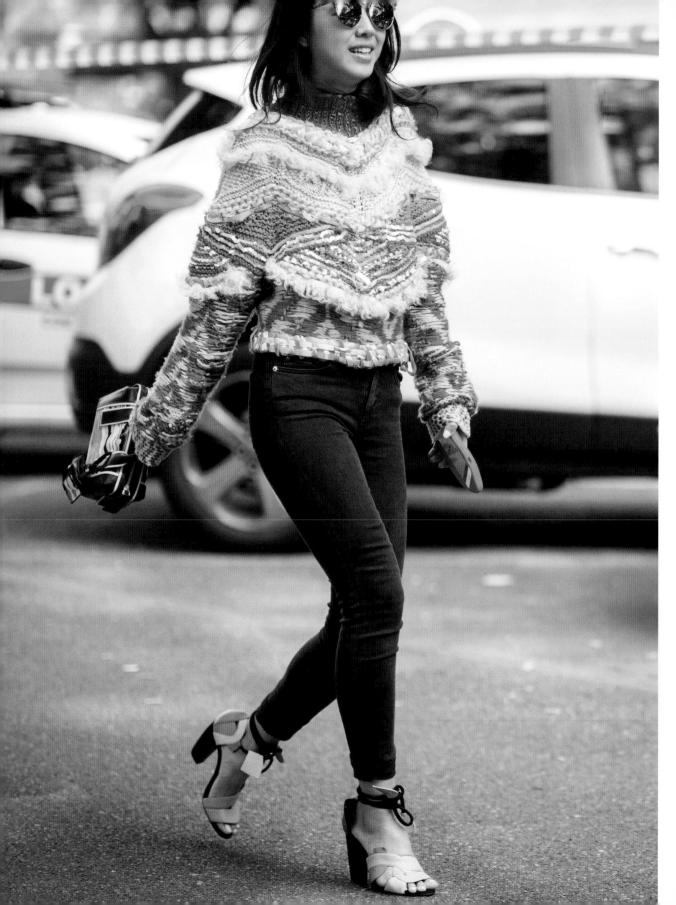

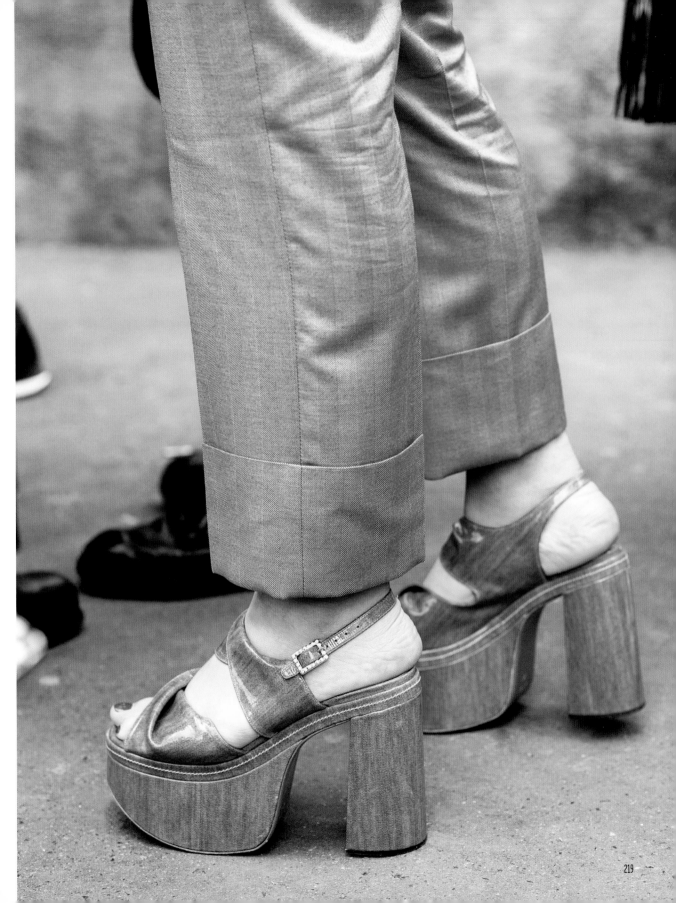

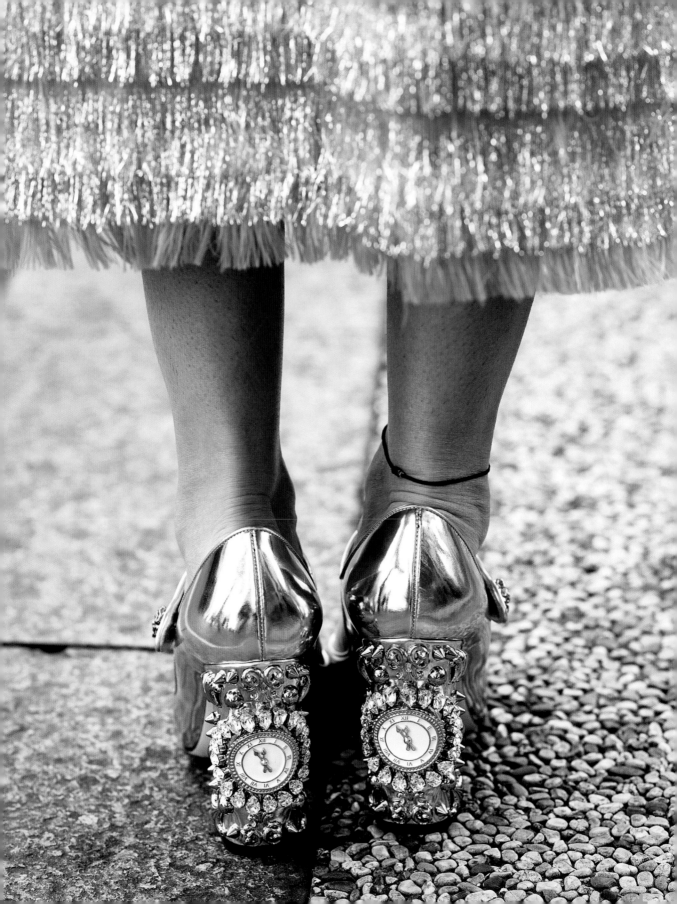

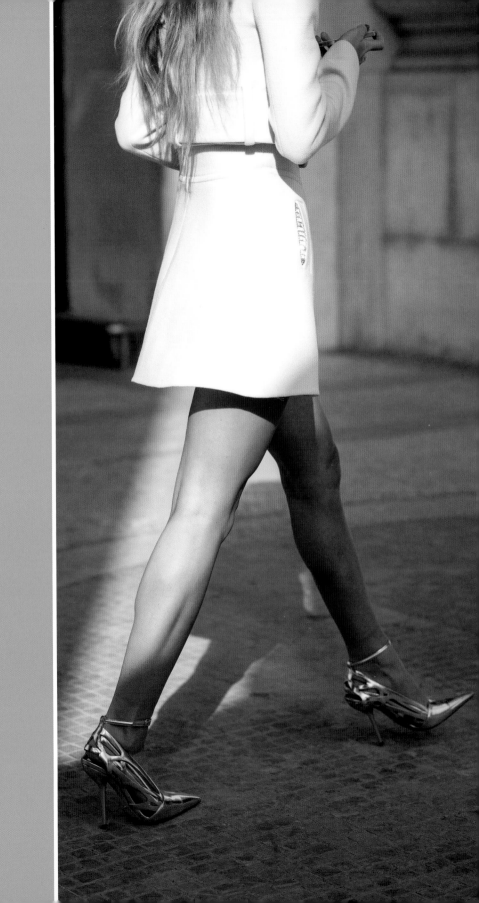

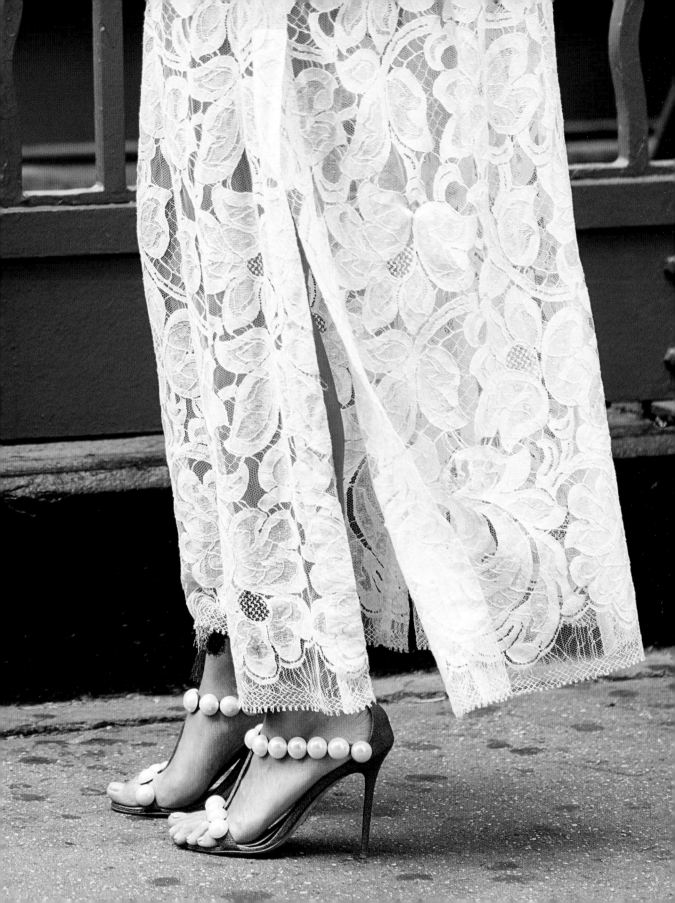

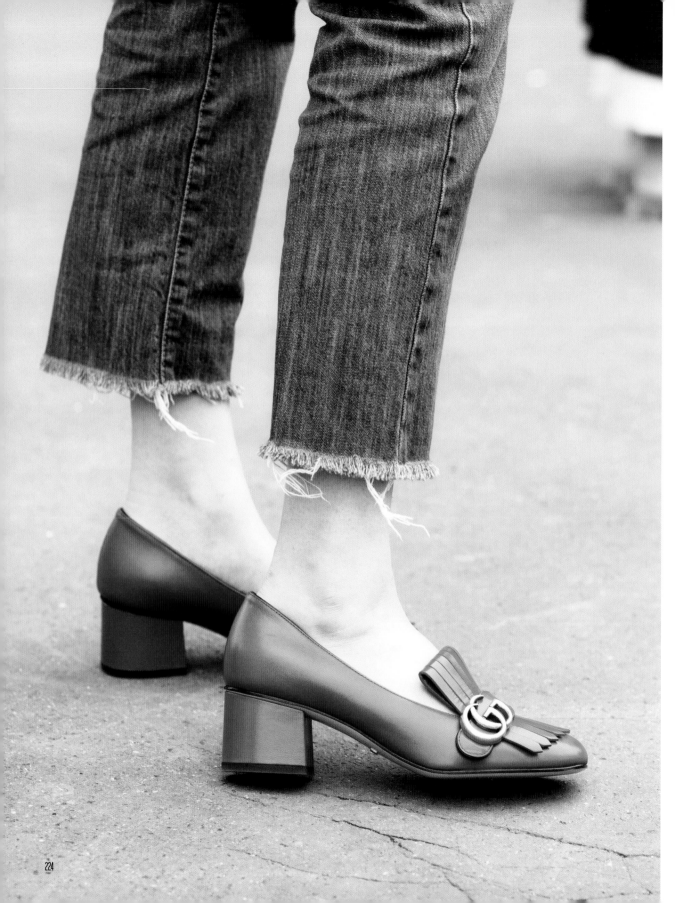

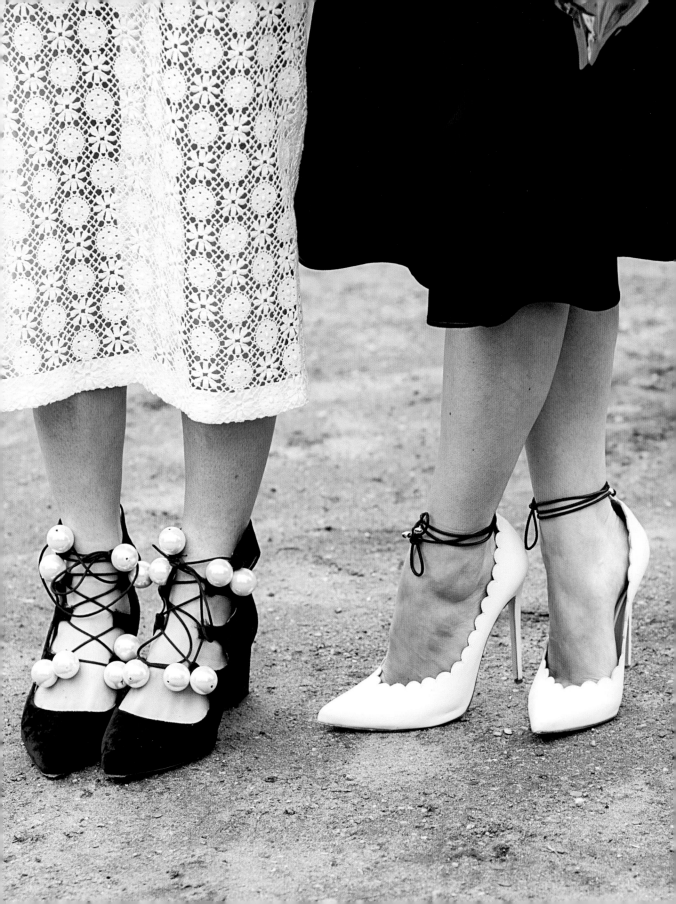

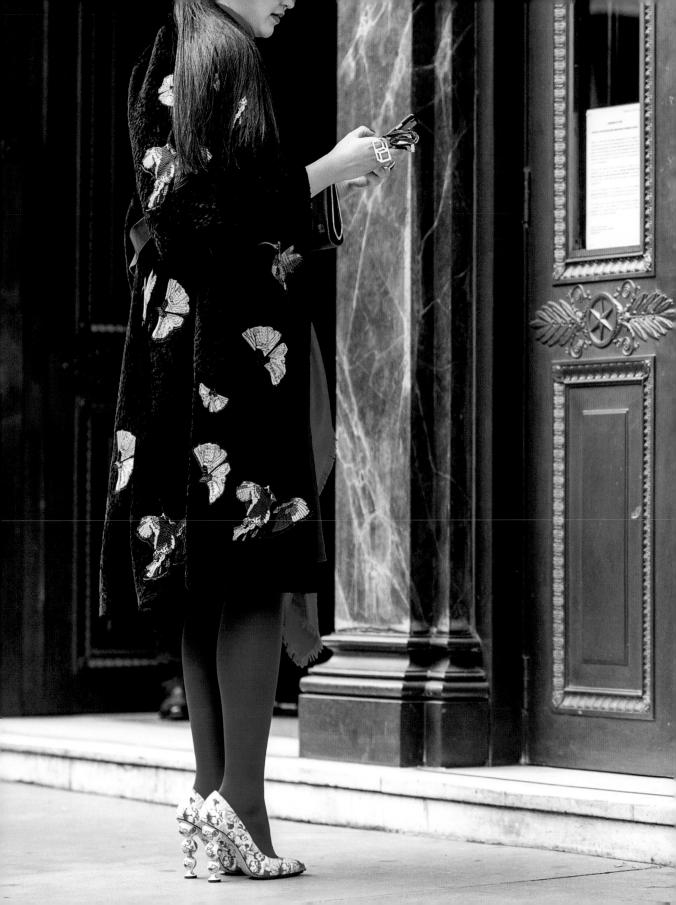

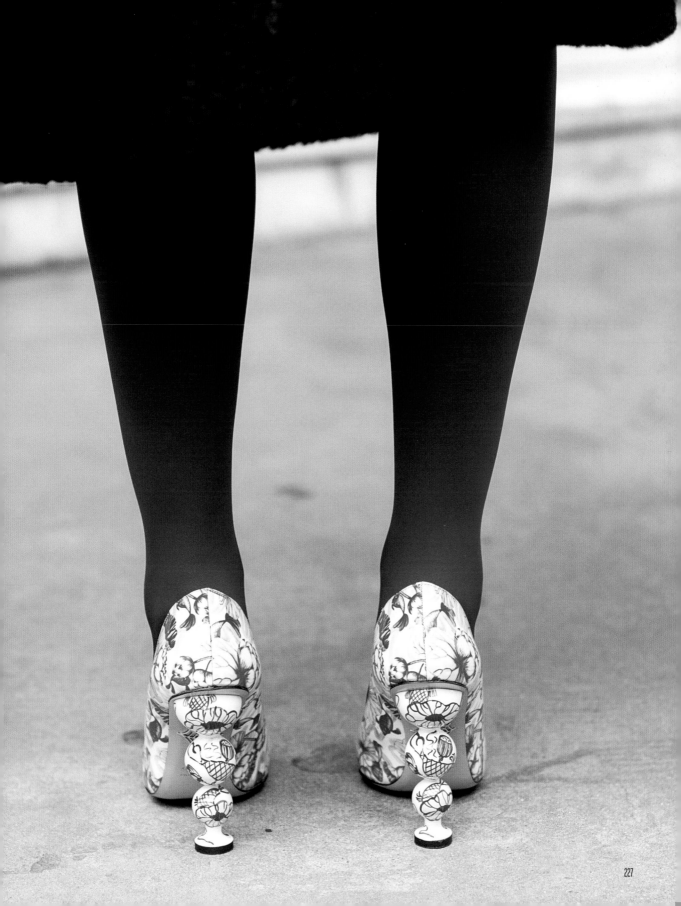

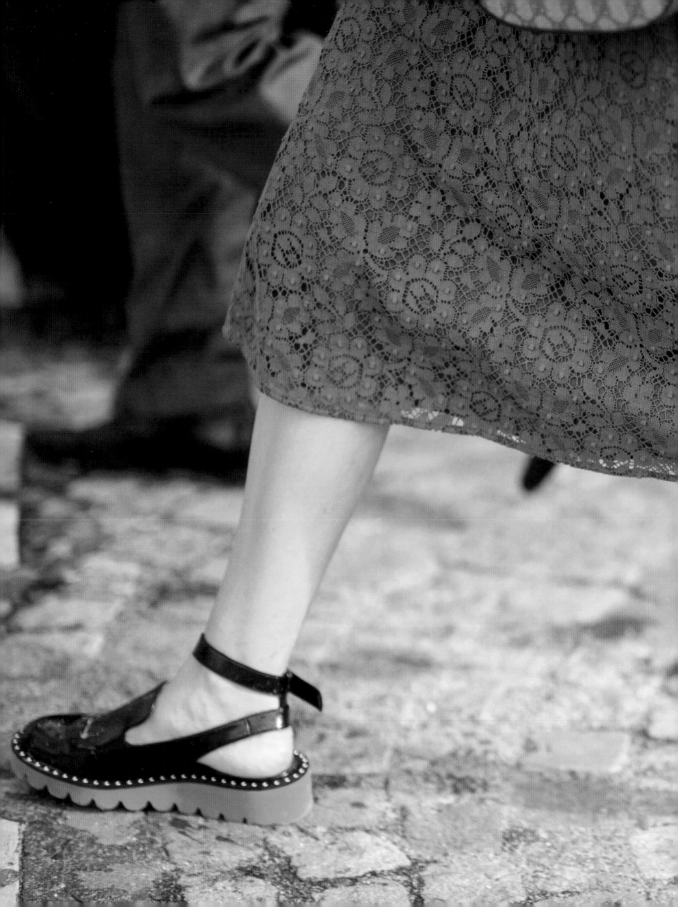

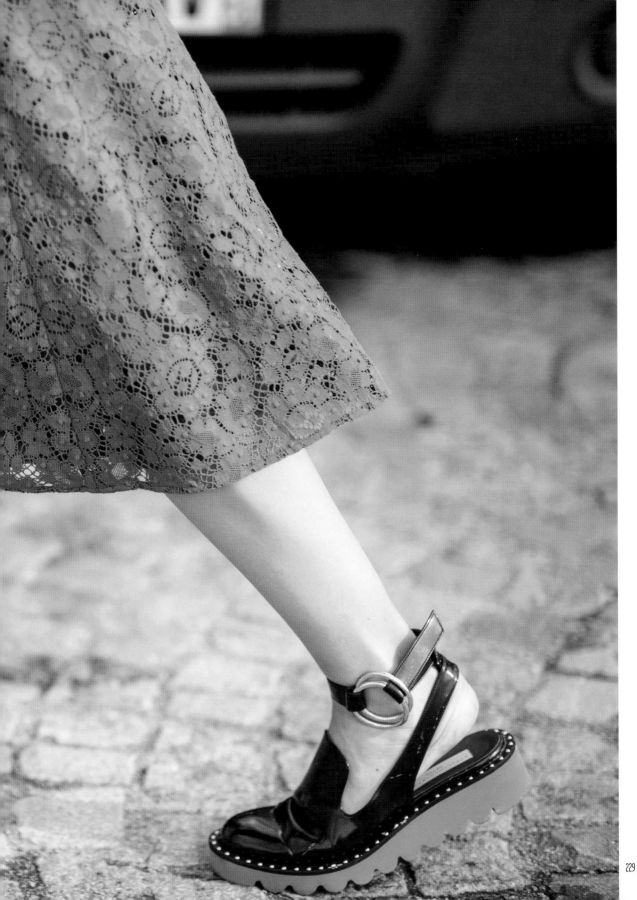

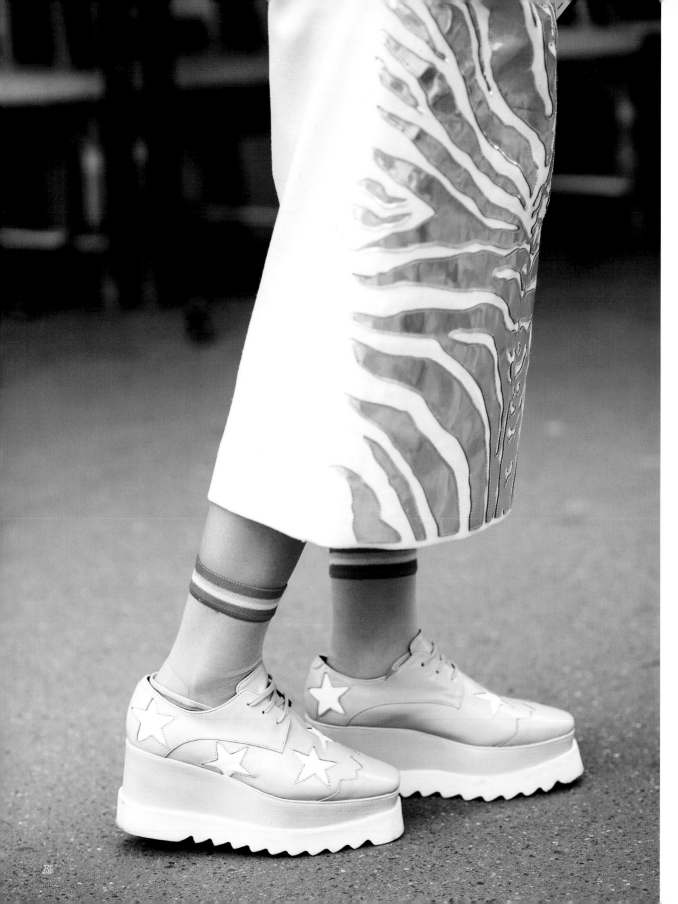

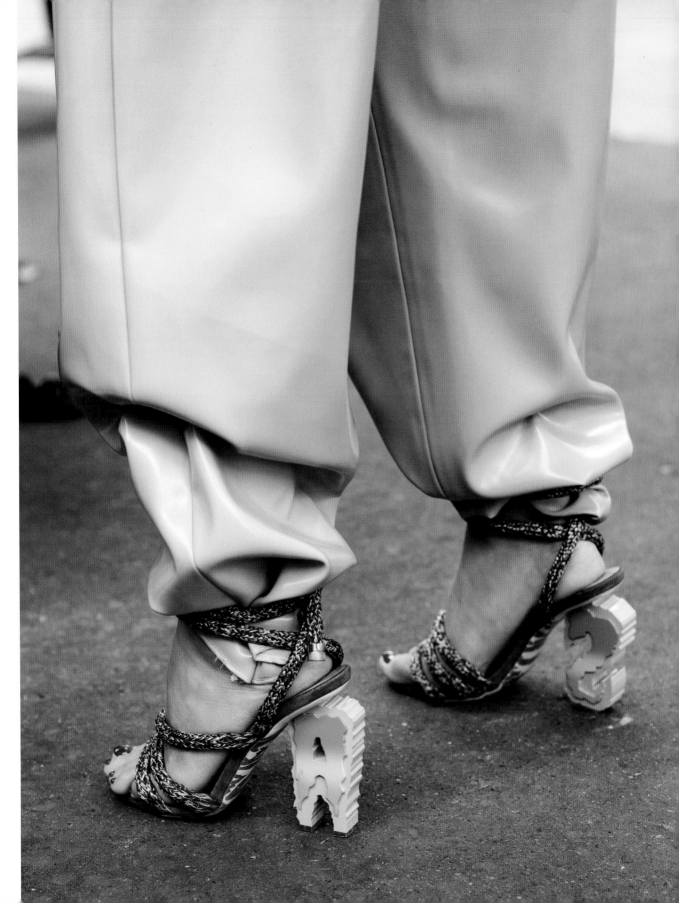

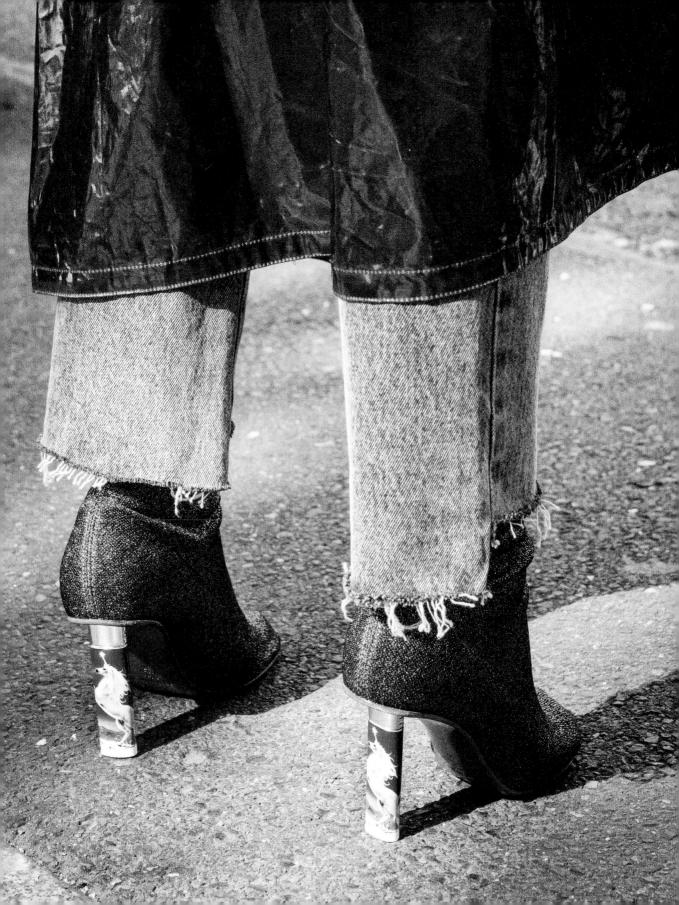

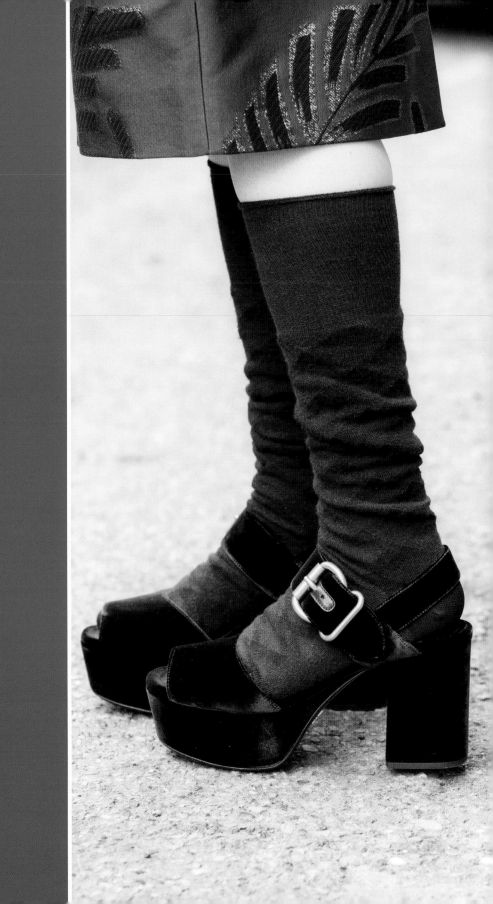

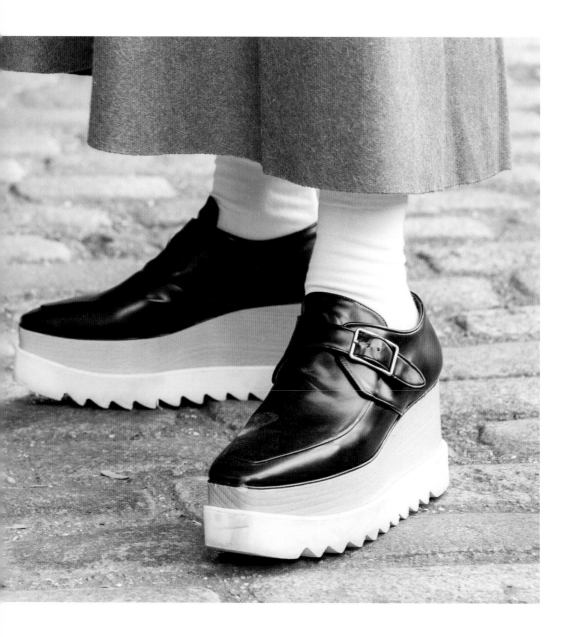

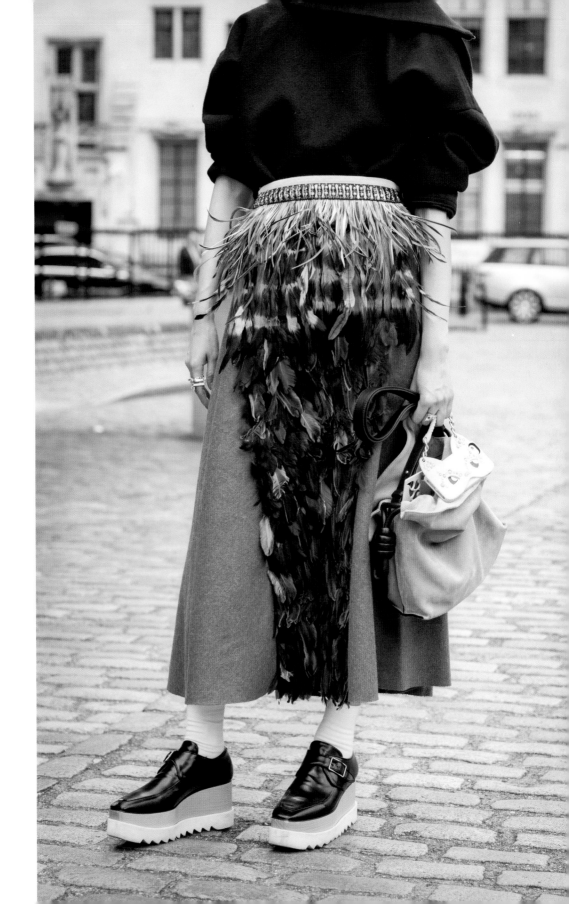

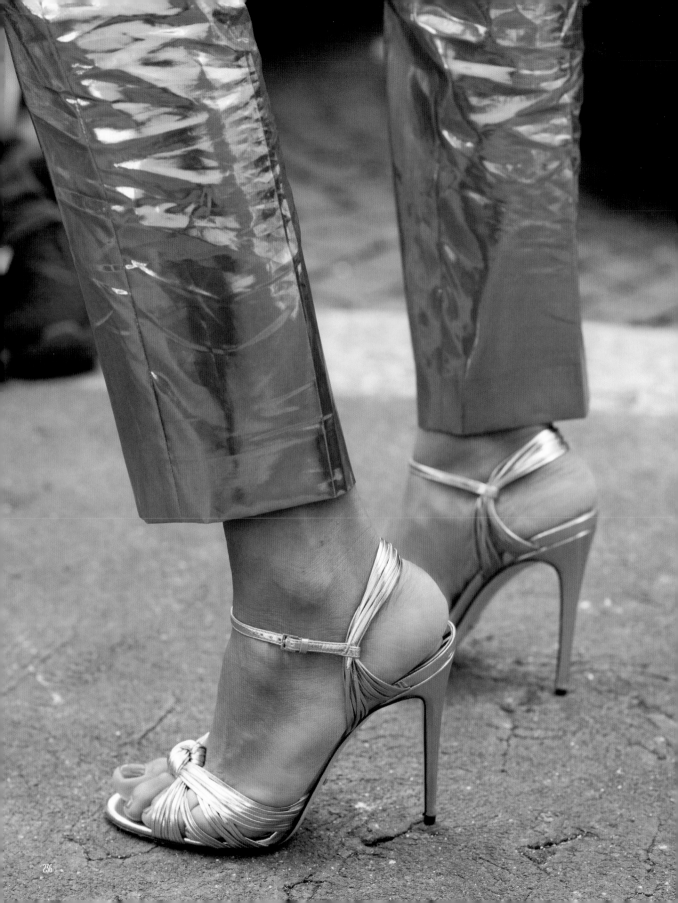

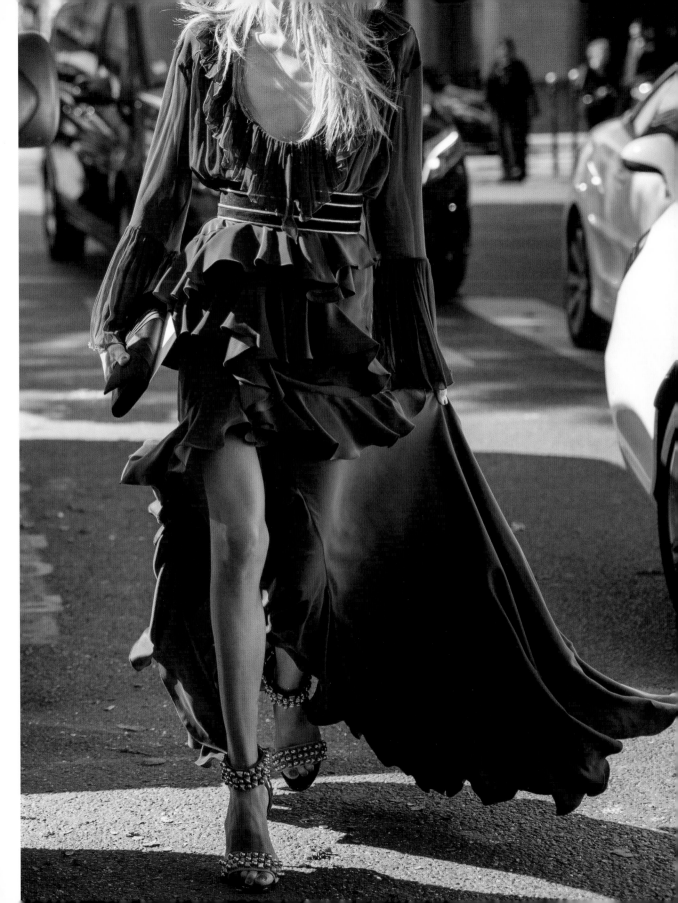

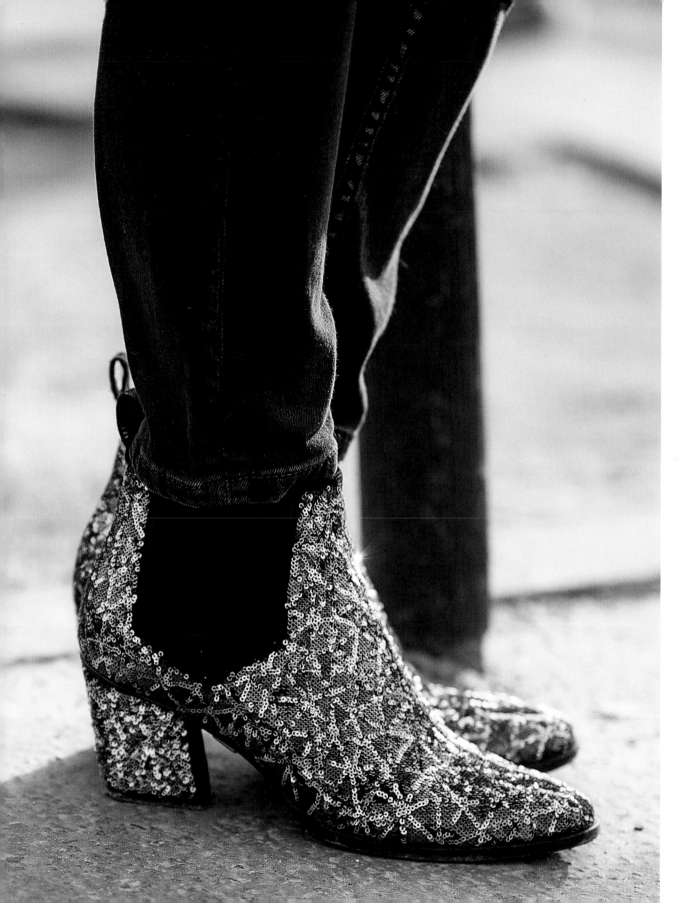

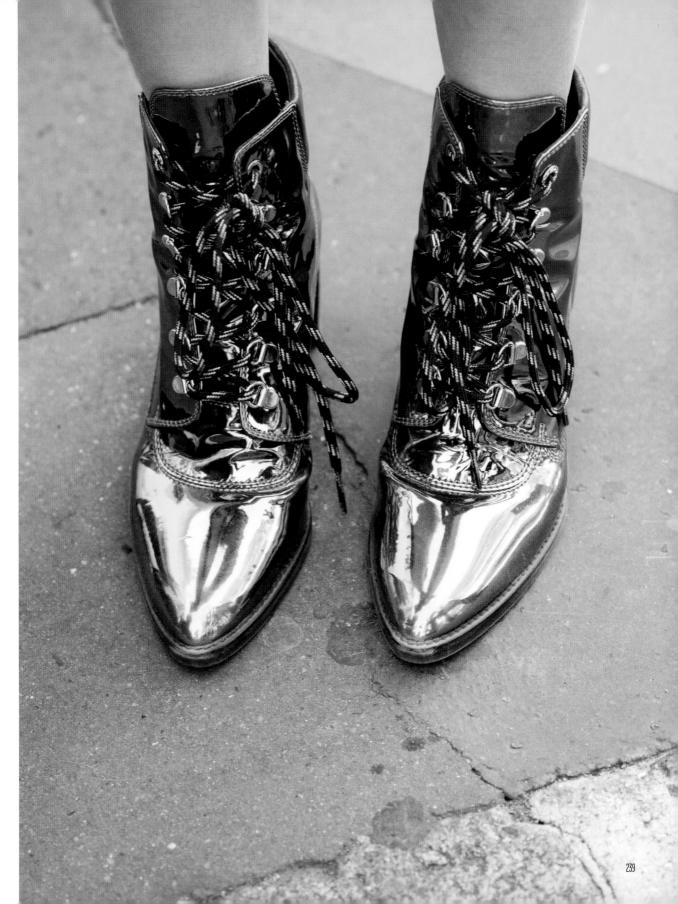

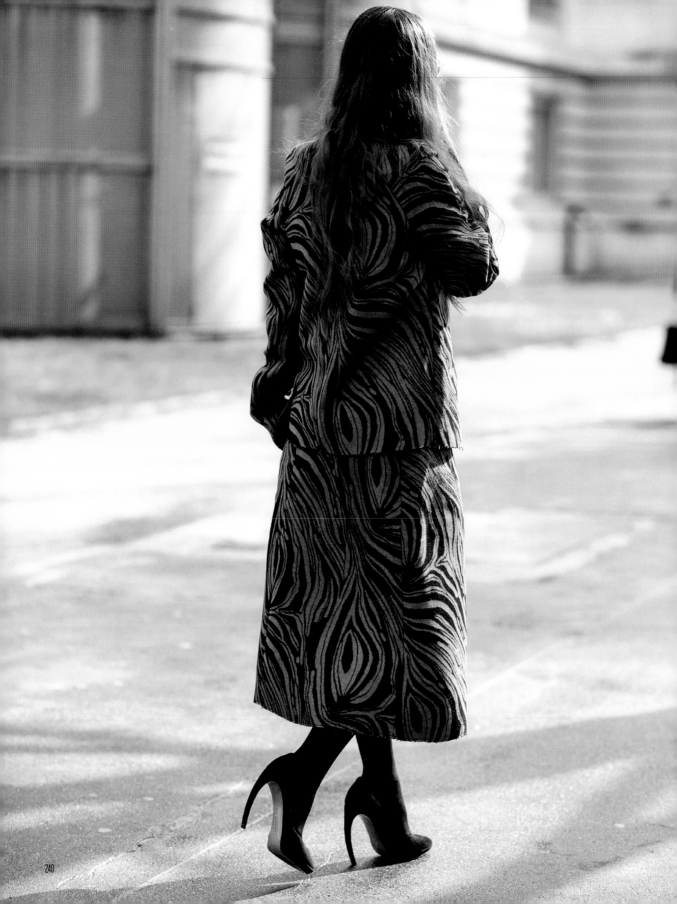

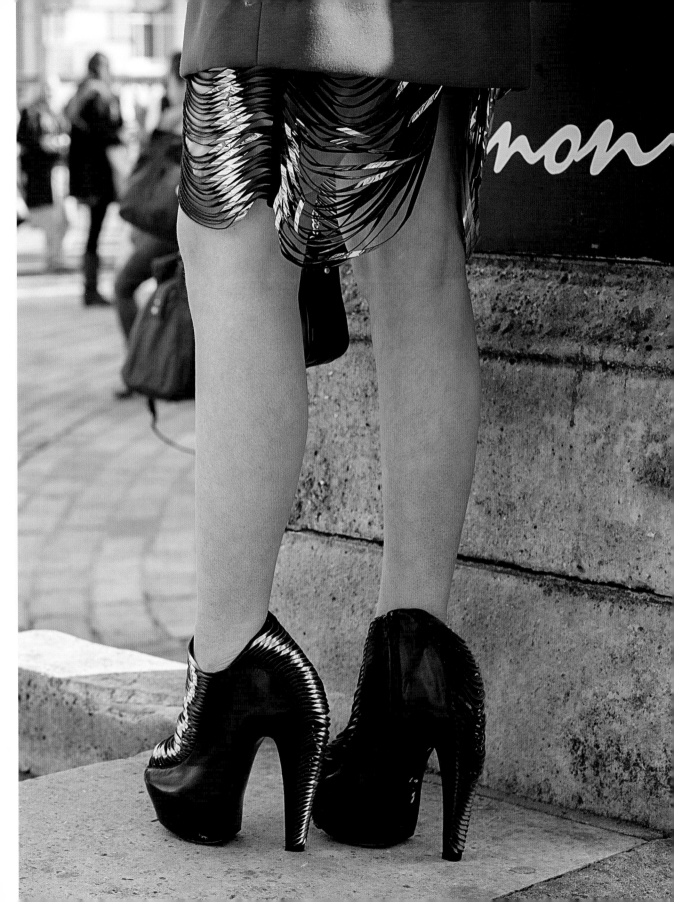

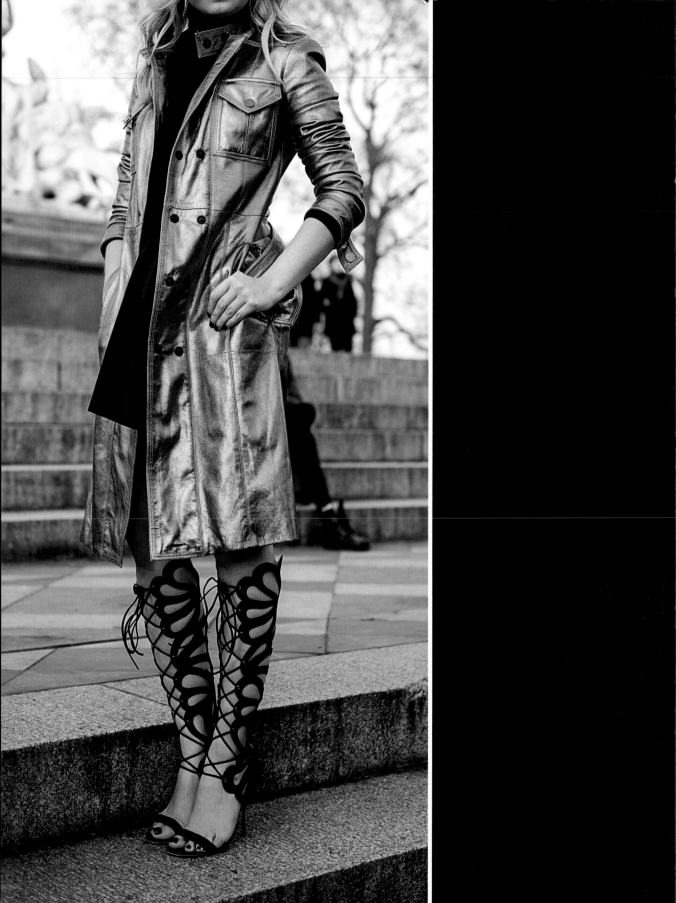

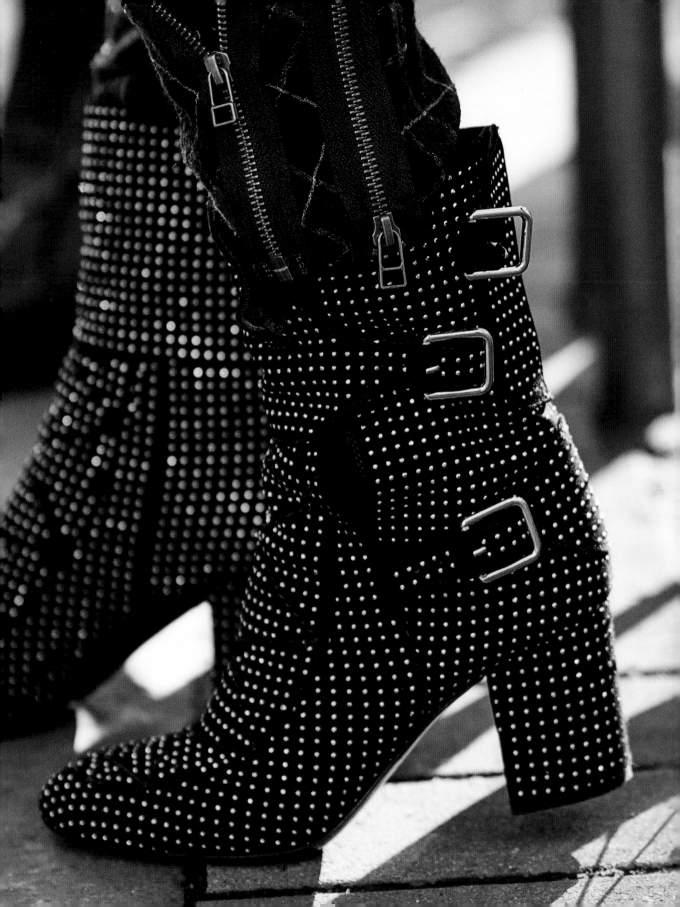

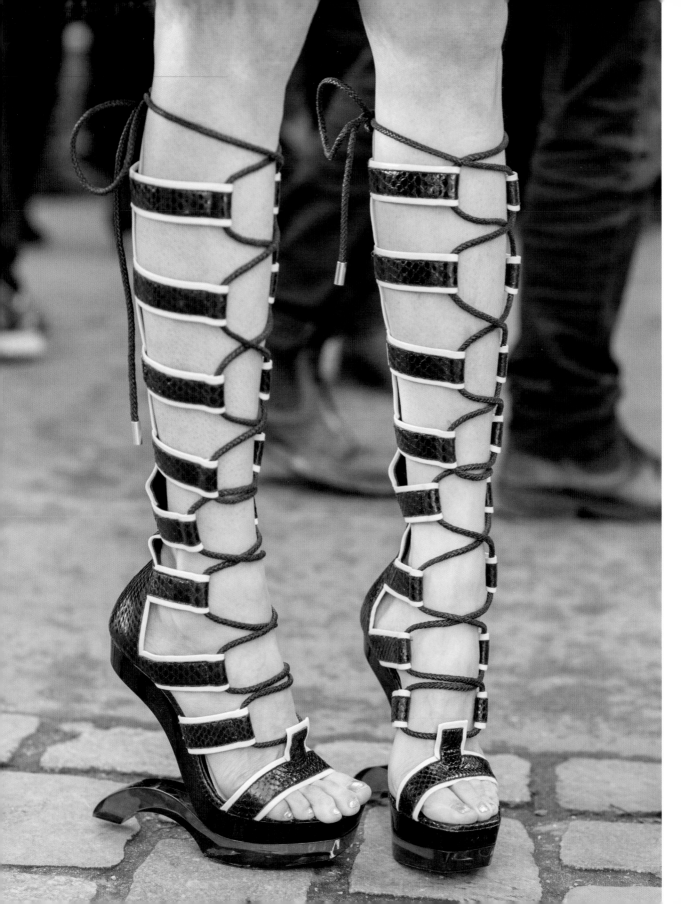

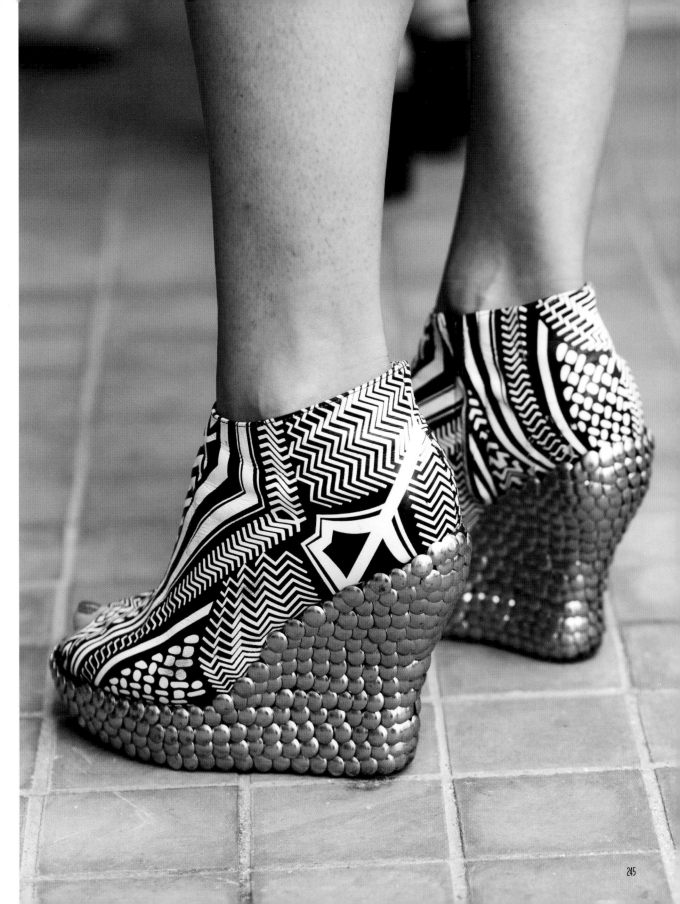

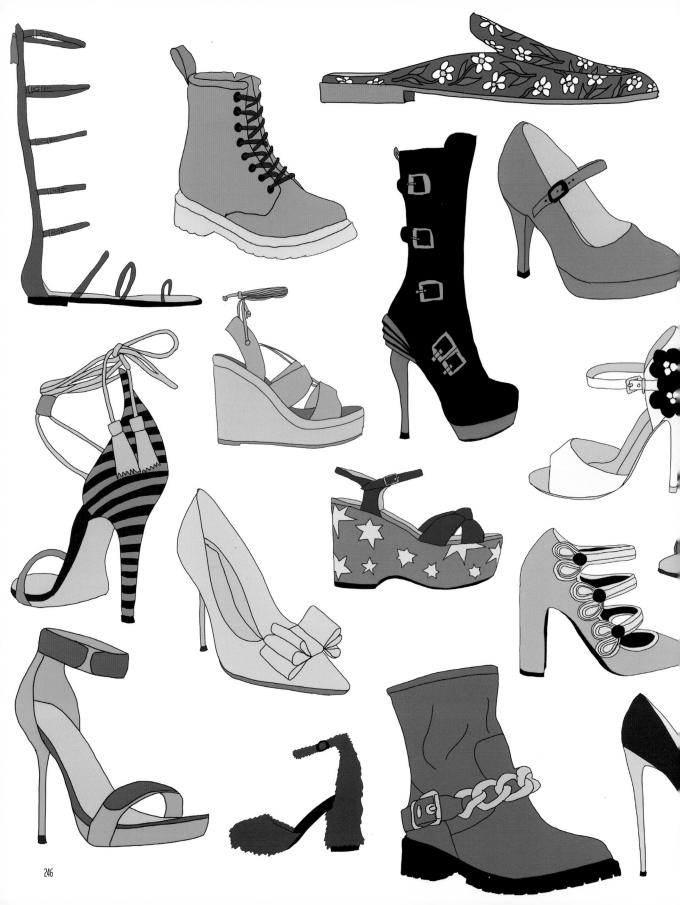

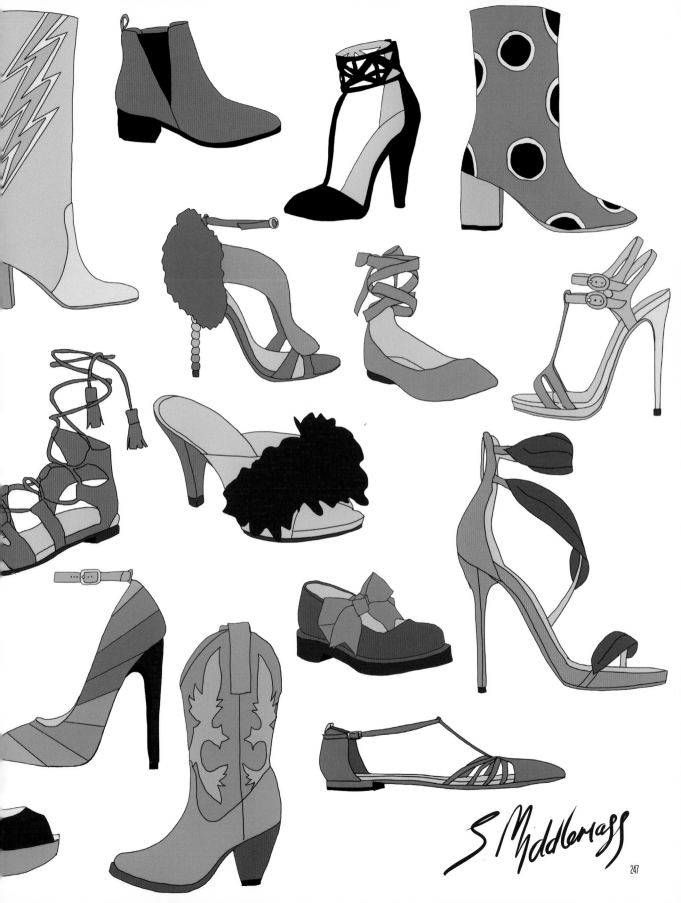

S Middlemass

Index

Index

Index

Suzanne Middlemass

Since completing her Fine Art degree in 2001, Suzanne spent the following few years assisting before enrolling in a Diploma course in photography at the renowned London College of Communication, London. Straight out of college she started working for magazines and, in 2011, she became a Glamour.com contributing Street Style photographer. Since then, her work has gone from strength to strength: her international publications include *Company, Cosmopolitan, Elle, Grazia, GQ*, Hearst publishing, *Hello Fashion, LOOK!, The Guardian, Women's Health* and *British Vogue* to name but a few, as well as being assigned by international brands, Furla and Havaiana Shoes.

Today, Suzanne travels the globe shooting street style and backstage at international fashion weeks for an array of universal brands and clients.

Après avoir obtenu un diplôme des Beaux-Arts en 2001, Suzanne a passé les quelques années qui ont suivi à prendre des cours avant de s'inscrire pour un diplôme de photographie au très réputé London College of Communication à Londres. Dès la sortie du College elle a immédiatement commencé à travailler pour des magazines et en 2011, elle est devenue photographe de style de rue chez Glamour.com. Depuis lors, son travail est allée de succès en succès : parmi ses publications internationales se trouvent *Company, Cosmopolitan, Elle, Grazia, GQ*, Hearst publishing, *Hello Fashion, LOOK!, The Guardian, Women's Health* et *British Vogue* pour n'en citer que quelques-unes, outre des missions de la part de marques internationales comme Furla et les chaussures Havaianas.

Aujourd'hui Suzanne voyage dans le monde entier pour photographier le style de rue et les coulisses des semaines internationales de la mode pour le compte d'une ample gamme de marques universelles et de clients célèbres.

Acknowledgments

I would like to express my gratitude to the people who saw me through this book; who supported and encouraged me.

First and foremost, I would like to thank teNeues for enabling me to publish this book, and to Carla, for being on the same page.

I would like to thank my family and friends for their love and support, and to Pete, for keeping me sane and who inspires me everyday.

Lastly, I would like to thank all the fabulous ladies whose style inspired me to do this book, ultimately, without them, there would be no book.

Je voudrais exprimer ma reconnaissance à tous ceux qui m'ont suivi tout au long de ce livre et qui m'ont appuyé et encouragé.

Tout d'abord j'aimerais remercier teNeues pour m'avoir donné la possibilité de publier ce livre et Carla, pour m'avoir toujours parfaitement compris.

Je voudrais remercier ma famille et mes amis pour leur affection et leur appui et Pete pour m'aider à rester saine d'esprit et m'inspirer jour après jour.

Et enfin je souhaite remercier toutes ces merveilleuses dames dont le style m'a inspiré à faire ce livre car au bout du compte, sans elles il n'y aurait pas eu de livre.

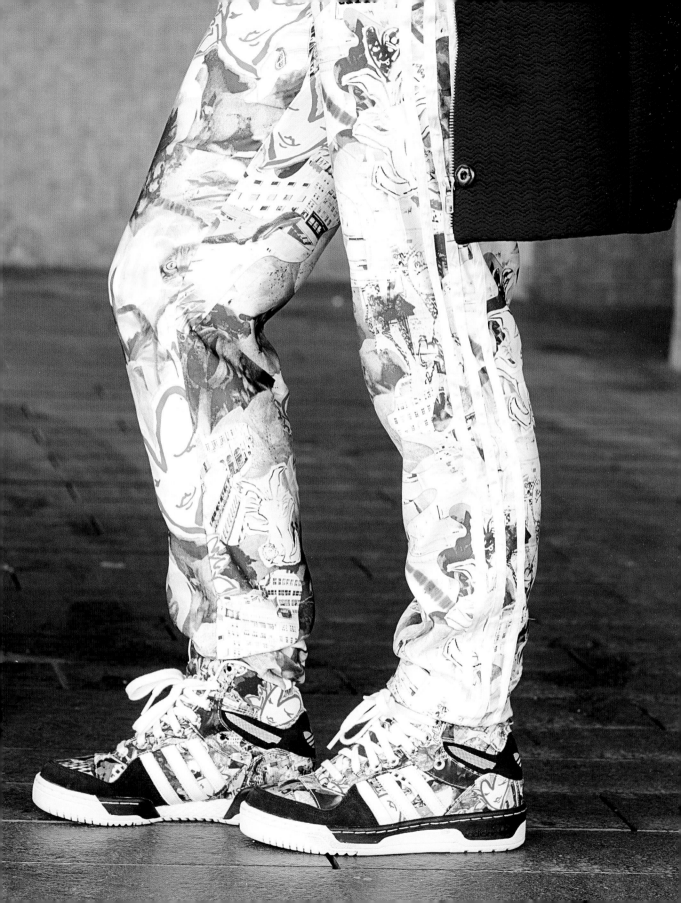

It's All About Shoes
© 2017 Suzanne Middlemass. All rights reserved.

Introduction by Suzanne Middlemass
Photography and illustrations by Suzanne Middlemass
Editor: Carla Sakamoto
Designer: Allison Stern
Production by Dieter Haberzettl
Color separation by Jens Grundei, teNeues Media

Published by teNeues Publishing Group

teNeues Media GmbH + Co. KG
Am Selder 37, 47906 Kempen, Germany
Phone: +49-(0)2152-916-0
Fax: +49-(0)2152-916-111
e-mail: books@teneues.com

Press department: Andrea Rehn
Phone: +49-(0)2152-916-202
e-mail: arehn@teneues.com

teNeues Publishing Company
7 West 18th Street, New York, NY 10011, USA
Phone: +1-212-627-9090
Fax: +1-212-627-9511

teNeues Publishing UK Ltd.
12 Ferndene Road, London SE24 0AQ, UK
Phone: +44-(0)20-3542-8997

teNeues France S.A.R.L.
39, rue des Billets, 18250 Henrichemont, France
Phone: +33-(0)2-4826-9348
Fax: +33-(0)1-7072-3482

www.teneues.com

ISBN 978-3-8327-6904-8
Library of Congress Number: 2016957914

Printed in the Czech Republic

teNeues Publishing Group
Kempen
Berlin
London
Munich
New York
Paris

teNeues